SPECTACULAR HOMES

of Georgia

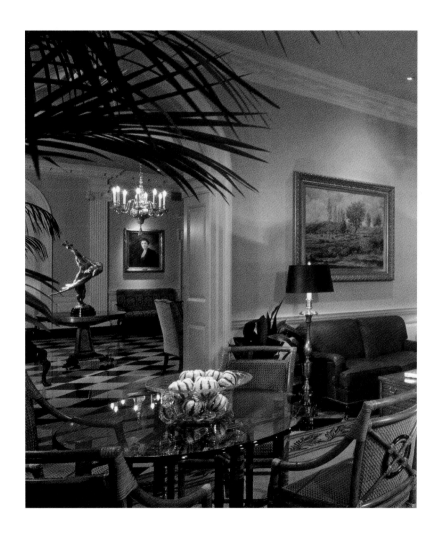

AN EXCLUSIVE SHOWCASE OF GEORGIA'S FINEST DESIGNERS

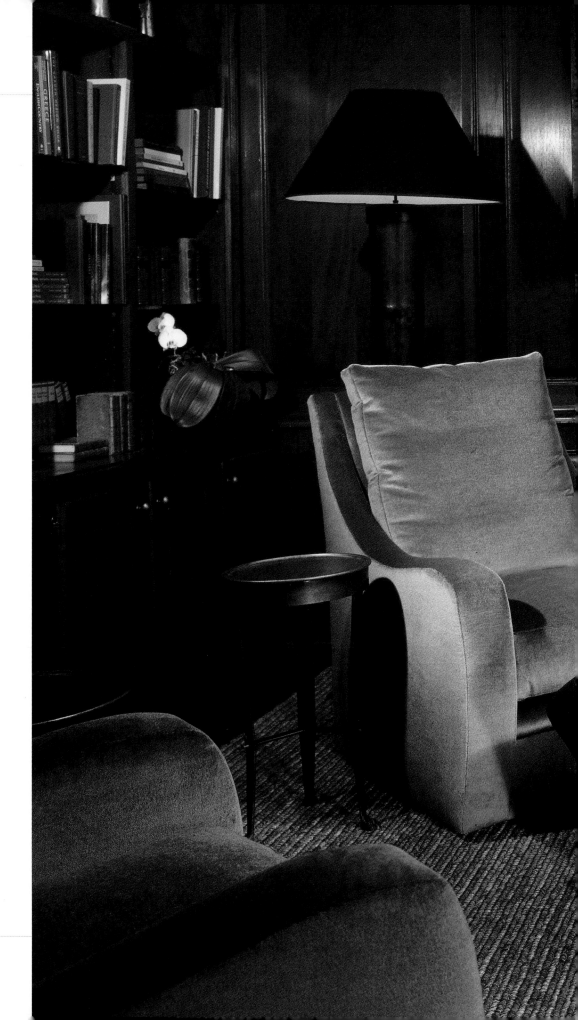

Published by

PANACHE
PARTNERS LLC

13747 Montfort Drive, Suite 100
Dallas, Texas 75240
972-661-9884
972-661-2743
www.panache.com

Publishers: Brian G. Carabet and John A. Shand

Printed in Malaysia

Distributed by Gibbs Smith, Publisher
800-748-5439

PUBLISHER'S DATA

Spectacular Homes of Georgia

Library of Congress Control Number: 2004117270

ISBN Number: 978-0-9745747-6-9

First Printing 2005

10 9 8 7 6 5 4 3 2 1

On the Cover: Designer: Kathy Guyton / Guyton Design Group
See page 47 *Photo by John Umberger*

Previous Page: Designers: Glenn and Paula Wallace / Wallace Designs
See page 153 *Photo by Chia Chiung Chong*

This Page: Designer: Kathy Guyton / Guyton Design Group
See page 47 *Photo by John Umberger*

SPECTACULAR HOMES

of Georgia

AN EXCLUSIVE SHOWCASE OF GEORGIA'S FINEST DESIGNERS

by Jolie Carpenter

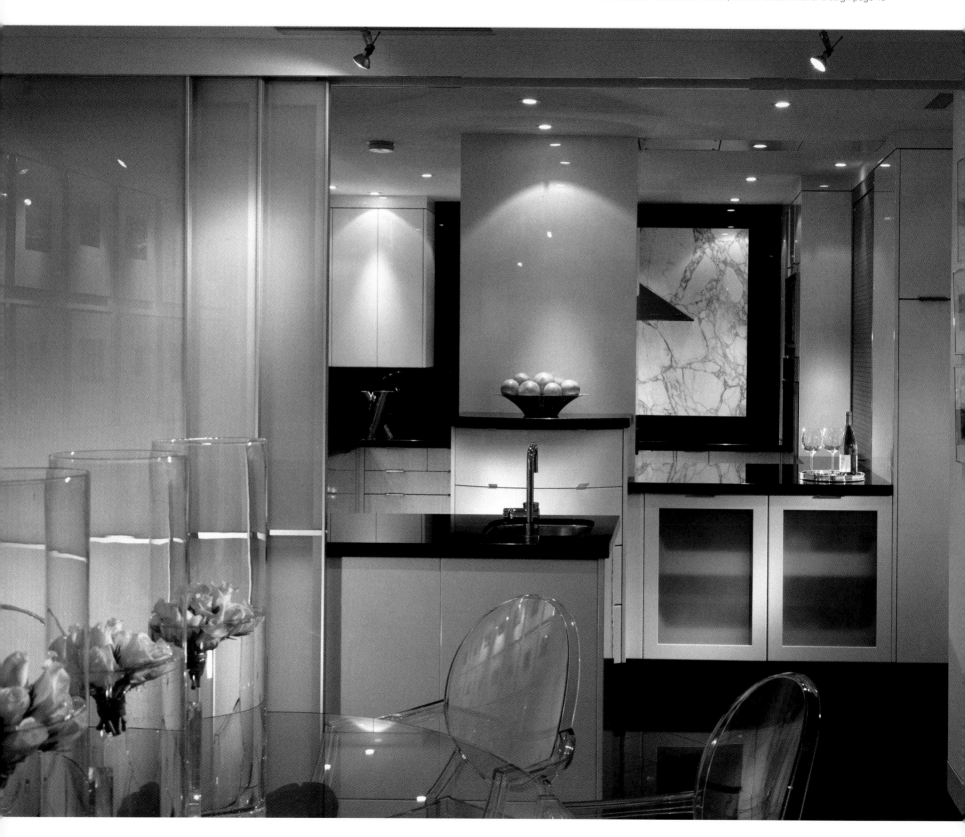

INTRODUCTION

Spectacular Homes is a collection of Georgia's finest designers showcasing their most outstanding body of work. As you experience *Spectacular Homes*, you will agree that each home is unique in its own right and the vision of these talented designers shine through as you turn the pages.

The Peach state (as we call it) embodies the hallmark of design talent that has prevailed here for hundreds of years. In Georgia, when it comes to choosing a style of design that best tells your story, a common theme amongst these selected professionals is simple...whatever the client wants. Many of today's best interior designers embrace the diversity of taste that has made its mark in not only Atlanta, but in the outlying areas as well. With such a culturally diverse society, the design community of Georgia has both national and international influences that make our homes as unique as the individuals themselves.

Through my travels around the state during this project, I quickly realized many of the things that Georgia has to offer. From the Blue Ridge Mountains down to the beaches of St. Simons Island, from the International Golf Community of Augusta to the big city lights of Atlanta, this is a state filled with heritage, hospitality, gentile spirits and a love for beauty. It is no wonder the talent in Georgia is as vastly different as the cities and towns that make up this great state.

The designers in the following pages are not only of great talent, many come with stories that are as unique as their design skills. In *Spectacular Homes of Georgia*, you will find a designer who is a descendent of the late Frank Lloyd Wright as well designers who have been recognized on a national level for their expertise and their accomplishments.

It was my great pleasure to seek out and work with some of the greatest talent the South has to offer. Along the way I had the pleasure of meeting some of the hospitable "folks" and, in the end, I was grateful to have had this opportunity. I was lucky enough to make some new friends as well.

So the next time you are in Georgia and you have the opportunity to travel throughout the Peach State, look around - soak it in - marvel in its wonder and diversity. Then maybe you will understand why Georgia should be on your mind.

Warmest regards,

Candace Werginz

Candace Werginz, Associate Publisher

5

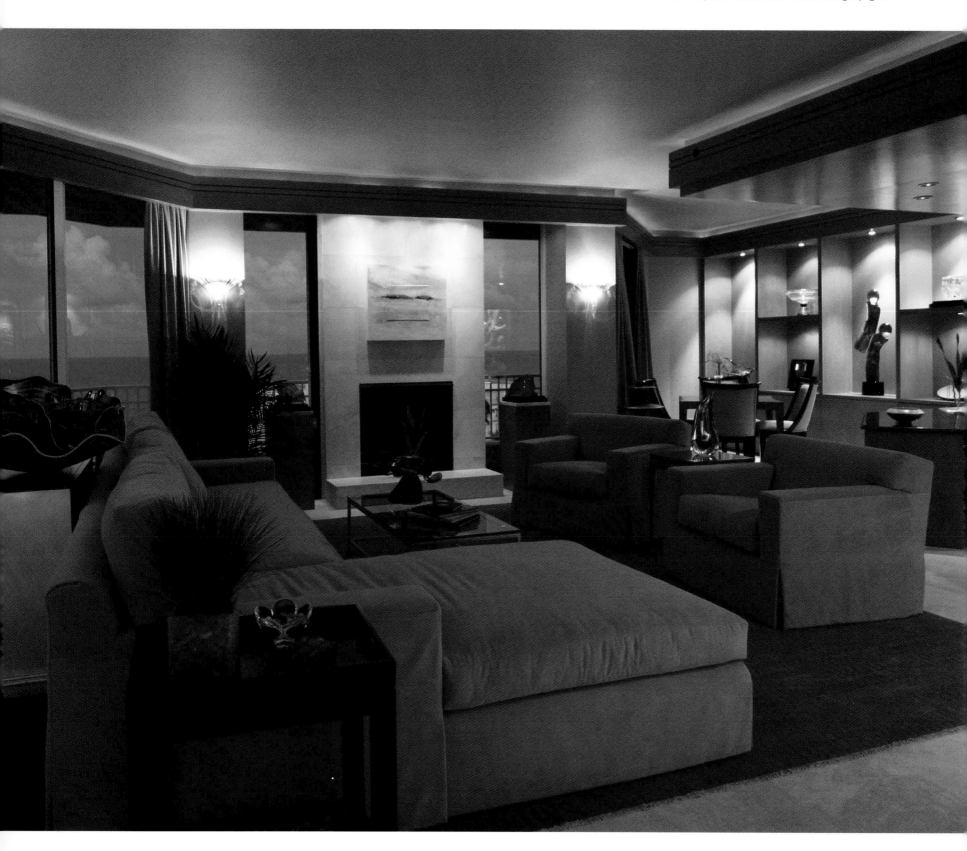

TABLE OF CONTENTS

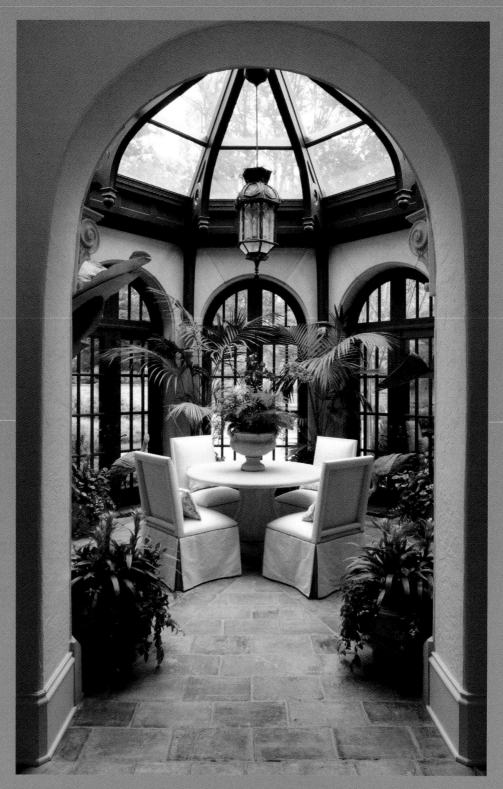

DESIGNER Beth Webb/Beth Webb Interiors, page 165

Georgia

AN EXCLUSIVE SHOWCASE OF THE FINEST DESIGNERS

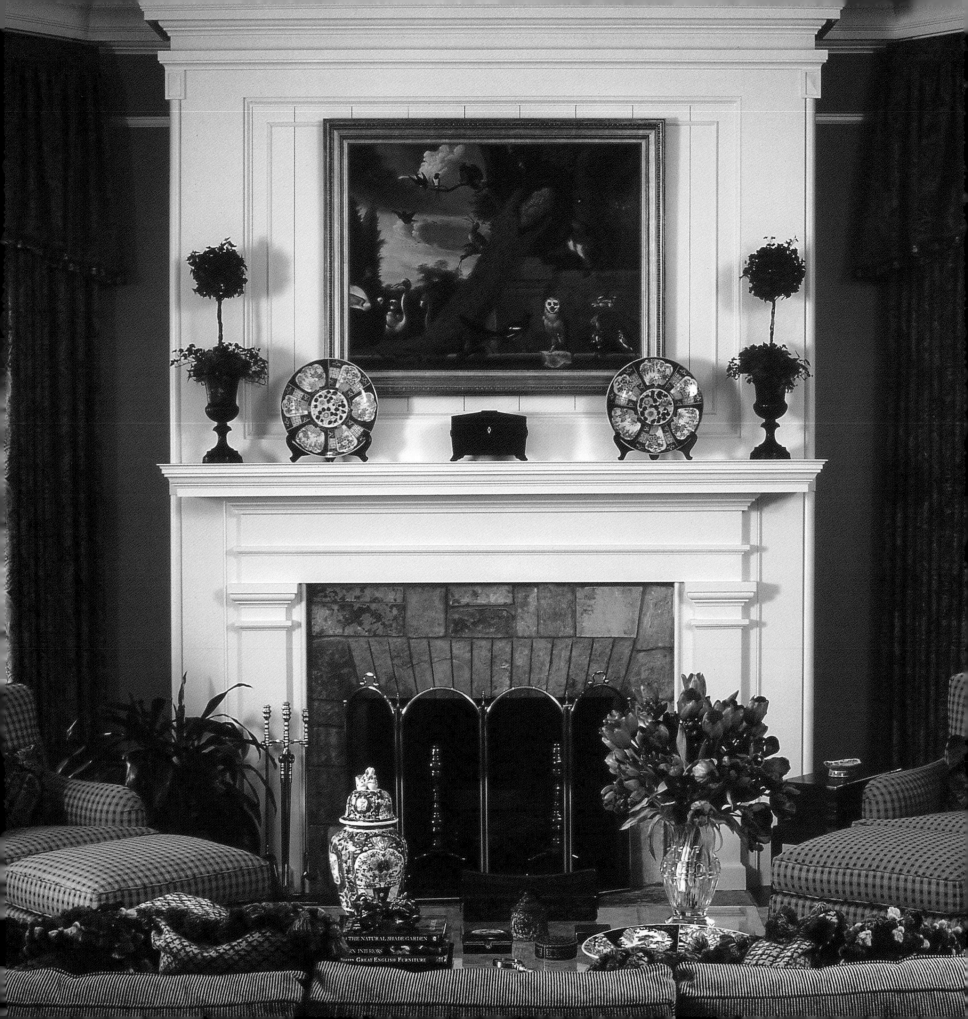

LEFT In this family room, John mixed rich colors and textures to achieve his signature clean-lined traditional look.

RIGHT A coromandel screen makes a dramatic backdrop for a vignette including antique urns and altar lamp.

JOHN BANKS

John S. Banks Interiors

John Banks has a classical grounding. He grew up in Eutaw, Alabama, in what he describes as an "American colonial house with columns in the front" and a traditional interior. And here in Georgia he considers the Swan House, with its exquisite Italianate detailing, the most impressive house around.

Still, one interior that remains a lasting inspiration for John is at the cool, Asian-contemporary Millenium Ritz-Carlton Hotel in Singapore. It has clean lines and cutting edge art, and was designed by feng shui masters. "It was fascinating to me," he recalls. "So cutting edge. Beautiful pieces, with a minimalist feel. But very comfortable."

These two sensibilities might seem at odds. But they come together in John's work to produce spaces that are at once traditional and clean-lined – and always comfortable and warm. He'll bring in contemporary

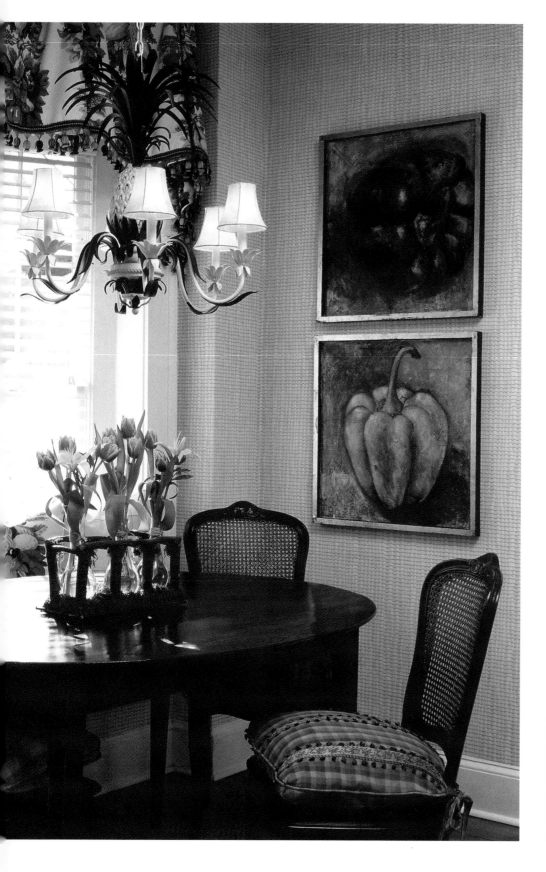

touches, especially through art, and use unexpected fabrics on traditional furniture. A mixture of styles helps him express a client's personality.

John cultivated his aesthetic with plenty of family support. "Both of my grandmothers had great taste and were interested in design; I picked up a lot from them," he explains. After earning a bachelor's degree in interior design from the University of Mississippi, his father encouraged him to do graduate work. He came to do that at the Art Institute of Atlanta – and the rest, as they say, is history.

Communication with clients is at the top of John's agenda. "I try to find out what is really comfortable for them, and what they think is the epitome of a beautiful room." These early conversations can sometimes reveal that a couple has divergent visions, and so John is called upon to negotiate the compromises. "I just put my guard down and get to know them as friends. It's important that they trust me," he says, but he's no dictator. He always makes a point, for instance, of presenting clients with multiple choices, and eliciting their views.

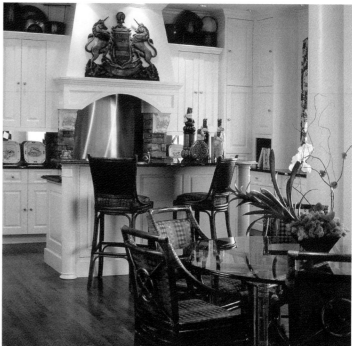

LEFT In this charming breakfast room, John reflected his client's vibrant personality and love of color.

ABOVE A McGuire table and chairs, rich textures and Indonesian accents give this kitchen its casual warmth.

John's favorite kind of project is to redo an existing house, creating an entirely new environment within it, and a new lifestyle for its owners. "I love going in and using their things to update it. We don't just throw things away and start from scratch, because it's not our house, or a show house; it has to have the clients' stamp on it."

John admits to being extremely particular, but he's also easygoing and calm. No wonder his favorite color is green – or that he's so adept at interpreting his clients' desires.

ABOVE RIGHT A bright Brunschwig & Fils print makes this living room not only dressy but casually inviting.

BELOW RIGHT The hues in a portrait of the client's son are echoed here in fabrics from Brunschwig & Fils and Cowtan and Tout.

More about John ...

WHERE DO YOU FIND INSPIRATION?

From traveling, and experiencing interesting hotels and restaurants. If money were no object, I would take a trip around the world.

WHAT'S THE BEST PART OF BEING AN INTERIOR DESIGNER?

Meeting and working with different people.

WHAT'S YOUR OWN HOUSE LIKE?

It's like a Highlands house in the city - of stone and cedar in a wooded setting, with big beams in the living room and lots of glass. It's filled with English antiques and a few contemporary pieces, and my collections of Imari and blue and white porcelain and antique walking sticks.

JOHN S. BANKS INTERIORS
John Banks, Associate ASID, IIDA
455 E. Paces Ferry Rd., Suite 310
Atlanta, GA 30305
404-266-0085
FAX 404-266-0770

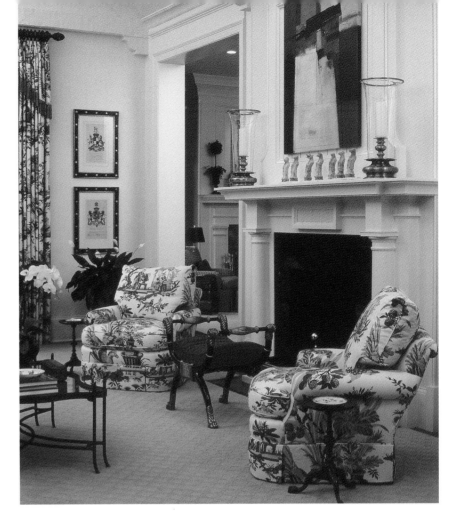

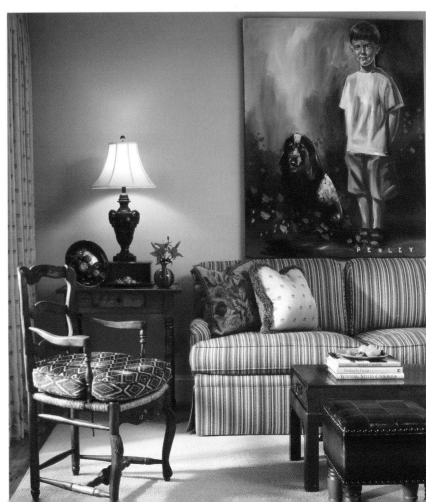

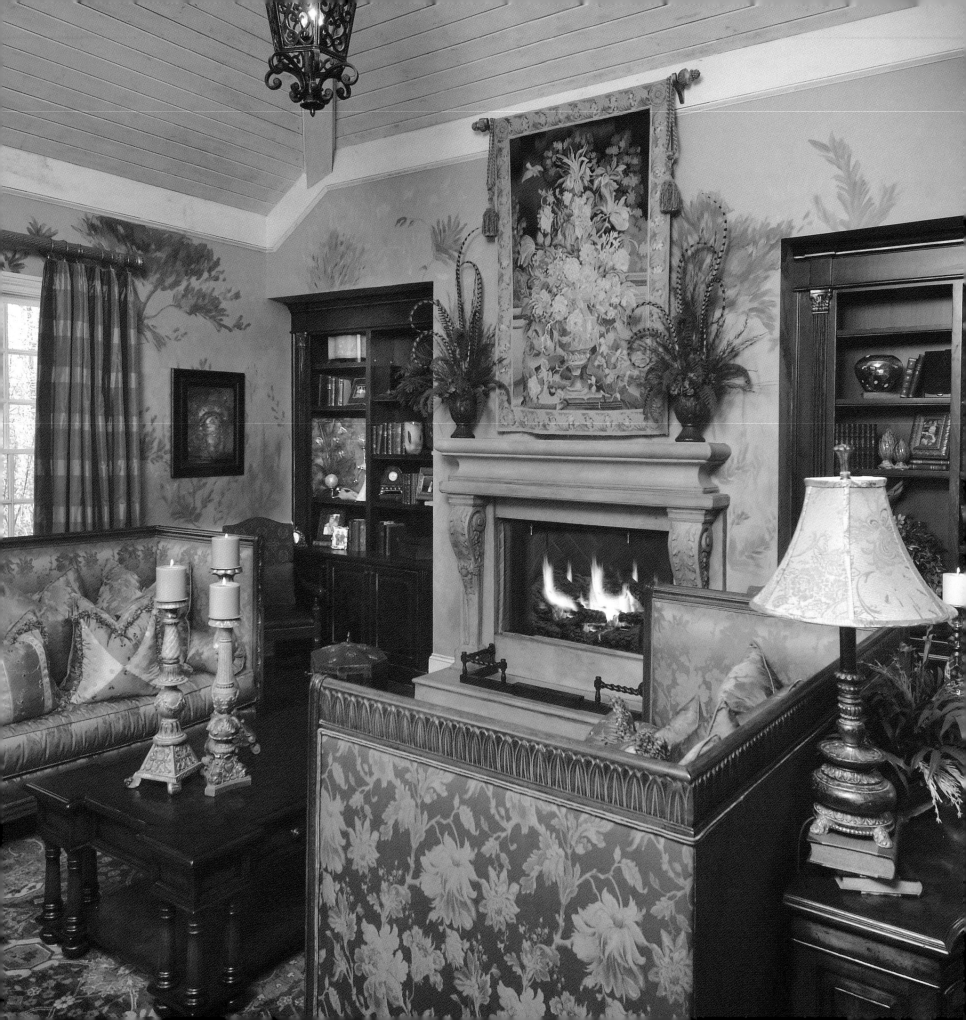

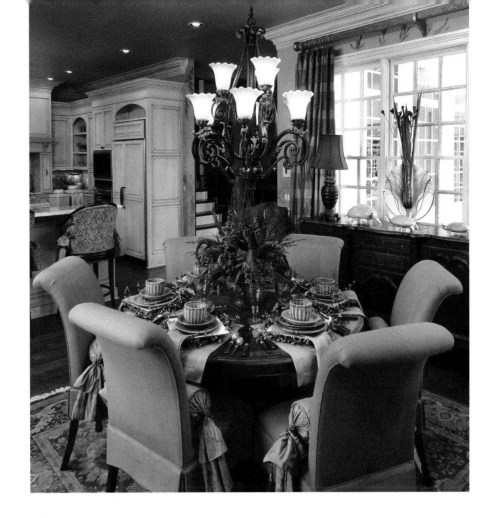

LEFT The keeping room in the 2005 Home of the Year at Governors Towne Club in Acworth shows Heather's lively approach to traditional design.

RIGHT The breakfast area has a bright, easy formality.

HEATHER BENTLEY

Heather Bentley Designs

Heather Bentley describes her interior design work as diverse in style, but with a leaning toward the traditional. "I do a lot of the 'Southern look,'" she explains. "But if I had to do the same thing over and over I'd get bored. So I like to throw in bright colors, like lime green, just to make it fun. And fortunately, I get to do a lot of contemporary projects, too."

Heather's mother was an interior designer. "I've always loved nice things," she says, and remembers being one of those kids who was always rearranging her room. Later she earned a degree in interior design. "That's when you find out it's not really about rearranging, but about architecture, scale, balance, and so on." Now she especially enjoys the challenges that call on that knowledge, such as space planning for a house that needs to be remodeled.

Heather, who does commercial as well as residential design, has been published in *Atlanta Homes & Lifestyles, Kitchen Trends,* and the *Marietta Daily Journal.* She served as chairperson for the 2005 Home of the Year in Acworth, where a different designer did each room. "It was terrific to see how diverse they all were, and how much they could bring that others wouldn't have thought of."

HEATHER BENTLEY DESIGNS
Heather Bentley, ASID
95 Chastain Rd.
Suite 202
Kennesaw, GA 30144
678-300-0140
FAX 678-363-6720

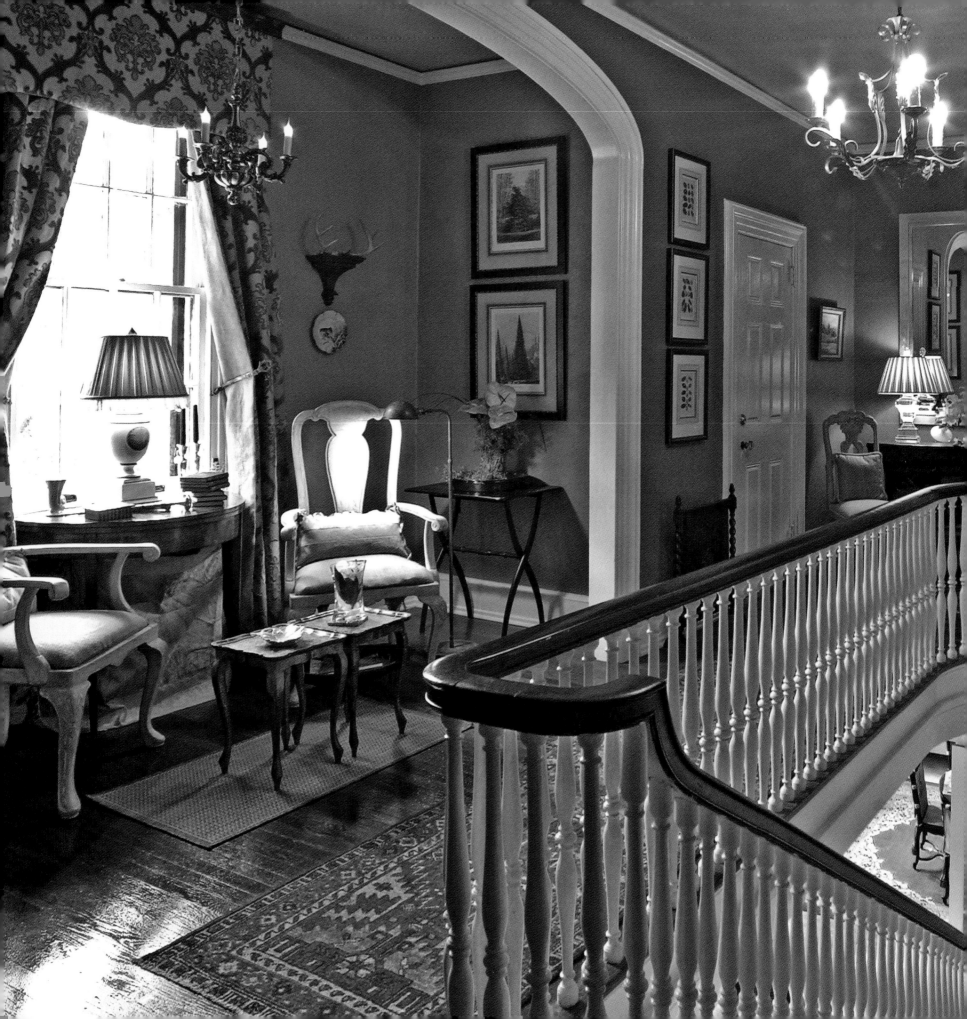

LEFT Pallette of soft gray browns serves as an ideal backdrop for a collection of prints as well as 18th century landscapes in oil. A crystal lamp sparkles in front of a silver-leafed custom mirror at the end of the hall. The creamy gray chairs in the niche and silver blue cushions and pillows are an interesting contrast against the wall color.

RIGHT Quiet reading niche softly illuminated by painted pastoral urn lamp. Burlap lined velvet scrolled panels frame the window of a 1920's villa. Heirloom pieces such as grandfather's walking stick handles punctuate the serene palette.

TRACY BENTON

Benton Cole Interiors

Tracy Benton believes historical houses in her hometown of Macon were one of the original sources of her interest in design. "While attending grade school in an antebellum house," she recalls "fascination with the details of the architecture."

Although various architectural styles are of importance to the designer, she lives in a rustic New England salt box with exposed beams. The home is cottage cozy with hunting lodge rusticity, collected Italian pieces and a shot of modernity. Combining these elements provides opportunity for experimentation. "Much of the time my home is a lab to try ideas."

As a designer, "a certain practicality and thinking ahead for the client are given consideration." Does this couple have small children and will this piece wear well with family life? Does this person have a busy career and need a carefree lower maintenance retreat? Her approach is to "orchestrate fresh distinct yet livable rooms by bringing different elements together and layering color, pattern and texture for a sharp yet subtle effect." She enjoys merging a little glamour in a project for the finale. "A beautiful mirror or 1940's French moderne piece adds a sparkle that makes you feel good when walking in a room."

An appreciation of combining different styles and periods harmoniously is effective in creating interest. She encourages a quiet contrast, and for the client to consider an element they may not have thought to be their taste. "When a really traditional person buys a painting evoking a contemporary feel, or a great looking Lucite lamp I know they are in tune with adding some edge." She notes, "it's equally if not more interesting for a client in love with contemporary agreeing to an old Scandinavian chair or bench for juxtaposition as your eye flows around the room."

Although she doesn't have a "specific style" she adds, "I don't like things overdone or too trendy, and a sense of elegance and luxury is always important even in the most casual room."

In working with clients, Tracy believes it is paramount to create a home that reflects the owners taste and lifestyle. Her goal is to guide the process and present ideas which reflect their favorite colors, passions, and style." She adds, "sometimes people don't utilize designers as well as they could" and suggests "a balance between a client's communication of likes and interests and deferring to the designer."

BENTON COLE INTERIORS
Tracy Benton
2582 Rockbridge Road
Macon, GA 31204
Macon – 478-745-1376
Atlanta – 404-409-0271

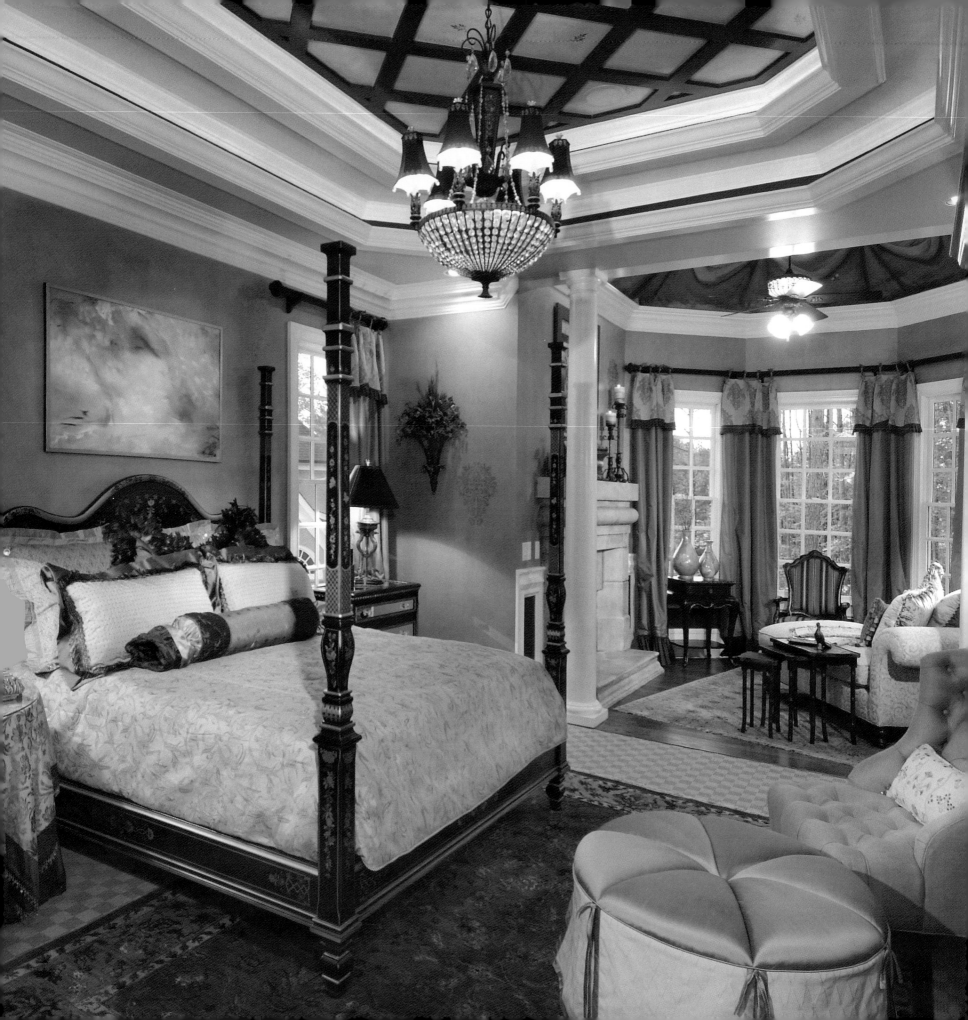

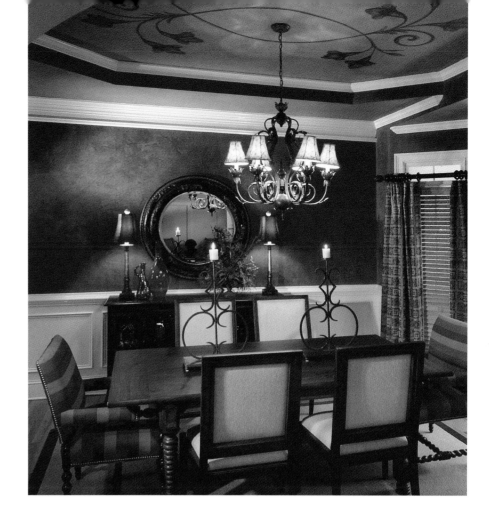

RIGHT Vivid red Venetian-plastered walls bring high energy to this dining room, while elements of leather, iron and heavy wood give it grounding.

LEFT The perfect blend of soft luxurious silks, elegantly detailed furnishings, and soft touches of faux artistry create the palette for this stunning bedroom. The walls create the backdrop for this masterpiece with warm washes of chocolate and soft bronzed medallions placed where you least expect them. The sitting room features a restful chaise under a celing of fauxed swags of silk with whimsical dragonfly accents.

CINDY DAVIS

C. Davis Interior Design, Inc.

When we were taught as children to respect and listen to our elders, Cindy Davis never knew how the words of her grandmother would lead her into such a successful design career. "She taught me the importance of buying quality and to never skimp on the details" says Cindy. "And never follow the trends but instead seek out creative formats that are always timeless," her grandmother would encourage. Those powerful words have become the bones of her design philosophy.

When describing the perfect client, Cindy cites their willingness to completely trust her firm to "think outside of the box" with the commitment that creative, yet functional design and an investment in quality furnishings, fabrics, and all of the details can enrich one's life. "Design should never feel forced or contrived, rather the feeling should be timeless and a reflection of the surrounding architecture

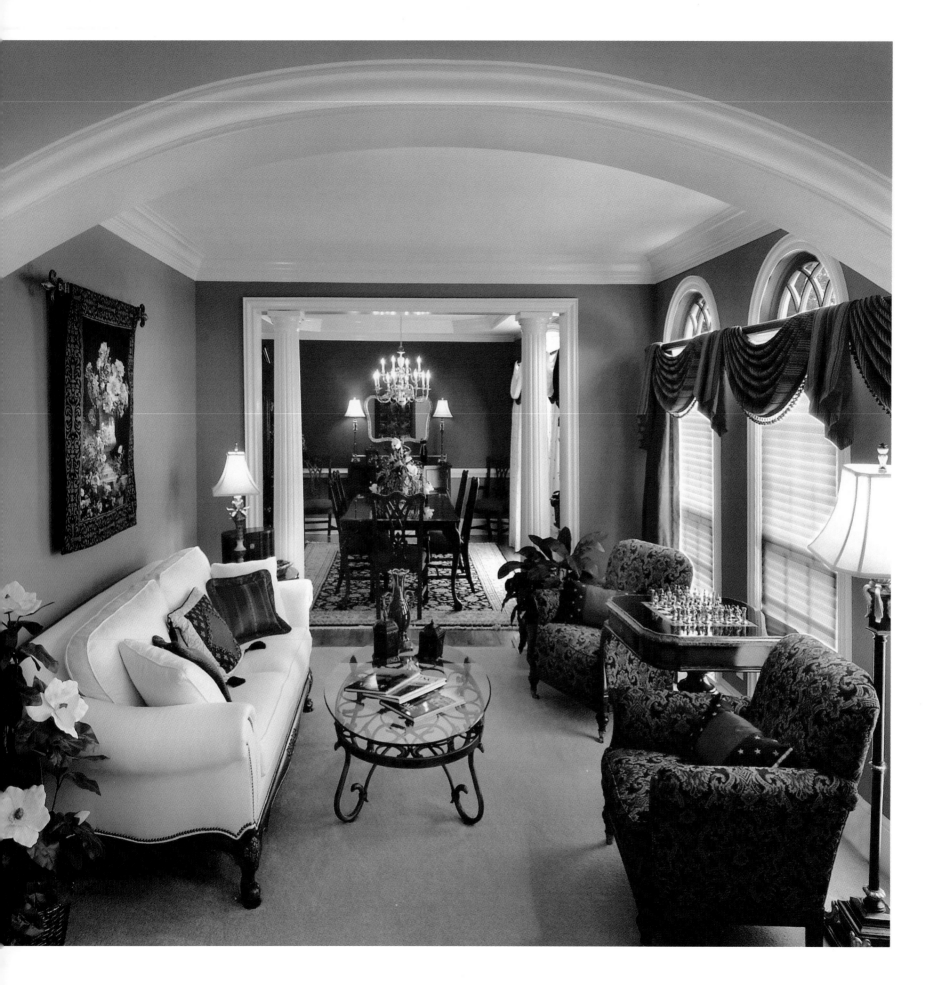

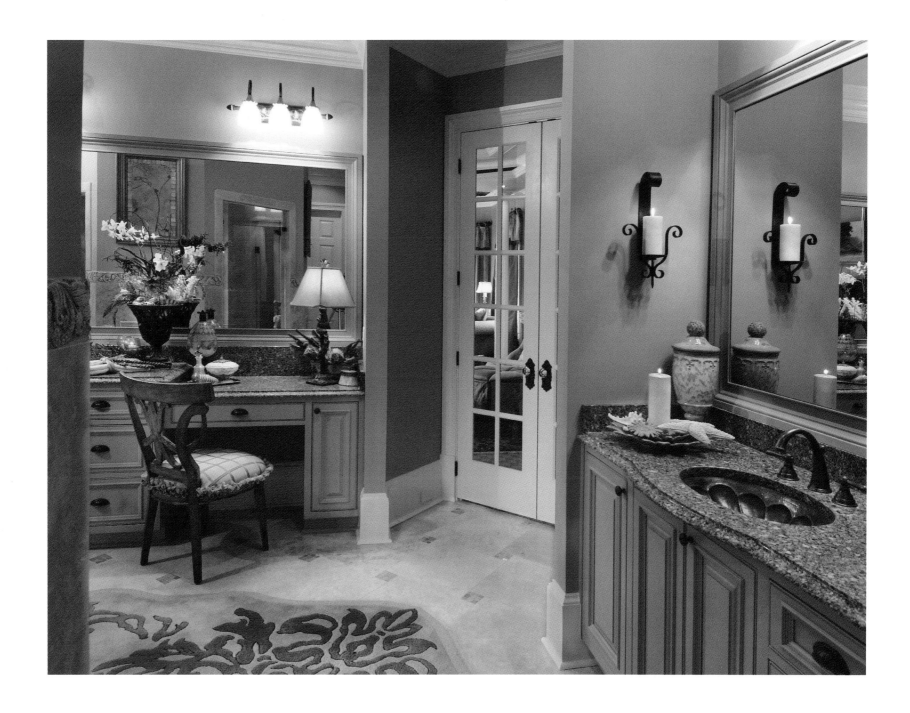

LEFT Red walls and accents unify these two spaces, which are enriched by fabrics from Jerry Pair and tapestry-covered chairs.

ABOVE Cindy designed this luxurious space incorporating Italian glass tiles blending with old world rustica handmade tiles to create a "jewel box" effect. The entry focal point becomes a custom designed wool rug reflecting an elegant coral detail which leads you into the large shower area.

and the client. These ideas are what led Cindy to develop her own design firm, C. Davis Interior Design. With just over 10 years of combined design experience, Cindy has quickly positioned herself, as a well-respected, fast-rising designer in the Atlanta market and built her business off the simple principles of listening to her clients and personally working with each and everyone.

Cindy graduated with honors from Jacksonville State University of Alabama with a bachelors degree in art/design. She understands the importance of overall scale and balance of each design element and the relationship to the architectural

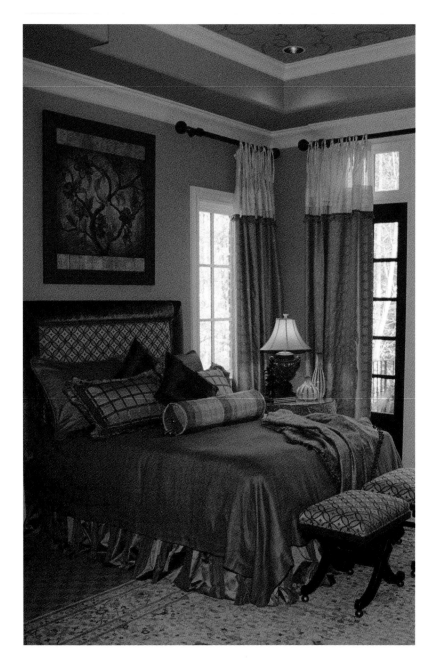

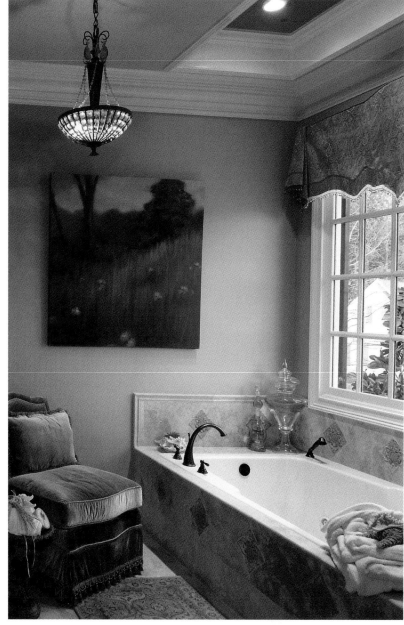

specifications. Cindy's business comprises of a complimentary mix of residential clients, from first home to secondary and final residences, as well as diverse commercial design projects. She brings her creative passion and expertise to her clientele and it becomes apparent from the initial architectural plan meeting right down to the final phase of placing that last perfect accessory.

As for Cindy's personal style, she describes it as a melding of many influences today and of centuries past. Her love of rich patinas tarnished over time and luxurious, richly textured fabrics from around the world can be seen throughout her own home. "I try to never to force my own personal style and taste upon my clients." "Everyone has their style, sometimes we need to dig a little deeper to find it, but one's personality always shines through! I always

want my clients to feel like they had a hand in this process, even if they want me to go cart blanche." Great design comes naturally and is a gift, it is not a haphazard process of just placing furniture, fabrics, and art. Design becomes a balancing act between architecture, color/fabrication details, furnishings/accent placement and family.

"To look at a thing is very different from seeing a thing. One does not see anything until one sees its beauty." —Oscar Wilde

Giving back to her community is as important as the advice she gives her client. Cindy's work has been featured in many Atlanta area show homes bene-fiting various charity organizations. Her participation in the Alliance Children's

Theatre Christmas House brings her great personal joy for it benefits bringing theatrical arts to children, which is something she holds near and dear to her heart. Her projects have also been featured in various Atlanta publications such as: *Atlanta Homes & Lifestyles*, *Atlanta Magazine*, *Today's Custom Home*, and *The Atlanta Journal-Constitution*.

Turning to her future, Cindy hopes to continue down this road of success and continues to day-in and day-out have the privilege of doing what is that she holds so dear—enriching the lives of others.

C. DAVIS INTERIOR DESIGN, INC.
Cindy Davis
95 Chastain Road, Suite 202
Kennesaw, GA 30144
770-443-6545
FAX 770-443-0283
www.cdavisinteriordesign.com

FAR LEFT A palette of sea-glass green and copper make this guest suite a tranquil retreat. The hand-painted floral swirls on the ceiling echo the rich folds of the draperies.

NEAR LEFT Relax and unwind as ocean inspired touches make this bathroom a truly relaxing experience.

BELOW A dramatic arch frames this gourmet kitchen. The clients wanted a complete remodel and Cindy listened. Softly antiqued cabinets blended with rich granite and beautiful stained glass touches give new meaning to "the joy of cooking".

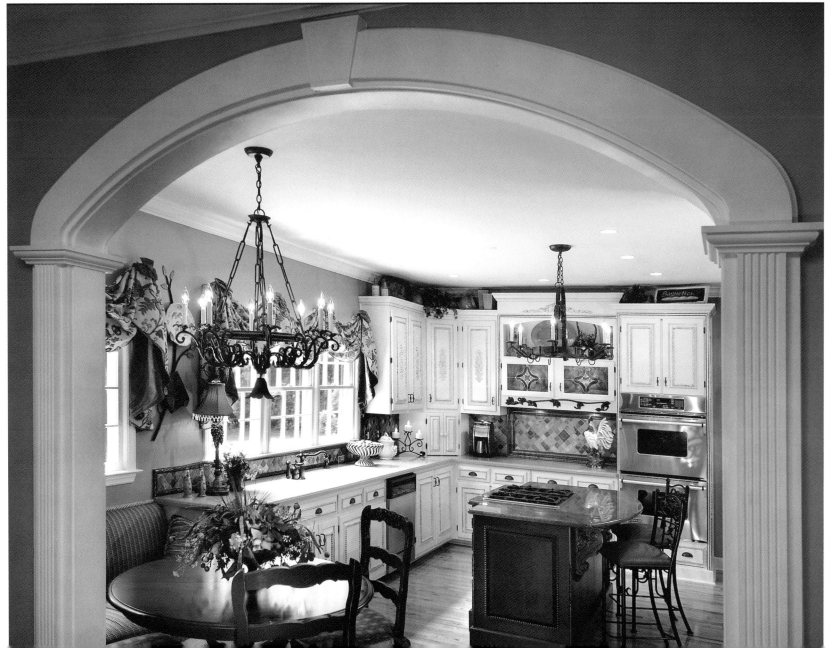

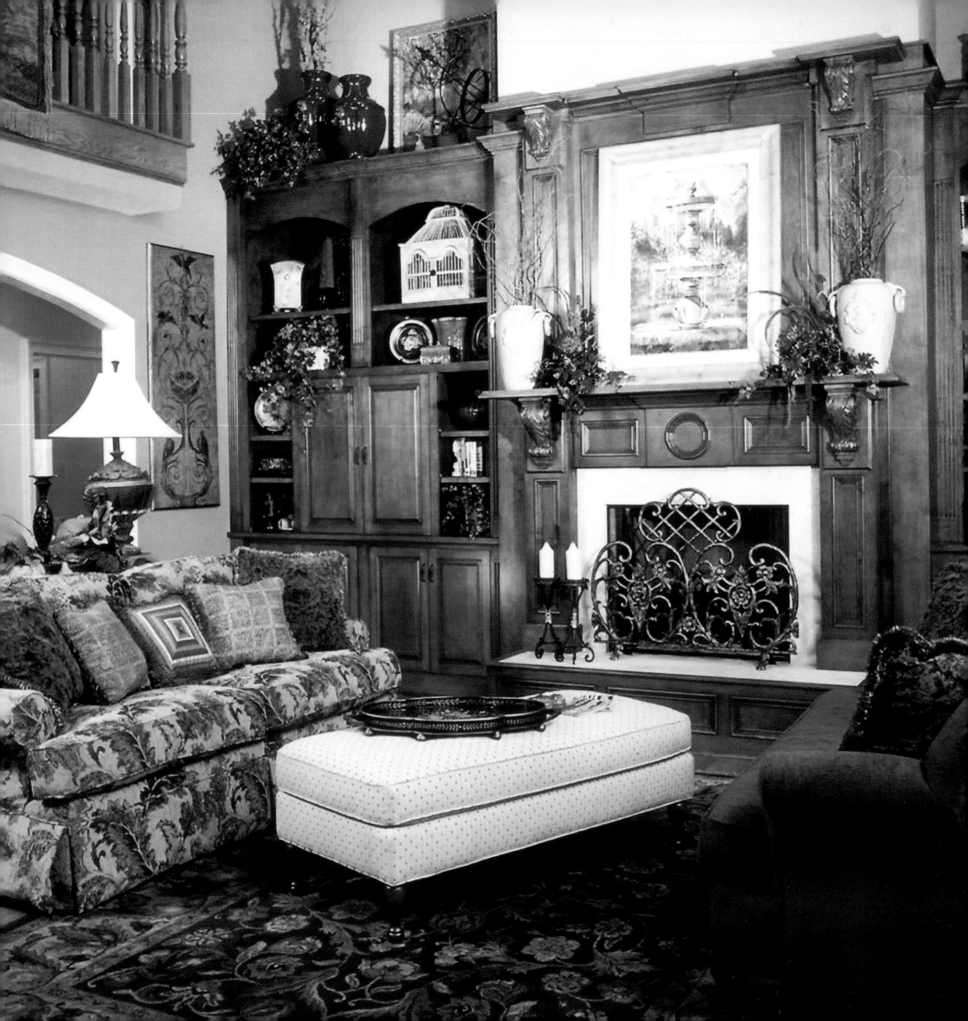

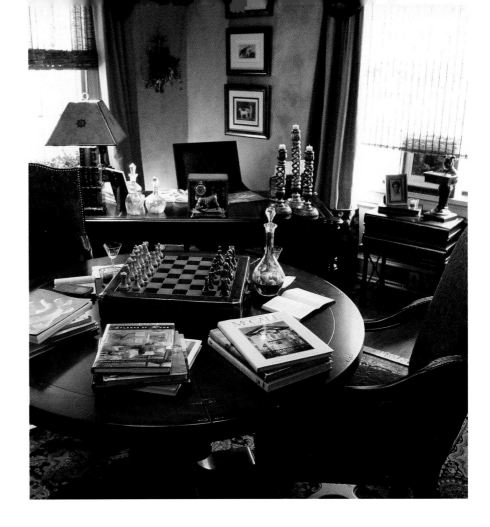

SHAUNA GOULDING-DAVIS

Shauna Goulding-Davis Interiors

"I'm not a monochromatic kind of person," Shauna Goulding-Davis admitted, over the phone. "Right now, for instance, I'm standing in my kitchen, which is kiwi green and cobalt blue. I can see into the dining room, which has raspberry walls with blue and white Chinese porcelain accessories. I love color and making it flow from room to room." Shauna also likes to layer textures and coordinating fabrics, and to mix together painted furniture with antiques and wrought iron pieces. She likes rounded upholstery styles, oriental rugs, oil paintings and "a touch of black for depth and sophistication." She calls her approach the "*Southern Living* look," and uses it to create environments that are cozy, kid-friendly and livable.

A native of West Virginia with a degree in interior design from West Virginia University, Shauna has recognized that this was her true calling ever since she was a kid. "It first started was when my mother would put out Christmas decorations. I would rearrange them and

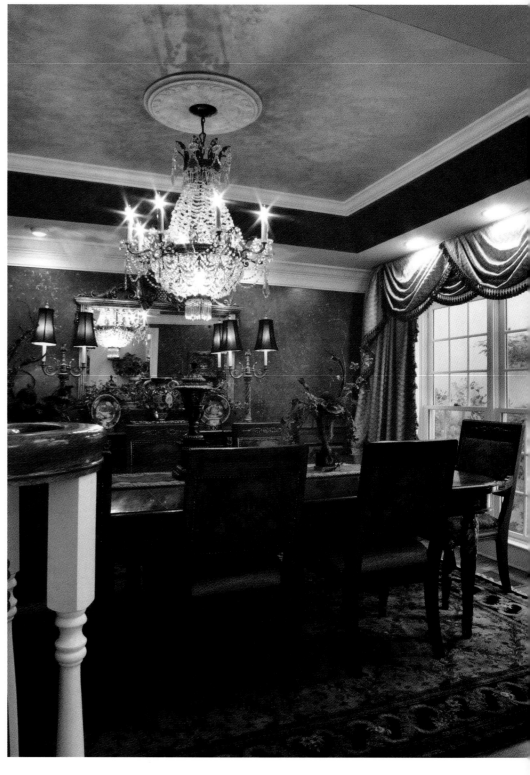

group them," she remembers. She has had her own design firm since 1988, and has taught interior design in the continuing education department of Macon State University since 1989. "Besides my use of color," she says, "what separates me from the competition is my commitment to making comfortable environments, rather than museum rooms."

"After all these years in the business, my passion for interior design has only grown stronger," Shauna says. "I eat, breathe and sleep this stuff." She even plans her vacations around where there will be a designer show house on tour. "I love to think of different ways to meet my clients' needs."

What design approach has Shauna stuck with that still works? "To balance color and pattern equally around a room in a way that makes the eye travel upward; it enhances the sense of spaciousness, livability and balance."

TOP LEFT
Neutral colors and a limestone floor help make this master bathroom a soothing retreat.

ABOVE
A hand-painted floral faux finish on walls and ceiling makes a dramatic backdrop for this dining room, where a crystal chandelier makes the draperies seem to glow.

FACING PAGE
Shauna created this arrangement with four tapestry chairs surrounding an overstuffed ottoman that's not only eye-catching but conducive to conversation.

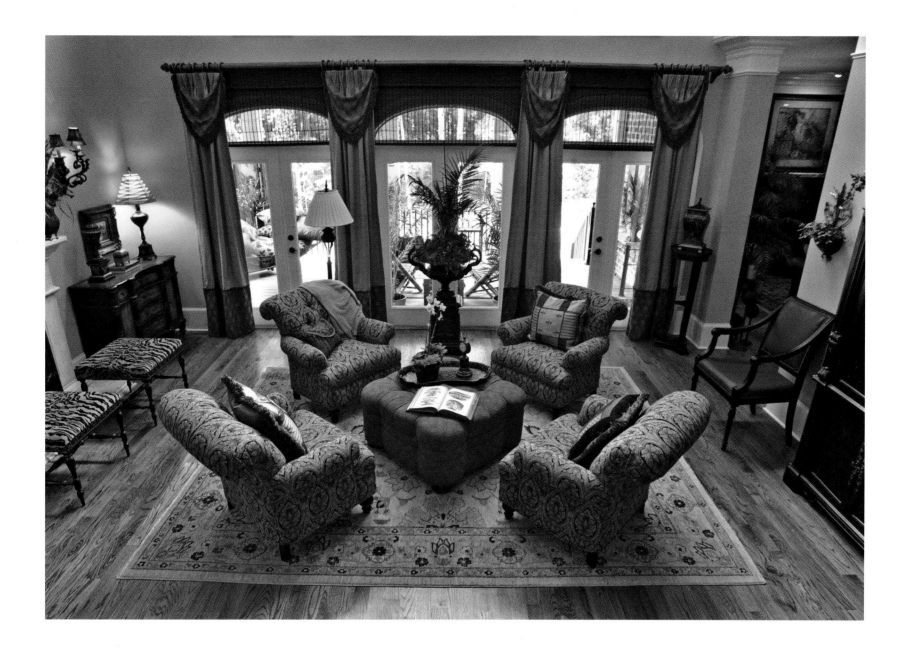

More about Shauna ...

WHAT'S ONE THING MOST PEOPLE WOULDN'T
SUSPECT ABOUT YOU?

I enjoy long weekend trips into the mountains with my husband—on our BMW touring motorcycle. You can tell I live in Georgia because I love country cooking, especially the desserts—peach cobbler, pecan pie and banana pudding.

WHAT'S THE BIGGEST COMPLIMENT YOU'VE
RECEIVED PROFESSIONALLY?

Being selected as the sole interior designer for the 2001 *Southern Living Idea House*. I must have done something right because the house sold within two hours of opening to the public.

WHAT SINGLE THING WOULD YOU DO TO BRING A DULL HOUSE
TO LIFE?

Add live greenery or fresh flowers.

I LIKE DOING BUSINESS IN GEORGIA BECAUSE...

There are great resources, little attitude, and friendly people who are eager to help.

SHAUNA GOULDING-DAVIS INTERIORS
Shauna Goulding-Davis
Allied member ASID
288 Whittington Court
Macon, GA 31216
478-784-9268
FAX 478-788-3472

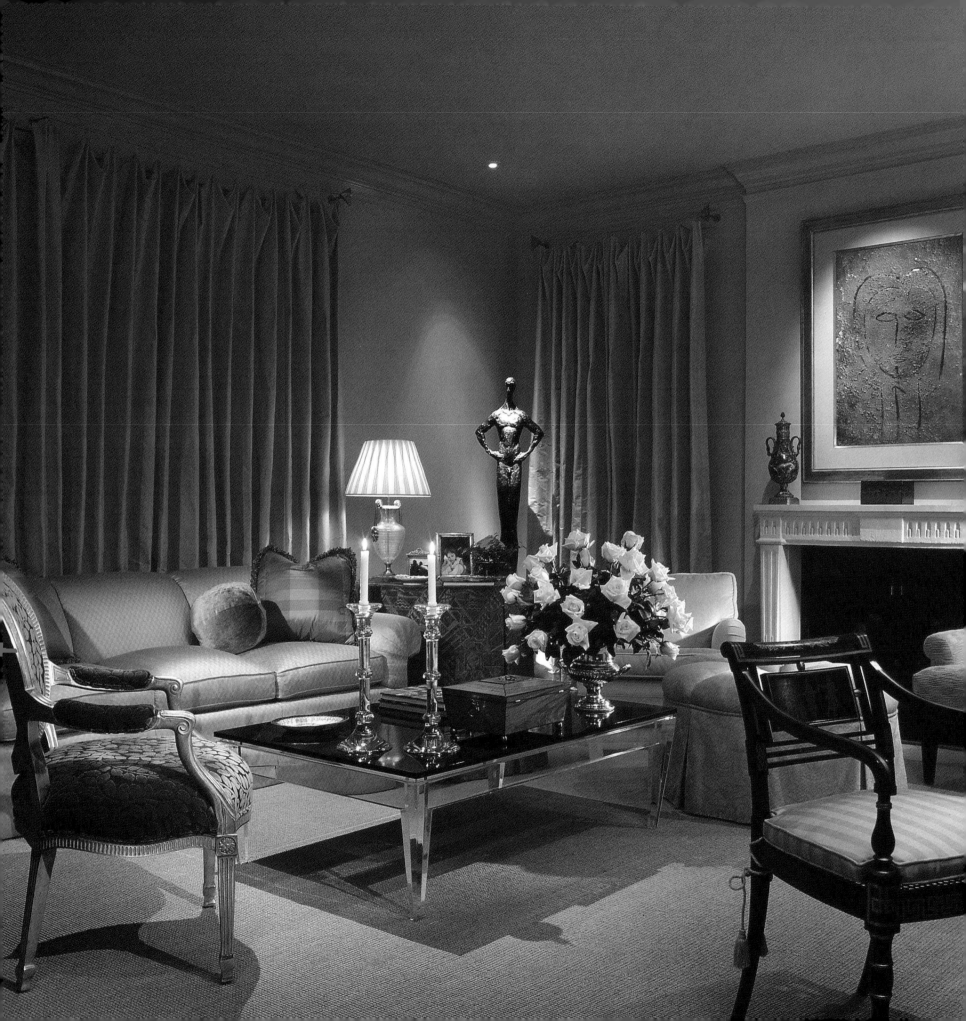

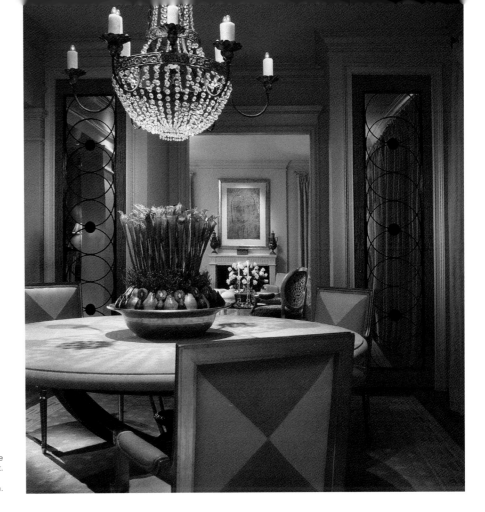

LEFT In this living room, a muted palette and soft lighting create the backdrop for an extensive collection of antique and modern art.

RIGHT Subtle geometries and restrained hues create a sophisticated dining room.

STANLEY ELLIS

Stanley Ellis, Inc.

Stanley Ellis' clients seem to enjoy the process almost as much as they do the finished product. That's because Stanley clearly understands that his vision must reflect their vision—and that his work must exemplify their unique personality and style.

Leading a full-service residential and commercial design team with offices in Atlanta and Mobile, Stanley's beautifully innovative concepts are built on proven design principles. But it's his exceptional ability to connect with people and clearly interpret their needs that continues to win him praise.

Educated at the University of Delaware and the New York School of Design, Stanley returned to his native Mobile, Alabama, in 1979 to establish Stanley Ellis, Inc., and four years later opened a retail arm known for exclusive and unusual gifts and accessories.

As the demand for his work began to increase in markets throughout the country, Stanley opened the doors of his Atlanta office in 2000. His projects grew to include private residences and second homes in Atlanta, Birmingham, Beaver Creek, Dallas, Ft. Lauderdale, Knoxville, Los Angeles, Mobile, New Orleans, New York, and Washington, D.C., as well as commercial projects for various media interests, medical facilities and law firms.

Stanley Ellis, Inc. has been featured in the Atlanta Symphony Show House, among others, and published in numerous publications such as *Veranda*, *Southern Accents*, *Southern Living*, *Showcase of Interior Design*, *Southern Edition*, *Atlanta Homes & Lifestyles* and *Beautiful Interiors*.

STANLEY ELLIS, INC.
Stanley Ellis
145 Fifteenth Street, Suite 1434
Atlanta, GA 30309
404-872-5510
FAX 404-873-6380

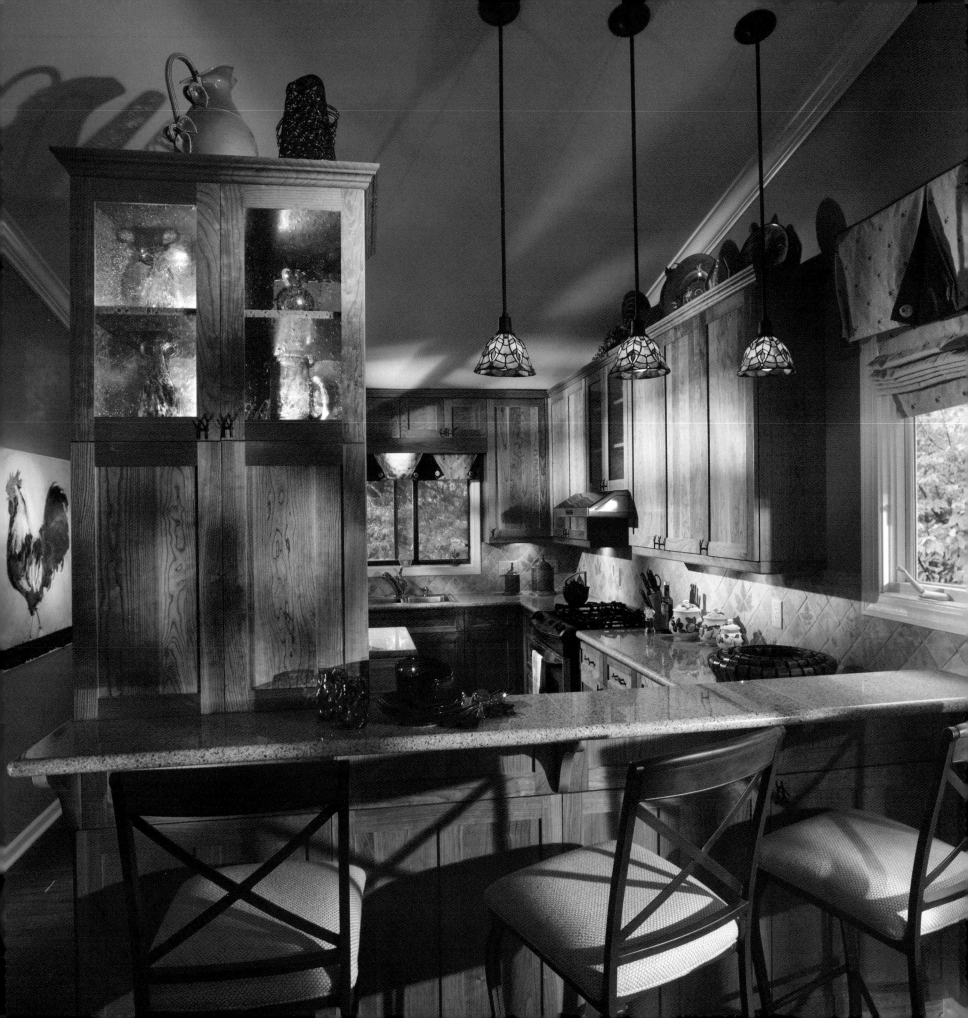

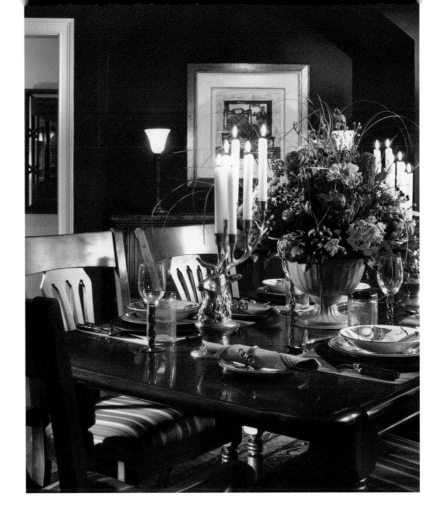

LEFT With warm natural cherry cabinets, rugged granite countertops, historic seeded glass, and rubbed bronze hardware, this Arts and Crafts kitchen is the ideal place for enjoying the company of friends and family

RIGHT Dining here is always a special occasion, though decidedly not too formal. The art glass pendant illuminates with brilliant color and architectural welcome.

MELISSA GALT

Melissa Galt, Inc.

M elissa Galt thinks of herself as a personal coach and guide. "Developing your interior develops you as an individual," she says. "The right designer will help you discover the real you."

That certainly must require confidence. But confidence comes naturally to Melissa. Just consider what she says she inherited from the three people who influenced her most: "The work ethic of my mother, the actress Anne Baxter; the supreme belief in his own abilities of my great grandfather, the architect Frank Lloyd Wright; and the imaginative genius of my godmother, the costumer Edith Head."

Melissa has operated her full-service residential design firm since 1994. She has taught design in the continuing education programs of Emory University and the University of Alabama, created rooms for

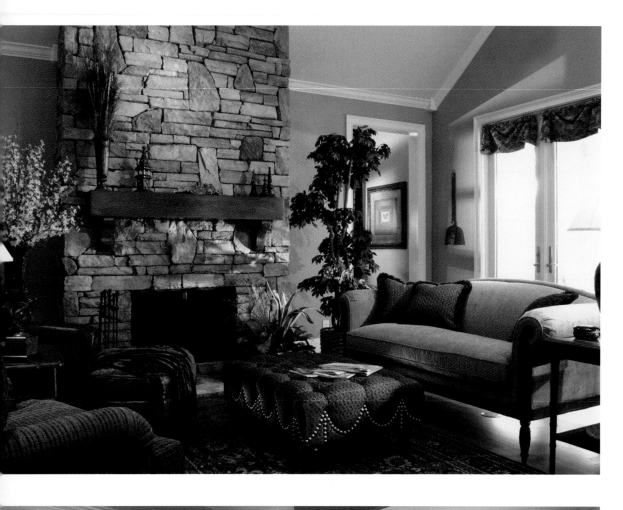

seven show houses, authored numerous magazine and newspaper articles, and been featured in *Southern Living*, *Atlanta Homes & Lifestyles*, *Atlanta Magazine* and the *Atlanta Journal-Constitution*.

Melissa creates interiors that appear to have evolved. "I emphasize a collected look," she says, "incorporating layered textures, original artwork, elements from around the globe and things personal and specific to each client. The greatest compliment I've received was from a client who so enjoyed what I had created for her that she found it nearly impossible to leave her weekend retreat."

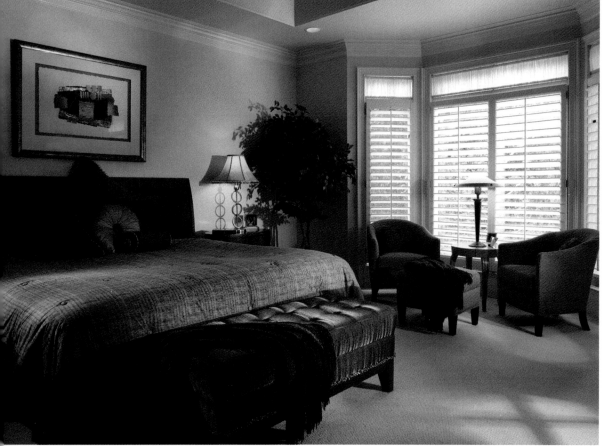

TOP LEFT
Designed for relaxation, the scheme is all from nature with the textures and colors bringing the best of the outdoors inside.

BOTTOM LEFT
A contemporary tribute in gleamy coppers, lively corals, delicious mango and shades of persimmon, this master bedroom is restful in composition but never boring.

FACING PAGE
Designed for a busy family, this Mission style kitchen offers cooking, a nook for studying, a breakfast bar, and even a casual dining table for family and friends.

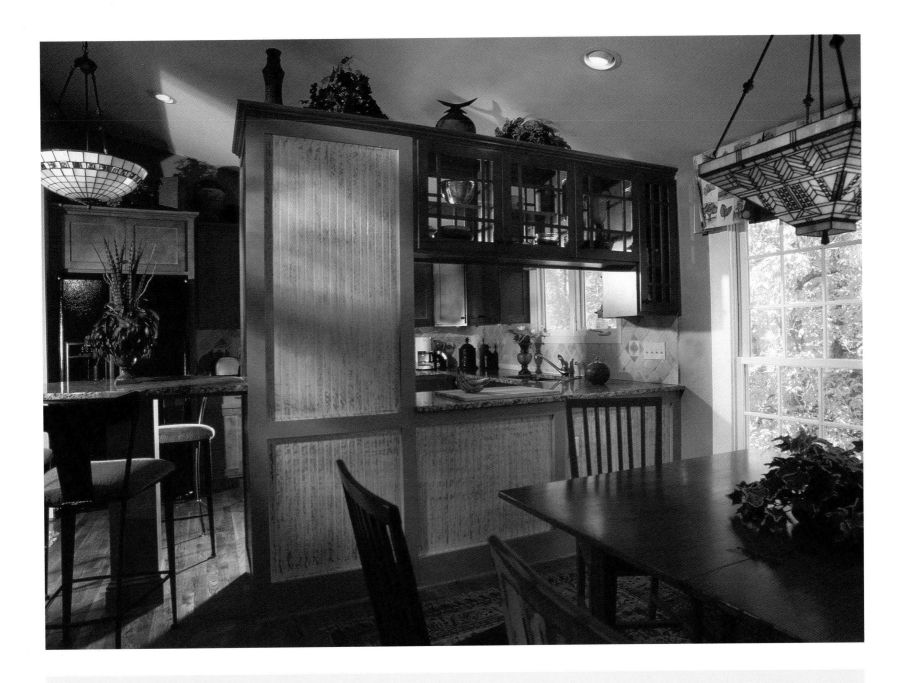

More about Melissa ...

NAME ONE THING MOST PEOPLE DON'T KNOW ABOUT YOU.

That I have a daredevil streak and have bungee jumped in New Zealand, tandem hang glided, parasailed, sky dived in North Georgia, and hot air ballooned over the wilds of Africa.

WHAT ONE ELEMENT OF STYLE OR PHILOSOPHY HAVE YOU STUCK WITH FOR YEARS THAT STILL WORKS FOR YOU TODAY?

Listen, listen, listen . . . under promise and over deliver

WHAT IS THE HIGHEST COMPLIMENT YOU'VE RECEIVED PROFESSIONALLY?

That my client found it nearly impossible to leave her weekend retreat, she enjoyed what I had created so much.

WHAT IS THE BEST PART OF BEING AN INTERIOR DESIGNER?

Making a fundamental positive impact on client's lives through great design. Coaching, guiding and directing others to finding themselves through the process of interior design.

MELISSA GALT, INC.
Melissa Galt
Member IDS, IFDA,
Allied ASID
3339 Alden Place Dr. NE
Atlanta, GA 30319
404-812-4613
FAX 404-812-4614
www.melissagalt.com

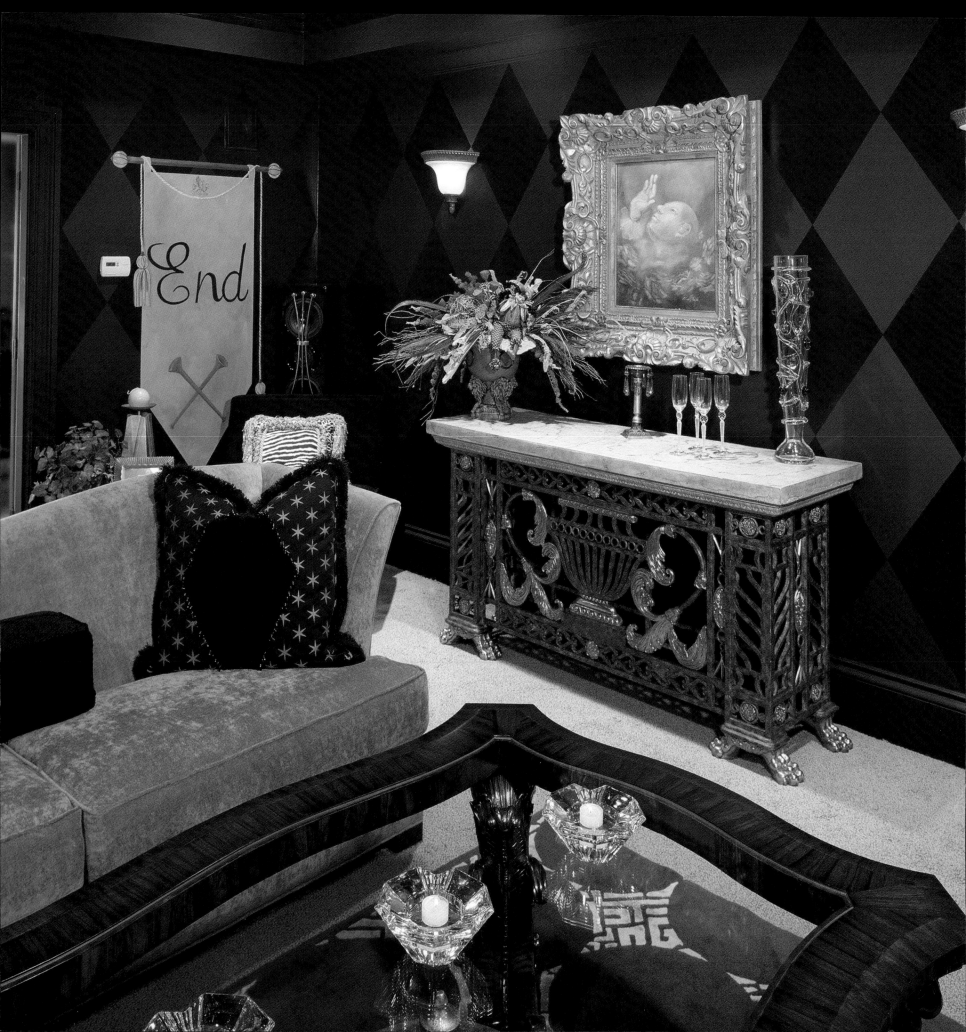

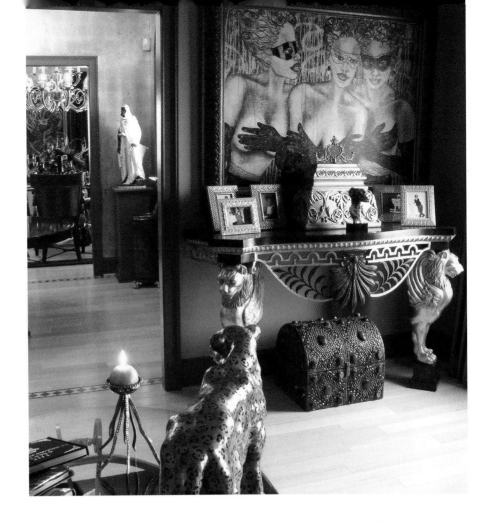

LEFT Stephanie imbued this home theater with drama by using harlequin-painted black walls. The metal console and the coffee table are by Maitland Smith, the sofa is by John Charles Furniture, and the art is by Brian Holt.

RIGHT In this living room vignette, a Vera Struck original hangs above a platinum-leaf Maitland Smith console. In the foyer beyond, a George Nock sculpture, "The Moor," stands before a platinum-metallic wall surface.

STEPHANIE GOWDY-NOCK

Stephanie V. – Allusions Interior Design

"I believe most people in fine arts have more than one talent," says Stephanie Gowdy-Nock. That's certainly true of Stephanie herself. She started playing with design as a kid of 12 or 13. "I rearranged my mother's house and people said, 'Wow! Who did it?' Then when I went into my mother's friends' or relatives' homes they'd ask me to do their rooms. It became like a game."

But when it was time for college Stephanie pursued her other talent, singing. She had a scholarship to study music, and later worked as a background vocalist for several famous performers. When she later decided to make her career in design, she returned to school.

But not for long. She quickly noticed that most of the other students would come up with the same solutions to any design problem. "All I did when I took voice lessons was learn to strengthen the natural gift

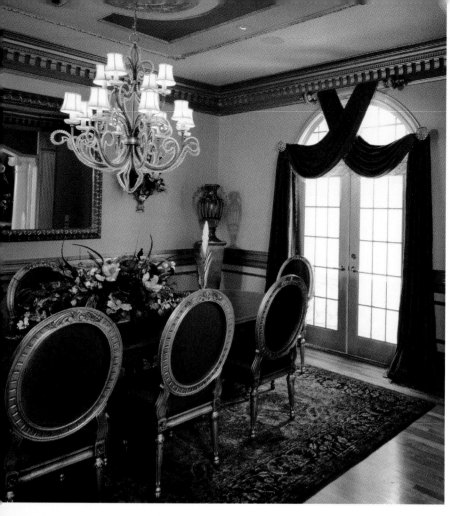

I had. I applied that to learning design. I just studied the principles myself—so that I would know when to break them. I didn't want to be like anyone else."

Sure enough, the interiors she creates today are absolutely distinctive. "I have a vivid imagination, and I love creating. It actually gives me a high. I don't look at other people's styles. Whatever the 'coming colors' are, I never use them." She does a lot of work she calls "ethnic, but that does not necessarily mean African American. It can be Italian, Irish, Jewish. Your home should show where you come from. But it should also show where you are going." Many of her projects are houses for professional athletes, all over the United States, while many others are mansions in St. Thomas, Virgin Islands. "The people who hire me," Stephanie says, "hire me because I am different."

"My own house," says Stephanie, "is flamboyant, sophisticated, and over the edge—but yet it's elegant. People who know me say, 'There goes the dramatic diva.'"

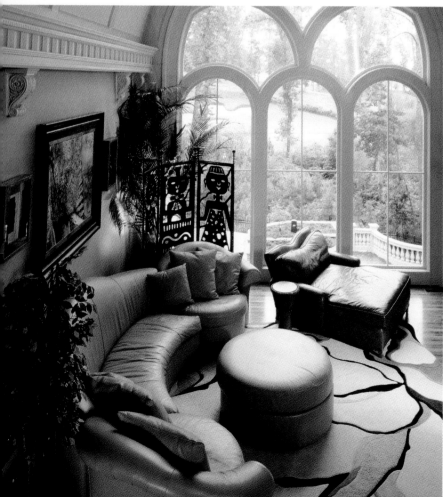

ABOVE LEFT Stephanie designed the unique drapery treatment to complement the Jefco dining room furniture and Fine Art Lamps chandelier. The flowers are by Valerie Ballentine of Withers, the urn and pedestal by Lam Lee.

LEFT Stephanie placed this custom designed leather chaise and sofa on a rug designed by the clients, Mr. and Mrs. Ray Buchanan of the Oakland Raiders.

ABOVE An Audrey Menefee painting hangs on walls in chocolate taupe. The exotic arrangement of feathers is by Valerie Ballentine of Withers.

More about Stephanie ...

WHAT COLOR BEST DESCRIBES YOU?

Platinum, because I'm very flamboyant.

WHAT IS THE SINGLE THING YOU WOULD DO TO BRING A DULL HOUSE TO LIFE?

Paint. You could change the mood of the whole world if it could only be repainted.

WHAT PHILOSOPHY HAVE YOU STUCK WITH OVER THE YEARS THAT STILL WORKS?

Never follow trends—create them!

WHAT SEPARATES YOU FROM THE COMPETITION?

I can create your wildest dreams because I'm not

afraid of breaking the rules.

ALLUSIONS INTERIOR DESIGN
Stephanie Gowdy-Nock
Member Atlanta Design Network,
Interior Design Society
9415 Knollcrest Boulevard
Alpharetta, GA 30022
678-777-5799

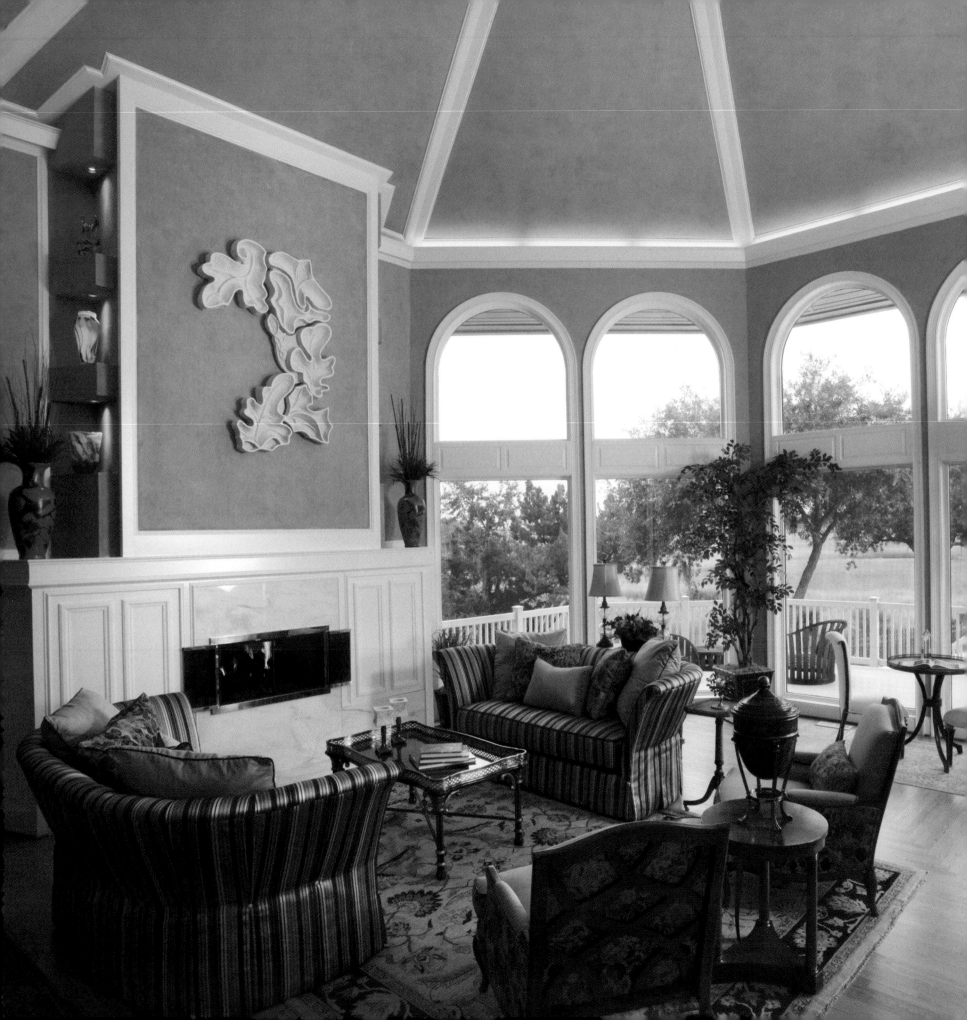

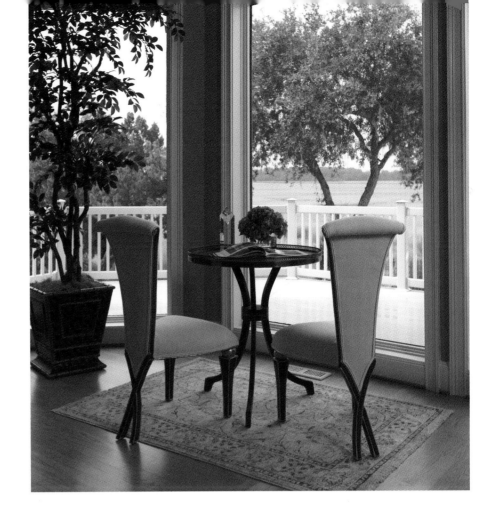

LEFT The feeling of the Grand Room is kept light and airy with a beautiful view of Savannah's intercoastal water. Richly hued chairs and sofas, all Henrendon, add luxury and warmth. All elements of the room are brought together by the hand-vegetable-dyed Sumaki rug.

RIGHT The perfect spot for taking time out of busy day to enjoy the view, these chairs showcase a decidedly classy look and "sexy" lines.

TERRY F. GROOVER

Island Interiors

" I see my role as a designer as creating mood and attitude," says Terry Groover. "I am so thrilled to complete a job, look at the beauty and detail, and see the happiness and satisfaction of a client who is completely astonished at the transformation."

Terry credits her mother, "a true Southern belle, who exemplified style and grace," as having had the biggest influence on her life and career choice. "She was always moving things around the home to get a different look, to create a different mood. She always encouraged me to live out my style and show my creativity and excitement." After earning a degree in interior design from Georgia Southern University, Terry first freelanced and then established her own Savannah firm, Island Interiors, "fulfilling my passion for art, fashion and design."

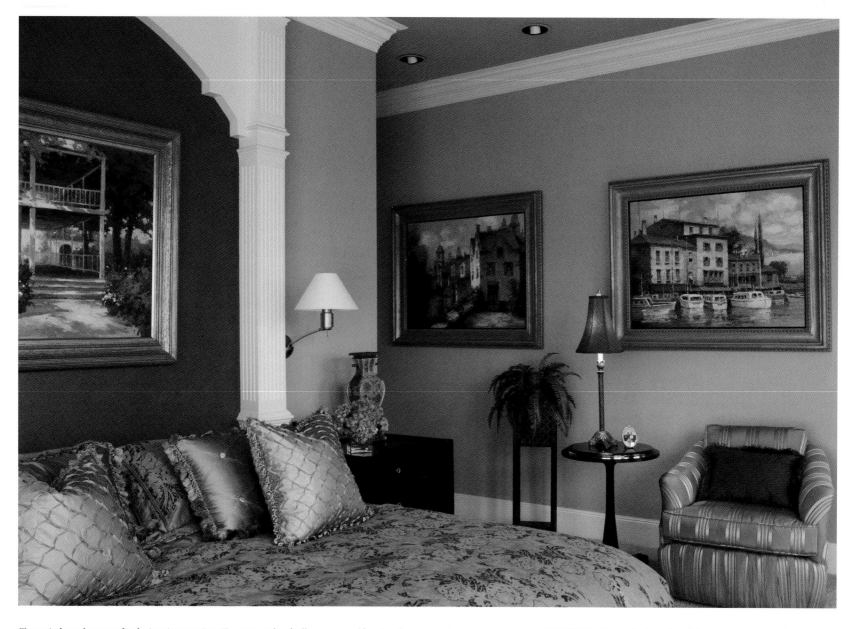

Terry is best known for being innovative. "I constantly challenge myself to implement unique combinations of color, textures, artwork and faux finishes." In the conceptual stages, Terry along with Judy and Richard Eckburg (featured home), knew that all the elements of Terry's design success, would have a place in their home. "Mr. and Mrs. Eckburg's home has been a dream, for their vision was very well thought out which enabled me to build upon and create a signature style that best fit Mr. and Mrs. Eckburg's lifestyle," says Terry. Her goal is to create environments that are relaxing, warm and inviting yet have a brilliant look. "I believe we were successful in creatng such a feeling in the Eckburg's home," says Terry. "I love putting the 'wow' in a space," she says, "whether the décor is traditional or contemporary."

"My primary purpose is to understand the personal needs and desires of my clients," Terry explains. "I provide a very personal service, from the initial consultation through installation and beyond. I have awesome, dedicated subcontractors and very talented design assistants who care as much about the success of each job and satisfaction of each client as I do myself."

ABOVE This Master Bedroom's defining element is the arch with columns, created in lieu of a headboard, with a faux painted chocolate background. Original oil paintings decorate the walls. Stroheim & Romann fabrics cover the chair and bedspread.

NEAR RIGHT This kitchen was given a glorious remodel, by giving the original pickled pine cabinets a faux oak wash and glaze, thereby giving them the appearance of the darker wood without actually having to replace them. The island and barstools were painted black and "aged" adding an eclectic touch.

FAR RIGHT The richness of this dining room is appreciated even more upon closer inspection of the red Venetian plaster walls accented with gold leaf. Crown molding and base boards were painted black also accented with gold leaf trim. Dining rooms chairs also covered in Stroheim and Romann.

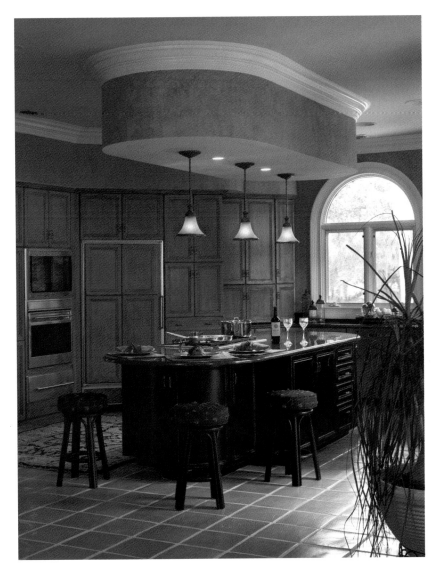

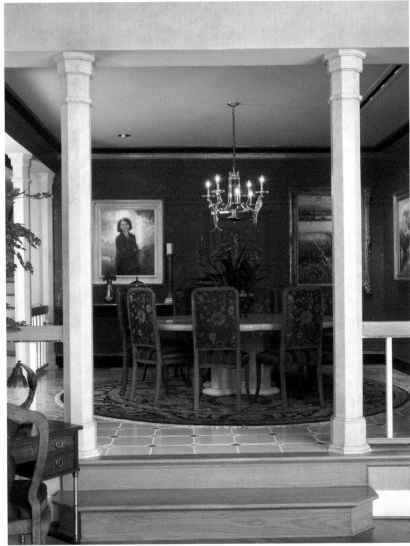

More about Terry ...

HOW DO PEOPLE WHO KNOW YOU BEST DESCRIBE YOU?

As vivacious, determined, high-spirited, talented, success driven and as having strong faith.

DON'T YOU EVER THINK OF YOURSELF?

I do indulge myself with a nice automobile. First impressions can make or break a deal, and I choose to go first class in a car that gets attention.

WHAT'S A DESIGN APPROACH THAT HAS ALWAYS WORKED FOR YOU?

Casual elegance. It's always livable and functional.

HOW WOULD YOU BRING A DULL ROOM TO LIFE?

By painting it a deep, rich color, then adding functional furniture, personalized accessories and a very nice designer rug. I am quick to suggest that a ceiling be accented with color, too.

HOW TO YOU RELAX AT THE END OF A BUSY DAY?

By spending time with my son Jason, a senior at Savannah Christian, who loves golf more than the air he breathes, reading and playing with my two brown miniature dachshunds and my golden retriever..

ISLAND INTERIORS
Terry F. Groover
8114 Waters Avenue
Savannah, GA 31406
912-352-8005
FAX 912-352-8140

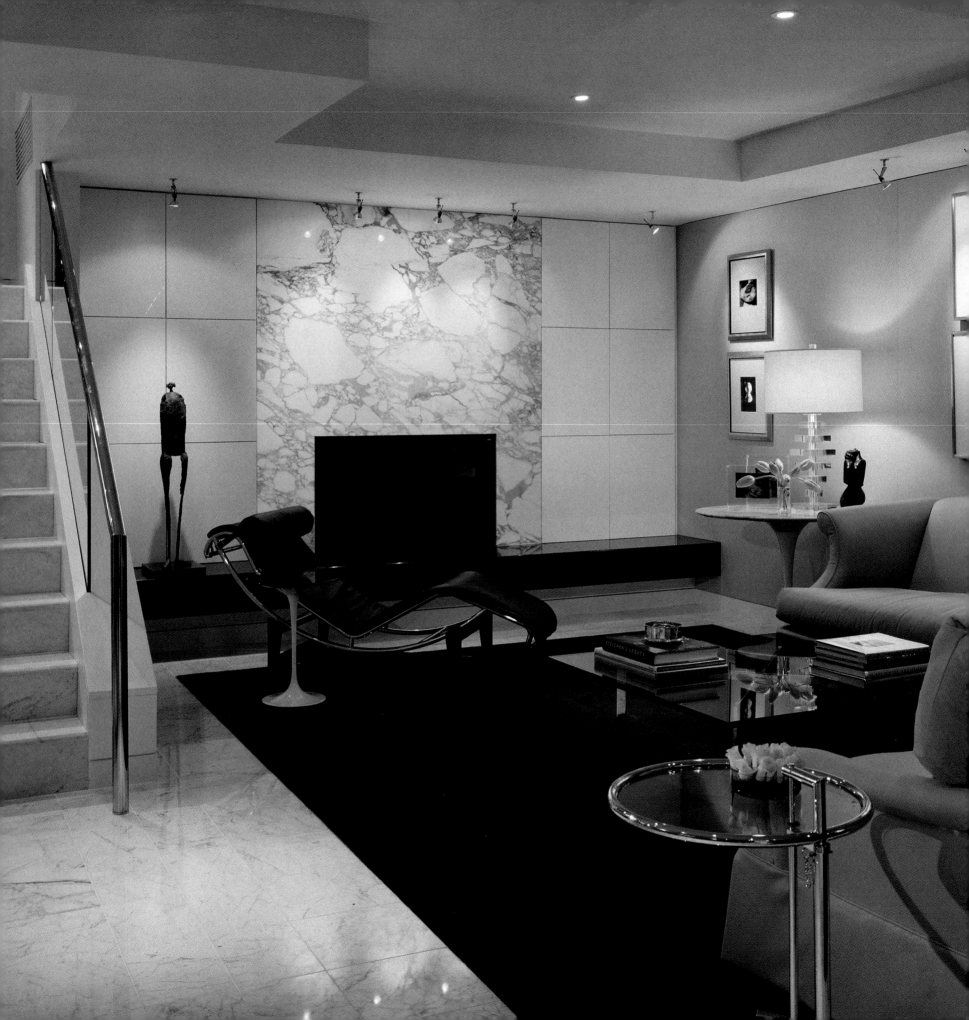

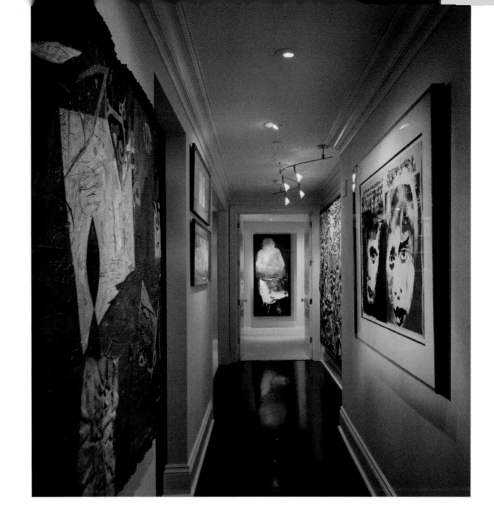

LEFT The staircase in this penthouse rises to a terrace level den and office with a city view. A slab of Calcutta Fabricatti marble flanked by band a floating black granite ledge give the room its drama. The sculpture is by George Mallett.

RIGHT This corridor was designed to be a gallery for the display of treasured art works.

RITA CARSON GUEST

Carson Guest Interior Design

Rita Guest began working as a designer in 1973, and founded her own firm, which now employs more than 20 people, in 1984. In the course of this enduring career, she has earned numerous distinctions and accolades—from having been the first registered designer in Georgia, #00001, to serving as president of both the Georgia chapter of the ASID and the Georgia Alliance of Interior Design Professionals, to having twice served on the national board of the ASID. She has won dozens of design awards, and appeared many times in both local and national publications.

"I got into interior design," Rita recalls, "because I loved drawing and painting, and wanted a related profession." The pleasure of improving people's lives may not have been part of her original impulse, but she appreciates it now. "So many of my clients love their homes," she says. "One tells me it is like living in paradise, another that it soothes her soul."

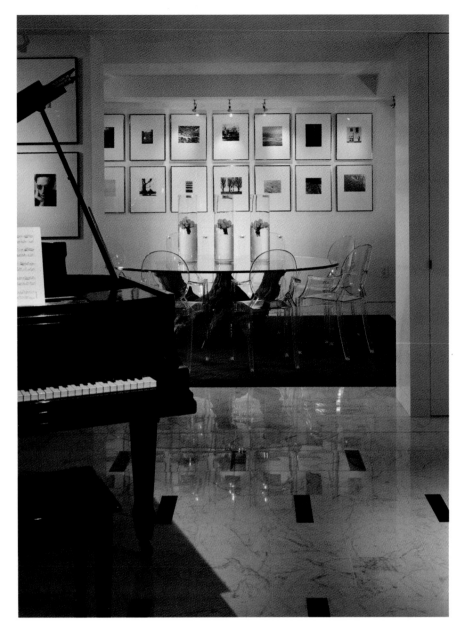

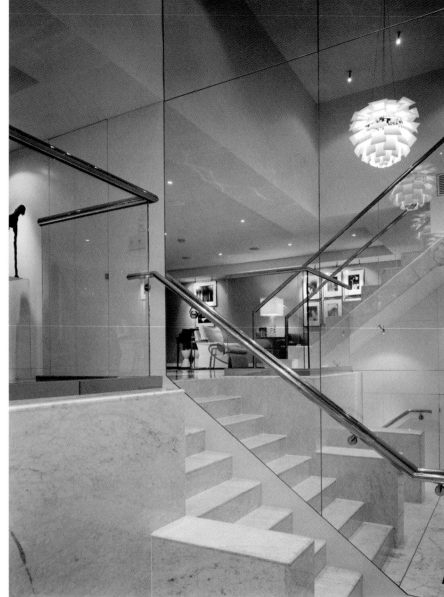

In addition to residential work, Rita does many projects for corporate clients and has created offices for some of Atlanta's most prominent law firms. Her design philosophy applies equally well to all these challenges. "Our work is classic," Rita says, "whether it's traditional or contemporary. I design spaces that do not date."

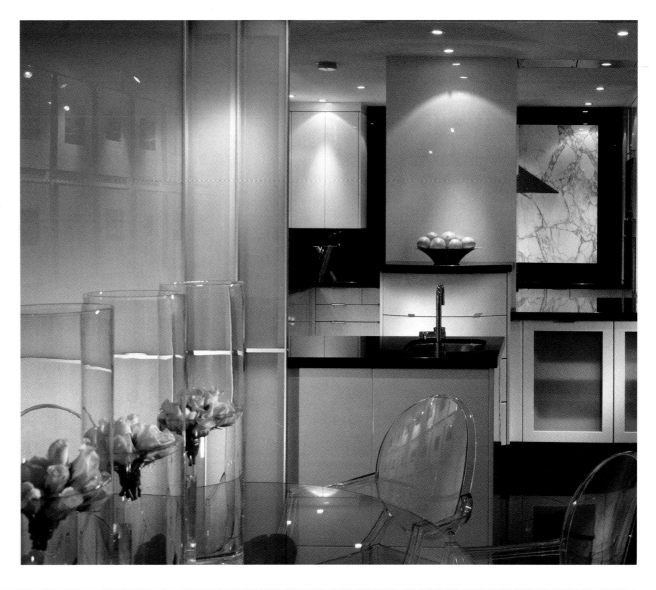

FAR LEFT This view expresses both the artistic and musical interests of the home's owners. The collection of black and white photos includes the work of many important 20th century photographers.

NEAR LEFT White marble, glass, chrome and mirrored surfaces give this space a sleek urbanity.

RIGHT Sliding glass doors separate this dining room from the contemporary kitchen. White lacquered cabinet offset the black granite tops and Calcutta Fabricatti marble. Philippe Starck ghost chairs seem to float around the crystal glass table top.

More about Rita ...

IF YOU COULD ELIMINATE ONE ARCHITECTURAL ELEMENT FROM THE WORLD, WHAT WOULD IT BE?

Strip shopping centers.

WHAT WAS THE MOST DIFFICULT PROJECT YOU'VE DONE?

I've had many tough design problems to solve over my career, but one that stands out was making a contemporary house feel traditional, to please my clients without destroying the character of the structure.

WHAT IS THE SINGLE THING YOU WOULD DO TO BRING A DULL HOUSE TO LIFE?

Color is key and lighting controls the color and drama of rooms—so good lighting is the answer.

WHAT PERSONAL INDULGENCE DO YOU SPEND THE MOST MONEY ON?

My Cavalier King Charles spaniel puppies. I can't imagine life without them.

WHAT ARE YOU READING RIGHT NOW?

I'm always reading several books at a time. Right now *How to Be Your Dog's Best Friend*, *Beautiful Interiors*, *Commune by the Great Wall*, *Yoshio Taniguchi Nine Museums*, and *The Art of Raising a Puppy*.

CARSON GUEST INC.
Rita Carson Guest, FASID
1776 Peachtree Street NW, Suite 120
Atlanta, GA 30309
404-873-3663
FAX 404-873-1021
www.carsonguest.com

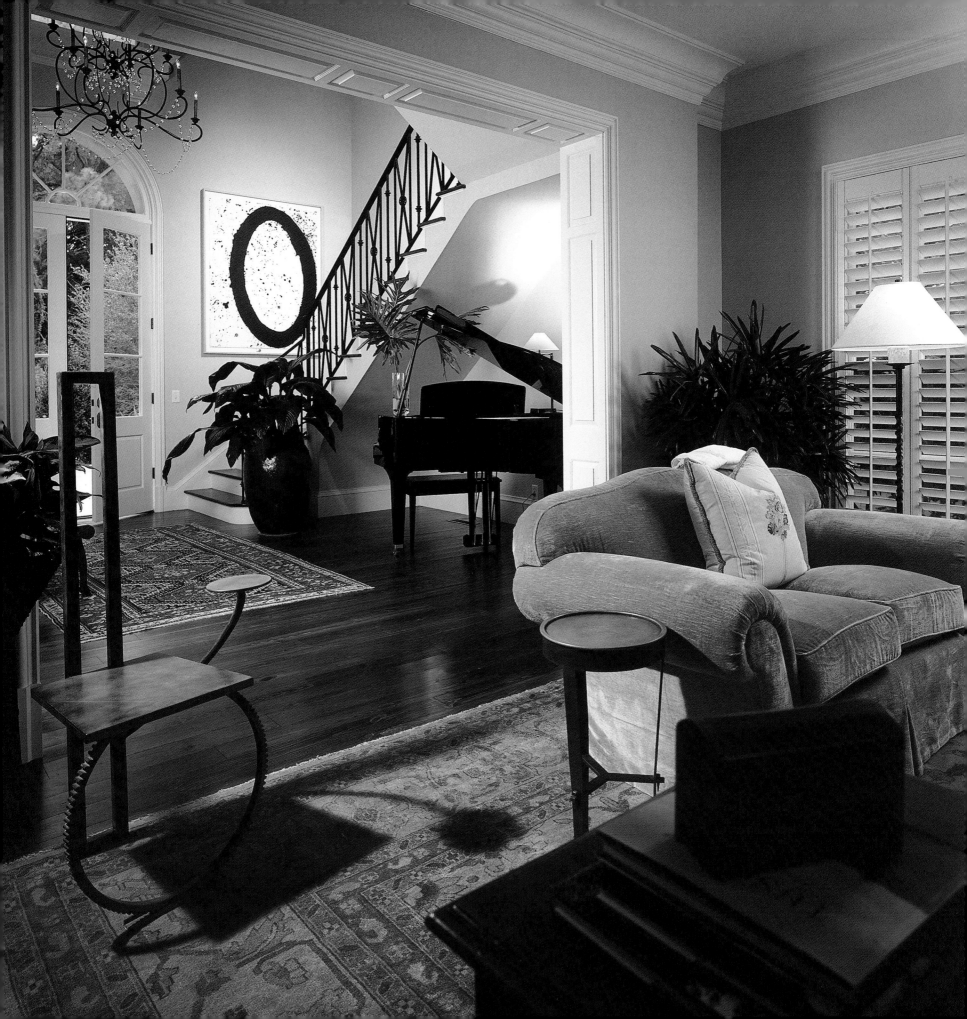

LEFT Touches of the unexpected - Kathy's signature - enliven the serene living room and foyer of a Sea Island home.

RIGHT An Indonesian bench was turned into an inviting swing in a rustic North Carolina mountain house.

KATHY GUYTON

Guyton Design Group

Kathy Guyton grew up in Mississippi, "in a small community with very little emphasis on design. Everyone had a lot of family pieces that had been passed down, that I didn't think were attractive but they all thought were wonderful. It just bothered me when things seemed too little, and there was lots of clutter."

As a young adult she lived in Cambridge, Massachusetts, while her husband attended Harvard Business School. "I saw a different sort of design there," she recalls, "still very traditional—and uncomfortable." The couple then moved to New York, where Kathy "began to see other styles, and realize that what I liked were pieces that were comfortable, friendly and simple. And the scale had to be right. I gravitated to a cleaner, more neutral background, and we became very interested in

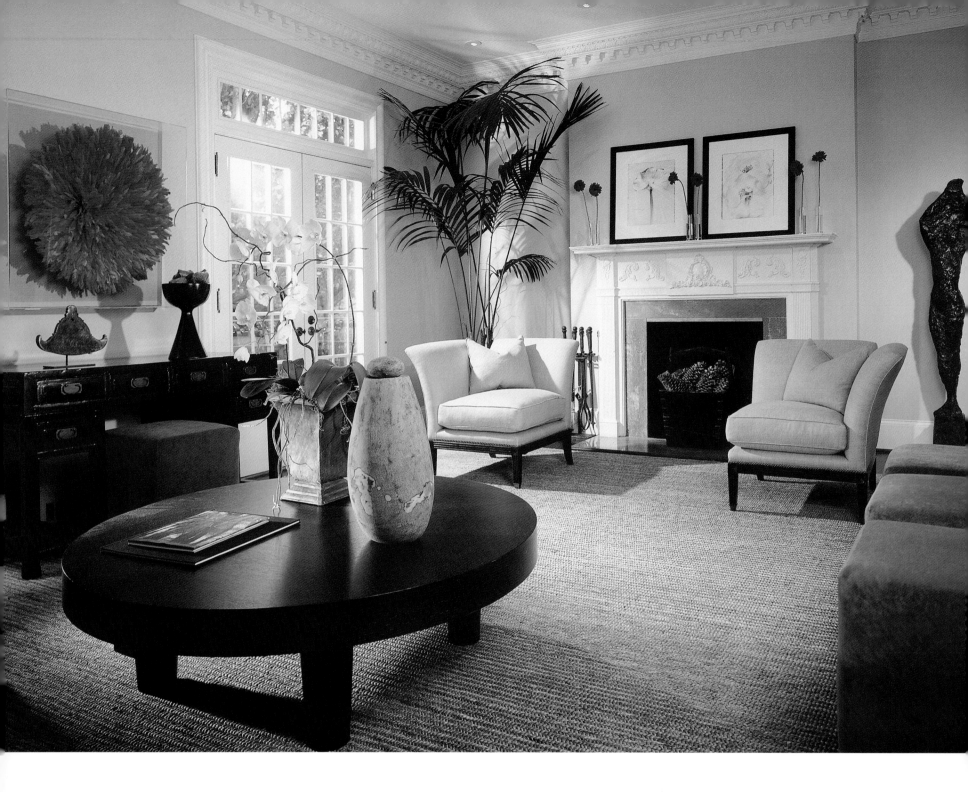

art, so when we had any money we would buy art, and oriental carpets," which she considers a form of art as well. After they returned to Mississippi and Kathy did their own house, friends started asking for help. "I did it for a cup of coffee and a piece of cake. Then I thought, there might be a business here." She never had any formal training. "But experience is a great teacher," she says.

Kathy has practiced in Atlanta since 1972, and become one of the area's most respected designers. Her work has appeared nationally in *Metropolitan*

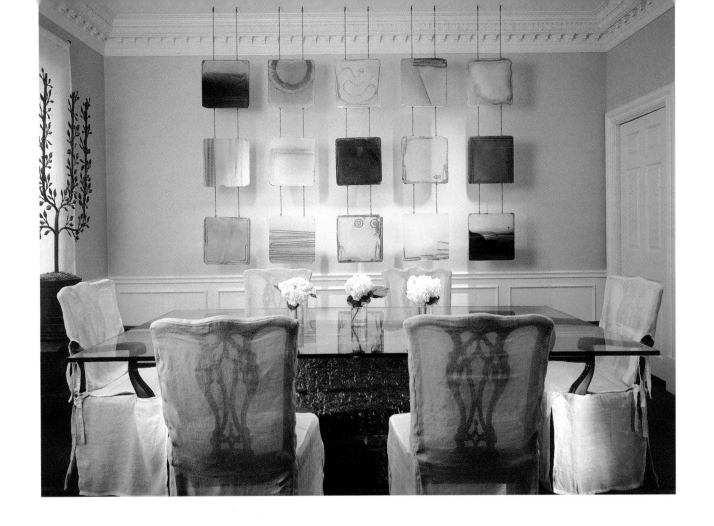

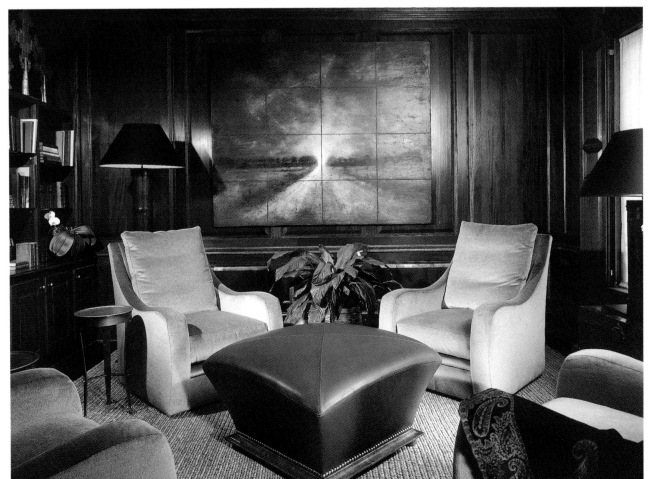

ABOVE
Ethnic and contemporary art and modern and transitional furnishings make the living room of a traditional Atlanta townhome fresh.

TOP RIGHT
Kathy says that this dining room is "all about shadows and reflections."

BOTTOM RIGHT
Library of Atlanta townhome – comfortable, simple, but elegant.

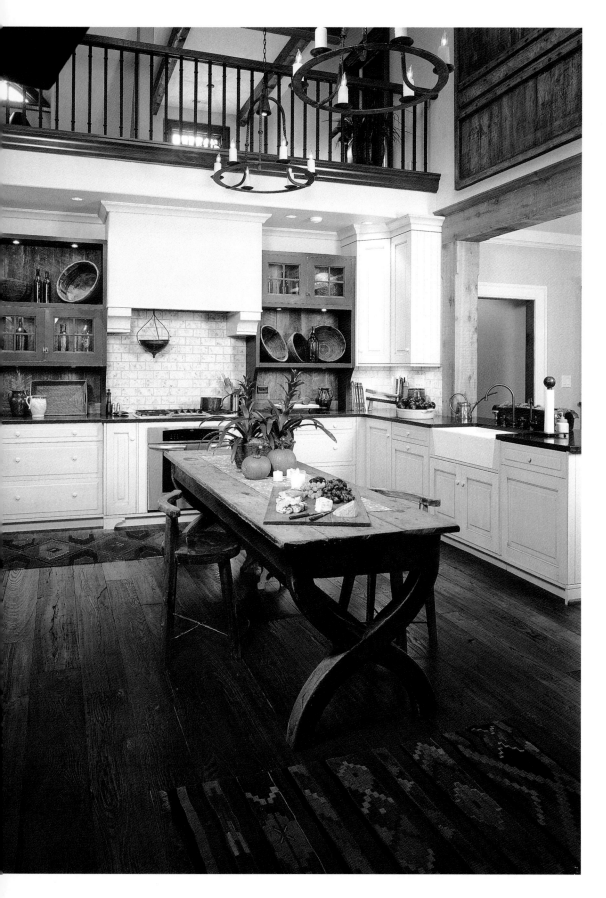

Home, *House Beautiful*, *Veranda*, *Southern Accents*, *Town & Country*, *Second Home* and *Coastal Living*, as well as local magazines. And she has won a number of awards from ASID.

"My business has evolved over the years into a 'family' of clients who remain friends," she says. "I feel lucky to do what I love with such special people—and be paid for it."

While hardly a strict modernist, Kathy's work is known for its casual approach that combines informality and drama, which she partly achieves through the bold use of architectural elements. "I don't really like draperies or do a lot of them," she says, "or wallpaper. I love texture and large scale pieces and simple good clean lines. I don't need a lot to make a statement."

Kathy feels her best fit is with clients who share her passion for art; the art can be the inspiration for the rooms. "When they really aren't interested in art," she admits, "then I struggle, because I have to create something that feels like art. I do it a lot with architectural pieces, and fabric, tapestries, handmade things."

When first getting to know clients, she says, "I try to get them to not tell me what they like, but how they live," trying, in other words, to understand their process rather than their things.

LEFT Primitive pieces are right at home in this elegant mountain house kitchen.

RIGHT Though it soars above Atlanta, the living/dining room of this condominium has rich, enveloping warmth.

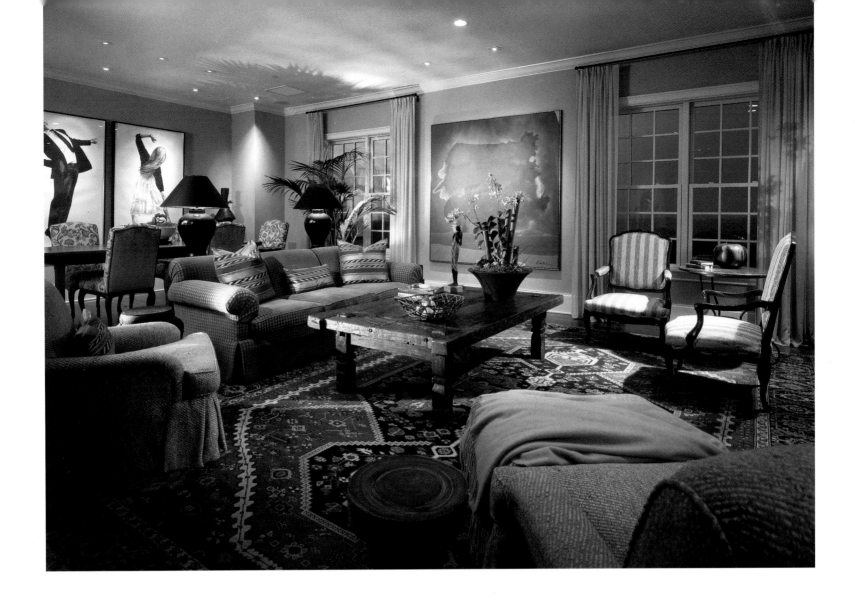

More about Kathy ...

WHAT PERSONAL INDULGENCES DO YOU SPEND THE MOST ON?

Travel, and my children and grandchildren.

WHAT ARE YOU READING RIGHT NOW?

Kite Runner and *Why I Don't Lunch*. I always try to read two books at a time.

WHAT WOULD YOU ELIMINATE FROM THE WORLD OF STYLE AND DESIGN?

Excess, pretense and Palladian windows.

WHAT COLORS ARE YOU INSTINCTIVELY DRAWN TO USE?

Neutral ones, because they are understated and relaxing.

WHAT IS YOUR LEAST FAVORITE PART OF BEING A DESIGNER?

I absolutely hate the ordering. I have wonderful assistance with that.

WHAT ARE THE BEST PARTS?

The beginning of a project, because it's the most creative part. The end is the most fun; it's such an affirmation of what you thought, and people are so thrilled.

GUYTON DESIGN GROUP
Kathy Guyton
Associate member ASID, IIDA
200 Bennett Street, NW
Atlanta, GA 30309
404-352-020
FAX 404-352-0238

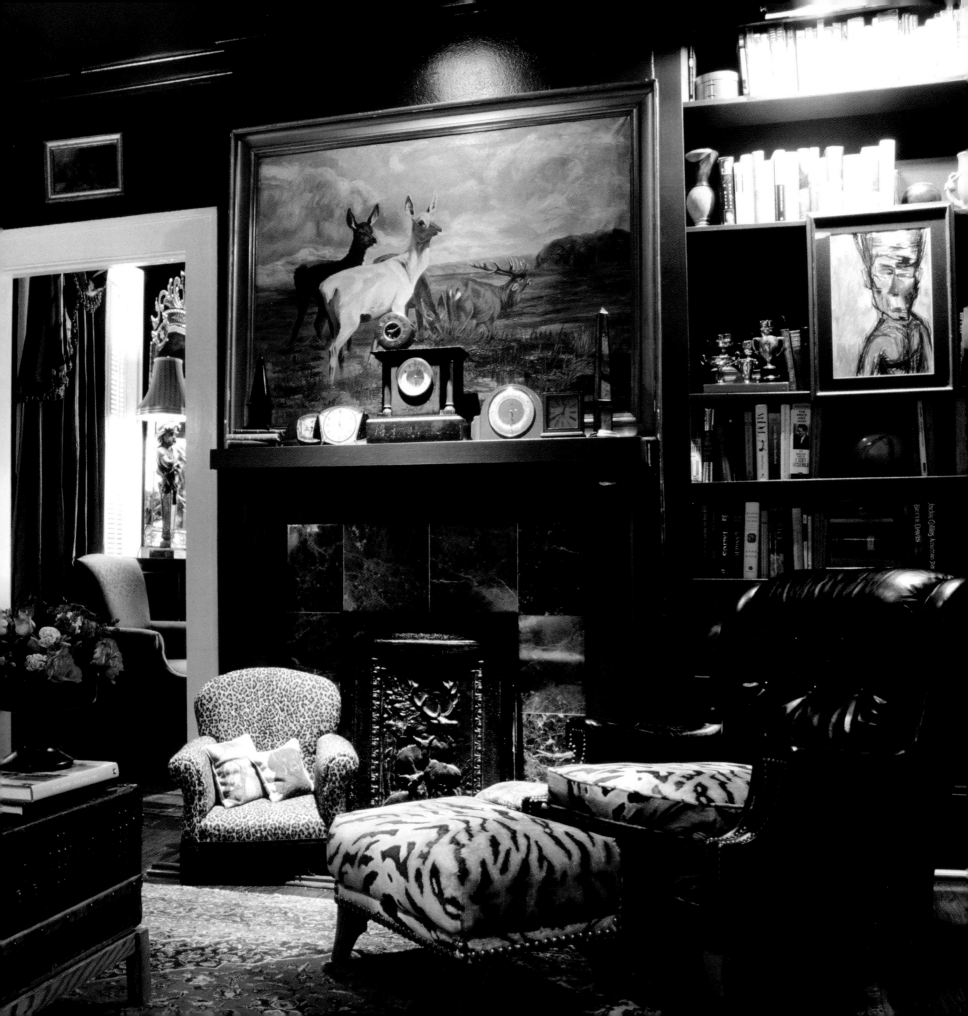

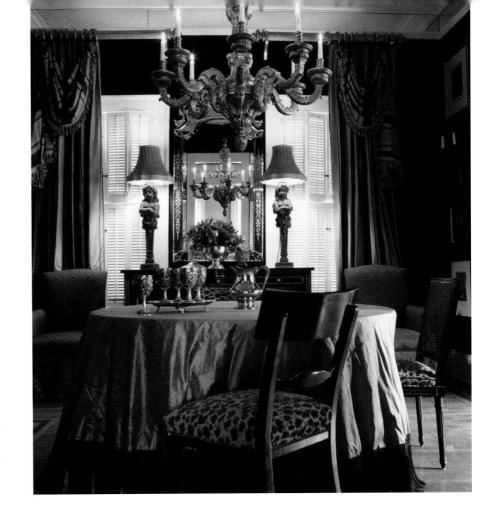

LEFT Chocolates, reds, paisleys and animal prints make this library a cozy reading spot or great for an after dinner cocktail. Fabrics are by Ralph Lauren and Schumacher.

RIGHT A dramatic dining room combines an eccentric mix of period pieces with caviar walls and elegant silk fabrics to create a dynamic space. Fabrics are from Brunschwig and Kravet.

DAVID HENSON

David Henson Interiors, Ltd.

David Henson might have been an architect, if that profession didn't call for so much math. "I love manipulating spaces," he says. "Making the ultimate environment for a client is the most gratifying thing."

David is passionate about historic houses and antiques, and is a self-confessed shopaholic. Having done the grand tour of stately British homes, he's particularly inspired by the Georgian and Regency styles. But he calls his look "tradition with a twist." The twist? Intensity. His rooms are layered and full, rich with unexpected objects and surprising juxtapositions. Even new, they seem to have the patina of age.

A graduate of the Savannah College of Art and Design, David set up shop in Atlanta in 1993. With his wife Kim, he also runs Henson and Henson

Home, a retail emporium where you'll find just the sort of fresh, unique furnishings he loves to collect and use in interiors.

"You have to have an innate sense of style to be a good designer," David believes. "But what makes clients the happiest is if you can make their dreams a reality and deliver a product they're comfortable living with. And to do that, you have to know how to listen."

DAVID HENSON INTERIORS, LTD.
David Henson
Allied member ASID
741 Miami Circle
Atlanta GA 30324
404-949-9191
FAX 404-949-9690

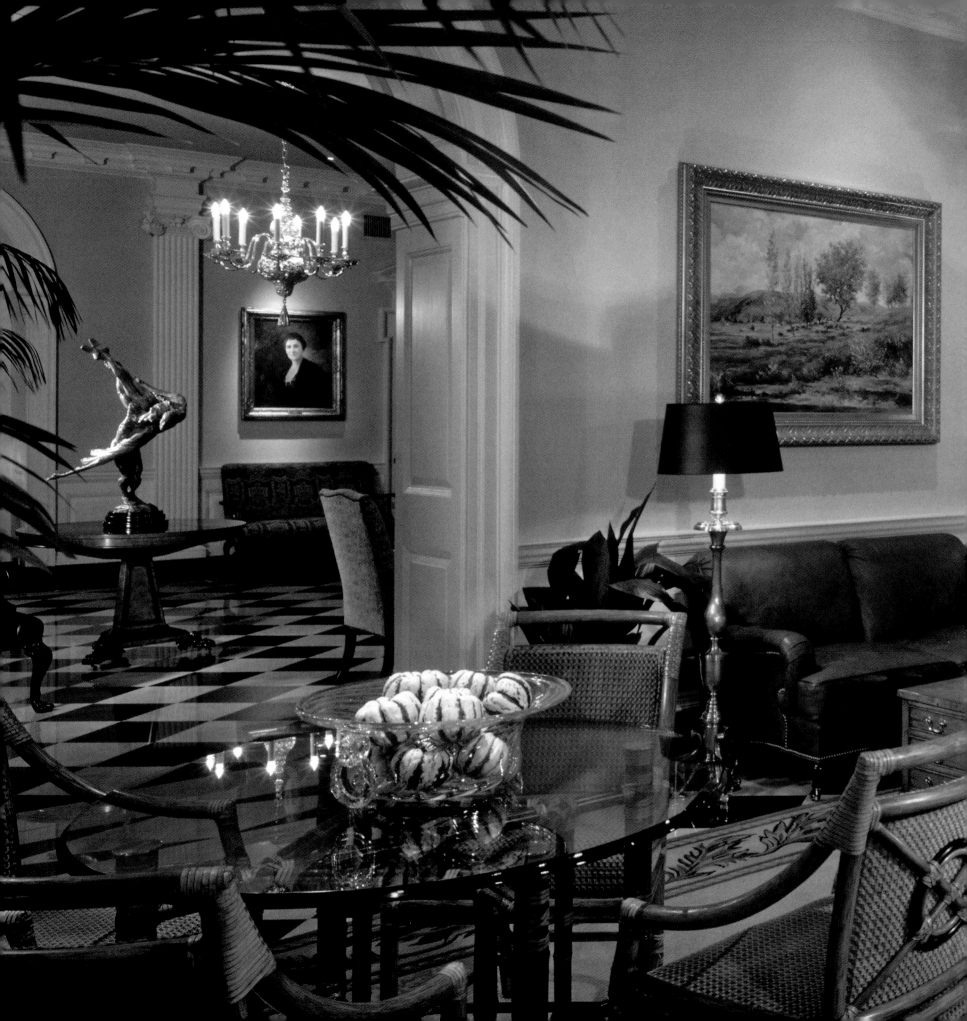

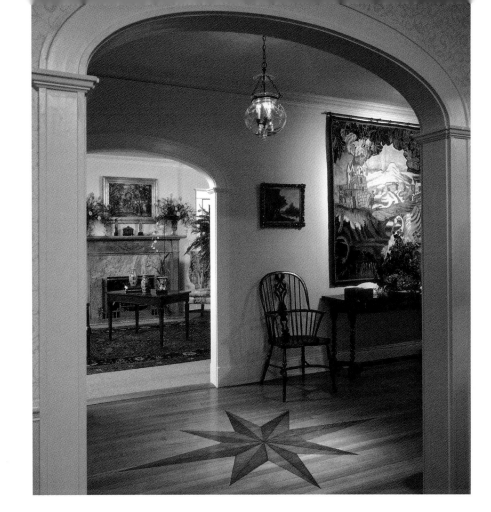

LEFT Douglas was commissioned to lead the renovation of this space, originally designed by noted Atlanta architect, Phillip Trammell Shutze. The project included design and installation of the dramatic black and white stone flooring, along with specification of new furnishings throughout.

RIGHT To complement the original architecture of a Druid Hills home, Douglas designed this marquetry pattern for the foyer floor. The 19th century tapestry softens the space.

DOUGLAS HERRIN

Douglas Herrin Inc.

Douglas Herrin's design career began at an early age. "Growing up in the family's home furnishings business, I became aware of my appreciation for interior design," he explains. His interest became an ongoing passion and has led to a fulfilling career.

Having been in the trade for more than 20 years, Douglas made a decision to establish his own firm 10 years ago. Since that time, his projects have ranged from primary residences and vacation homes to executive offices, private jets, and the renovation of several of the neoclassical interiors at the Emory University Hospital.

Douglas believes that the finest interiors evolve through time. He encourages clients to collect art and furnishings as they travel. "I feel if someone is enthralled with a piece, I will find a place of importance for it." Douglas says that this approach adds individual personality.

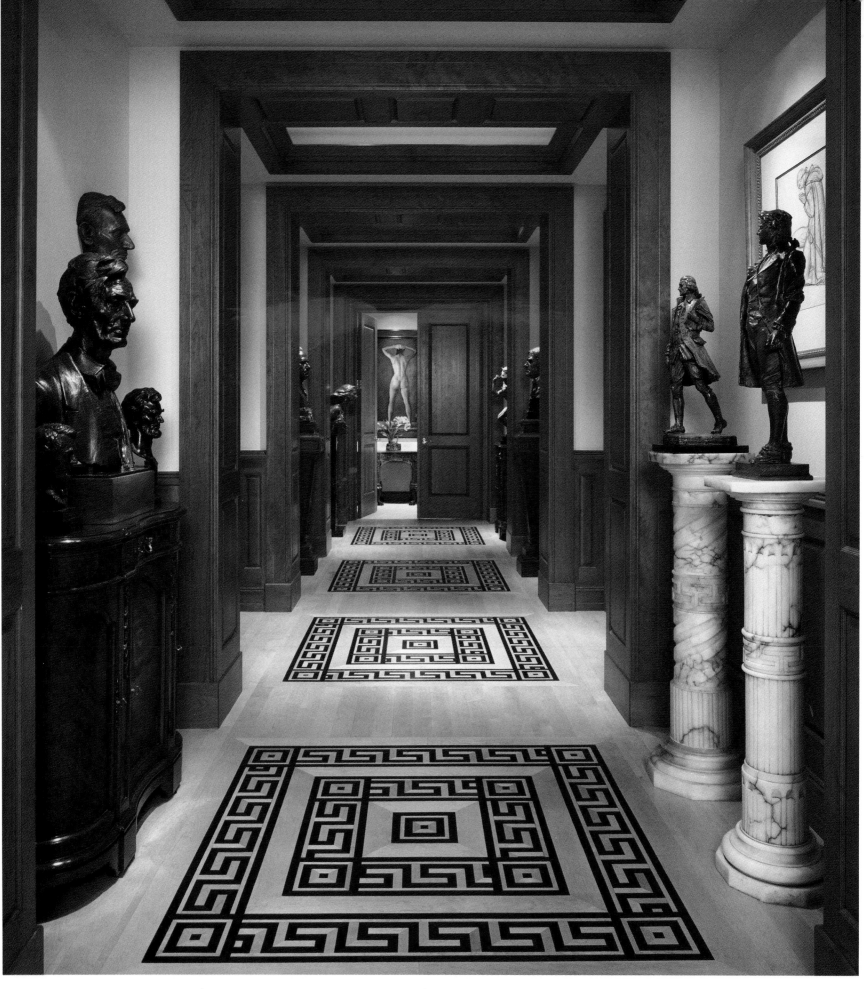

Among his clients are numerous serious art collectors. They know he will welcome their new acquisitions with enthusiasm.

Douglas' style is definitely traditional, incorporating architectural elements. Whenever possible, he allows existing architecture to take a leading role in determining the look of an interior. When the opportunity arises, he specifies distinctive millwork and other architectural elements to serve as the background for custom furnishings.

"Listening to the client is my strong point," says Douglas. "Without a doubt this enables me to build the trust necessary for long lasting relationships and client referrals. I'm an extremely visual person, and with new clients that enables me to assess what they have and where they've been."

"I'm very hands-on in the field," Douglas adds. "I believe that kind of commitment is vital to a finished product that exceeds clients' expectations."

More about Douglas ...

WHAT IS A SINGLE THING YOU WOULD DO TO BRING A DULL HOUSE TO LIFE?

Evaluate and rearrange existing furnishings so they better relate to the space.

HOW WOULD YOU CHARACTERIZE YOUR STYLE?

My preference is for English and American interiors—more relaxed rather than extremely formal.

WHAT IS THE BEST PART OF BEING AN INTERIOR DESIGNER?

The reward of seeing clients living and entertaining in spaces created for them.

WHAT PERSONAL INDULGENCE DO YOU SPEND THE MOST MONEY ON?

Developing my country home and its gardens.

DOUGLAS HERRIN INC.
Douglas Herrin
Fine Interiors
Atlanta, GA

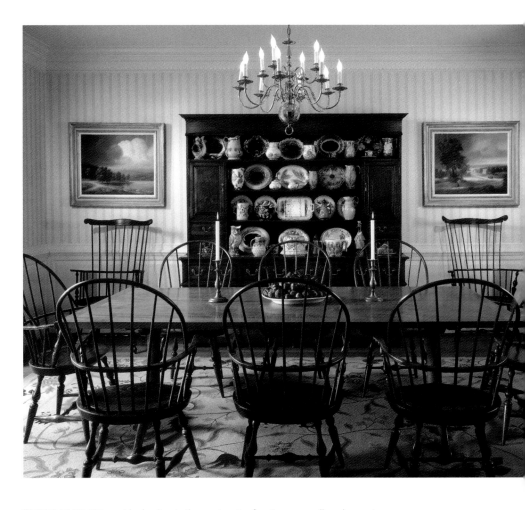

FACING PAGE This corridor leading to the master wing functions as a gallery showcasing an extensive collection of fine art treasures. The ebony-inlaid floor was a nod to the client's Greek heritage.

TOP This classic dining room presents itself in the American style. Antique paintings and accessories lend a feeling of antiquity to the reproduction furniture and the handmade rug.

BOTTOM Douglas' clients' requests frequently extend to projects beyond their homes, such as specifying the interior finishes for this private jet.

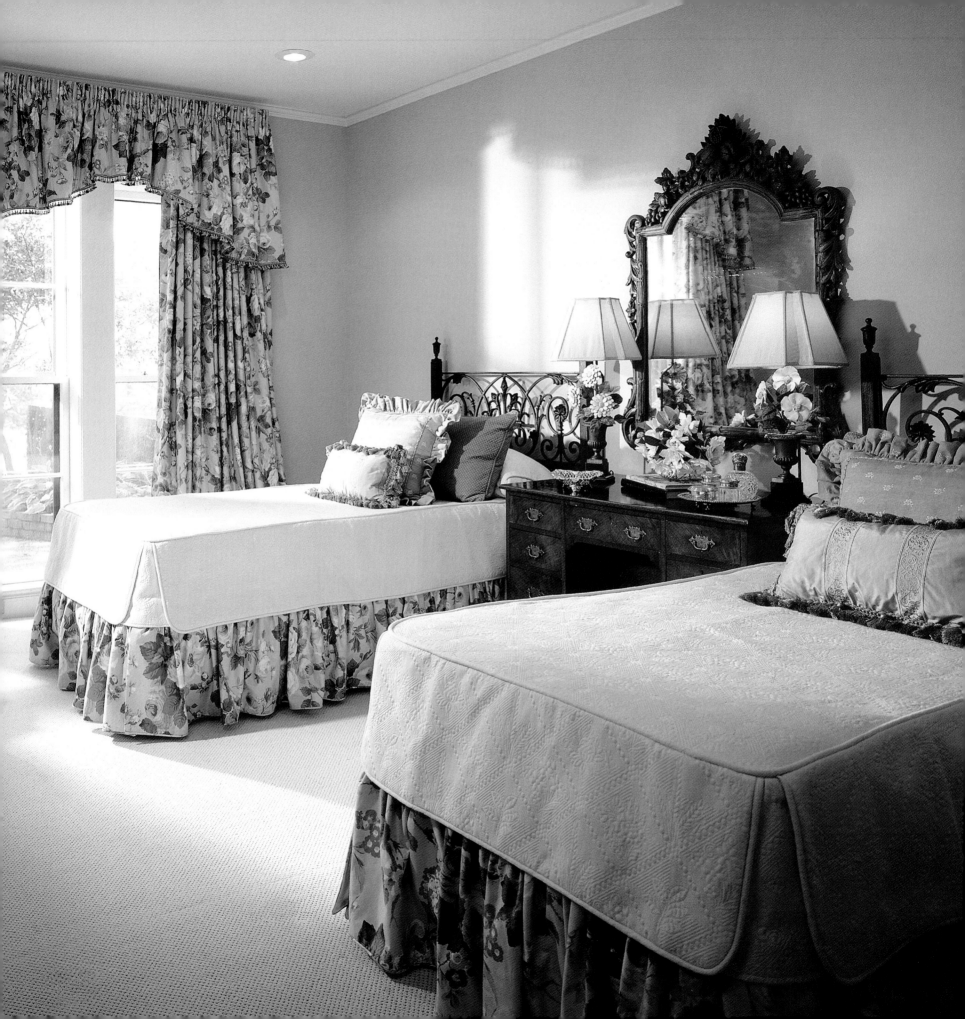

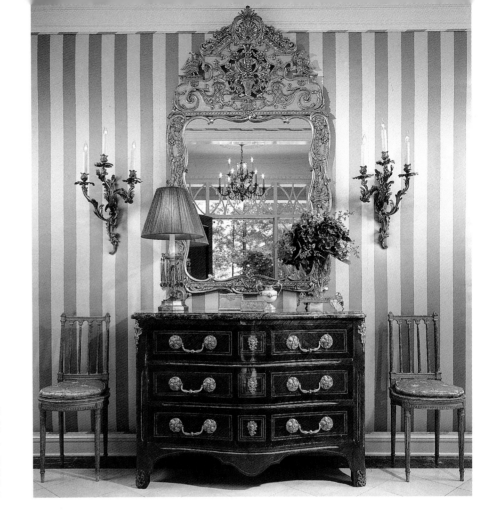

LEFT In this bedroom, intimacy is enhanced by an ornately carved circa 1870 English fruitwood mirror, sinuous antique iron headboards and charming 19th century ceramic and tole floral bouquets made into lamps. The shams are by Cowan and Tout, the dust ruffle and drapes by Travers.

RIGHT Exuberant striped wall covering by Jane Shelton is the background for a collection of antiques sourced at That Added Touch, in Columbus: French serpentine chest, Louis XV sconces, 18th century Louis XVI-style chairs, a circa 1870 French gilded mirror and an amber luster lamp.

ASHLEY HOLT

Ashley's Interiors

" I have a passion for gracious living," says Ashley Holt. "My goal is to create a personal space that is unique to my client and is lovely to the eye. I don't like feeling that a room was decorated from top to bottom—or that I just walked out of it, even though I might have."

Ashley finds inspiration for her work in the great country houses of England and France. She especially cites Cliveden, once the home of the Astors, which is filled with antiques and original portraits. "That moves me," Ashley says. "I always want to start from something that a client is passionate about. If not art, then something from your family, or that reminds you of a place you've been. I can make a pretty room for anybody, but I can't make a room someone adores unless there is an emotional attachment."

Ashley's roots in design go deep: her family operated King's Interiors in Columbus, and her mother was an artist. She earned a degree from the University of Georgia with a double major in interior design and public relations. She enjoys interactions with clients as much as designing their spaces. "The highest compliment," Ashley observes, "is a client's expression of joy and awe at what you have created for them."

ASHLEY'S INTERIORS
Ashley Holt
1130 Lockwood Avenue
Columbus, GA 31906
706-322-5550
FAX 706-323-0518

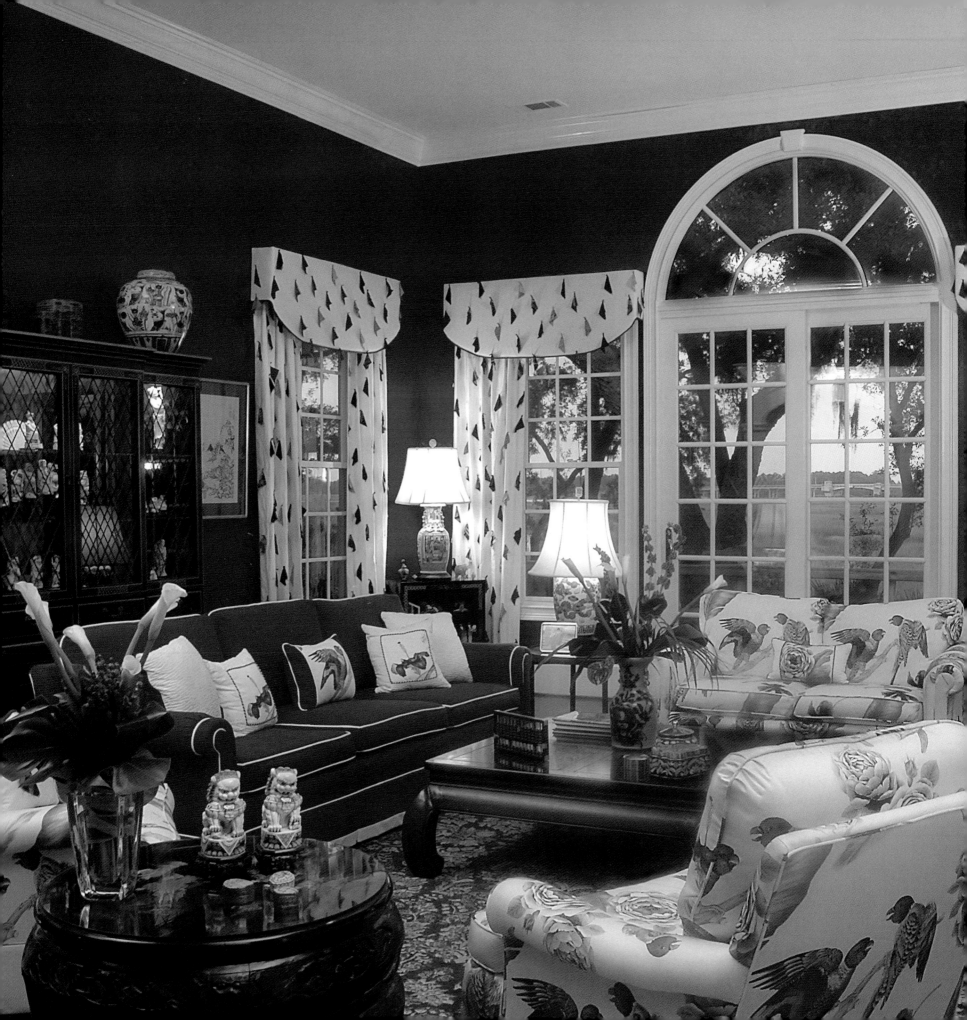

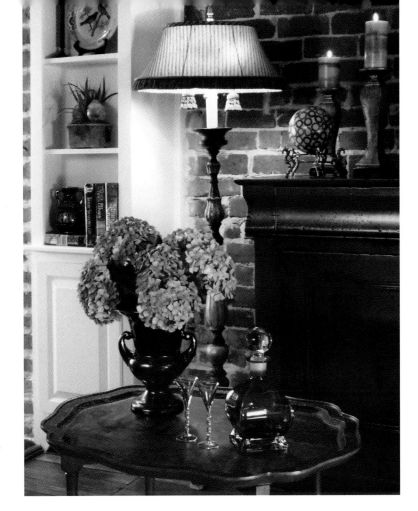

LEFT Bold color, imaginative pattern and Lionheart's signature pillows complement the collection of rare oriental pieces in this marsh-front home.

RIGHT An understated bookcase hides plumbing in this historic house, where antiques show beautifully.

DOTTIE HUGHES

Lionheart Interior Design Inc.

"Lionheart Interior Design is not about flash," says Dottie Hughes, "but about substance, style, and fresh approaches to traditional ideas."

The Savannah-based firm specializes in the fine art of residential interior design of historic and resort properties, as well as for luxury marine craft and select commercial projects, including several world famous historic inns. "I love new construction and renovation, when I can be part of the creative process, interacting with the architect, builder and owner," Dottie says.

With international interest in the coastal Savannah area as a best place to retire, newcomers are choosing first, second and third homes in the Low Country region. They appreciate Dottie's native South Carolinian, Southern-friendly approach to business.

"Well-traveled clients bring an enormous range of lifestyles and tastes. I encourage my clients to be adventurous as together we explore to bring their dreams for individualistic, distinguished surroundings to reality," shares a reassuring Dottie. "My nine-year-old daughter's opinion is that my clients should have 'roaring designs.'" Energized by diversity of styles and on the atypical request, Lionheart product designs include signature pillows and cabinets.

Anchored with a bachelor's degree in business and finance, Dottie—known to her friends as a "Steel Magnolia"—encompasses on-time and on-budget objectivity, plus a commitment to optimum value for projects and product acquisition.

LIONHEART INTERIOR DESIGN
Dottie Hughes
50 Dame Kathryn Drive
Savannah, GA 31411-1604
912-598-8024
FAX 912-598-8025
www.lionheartinteriordesign.com

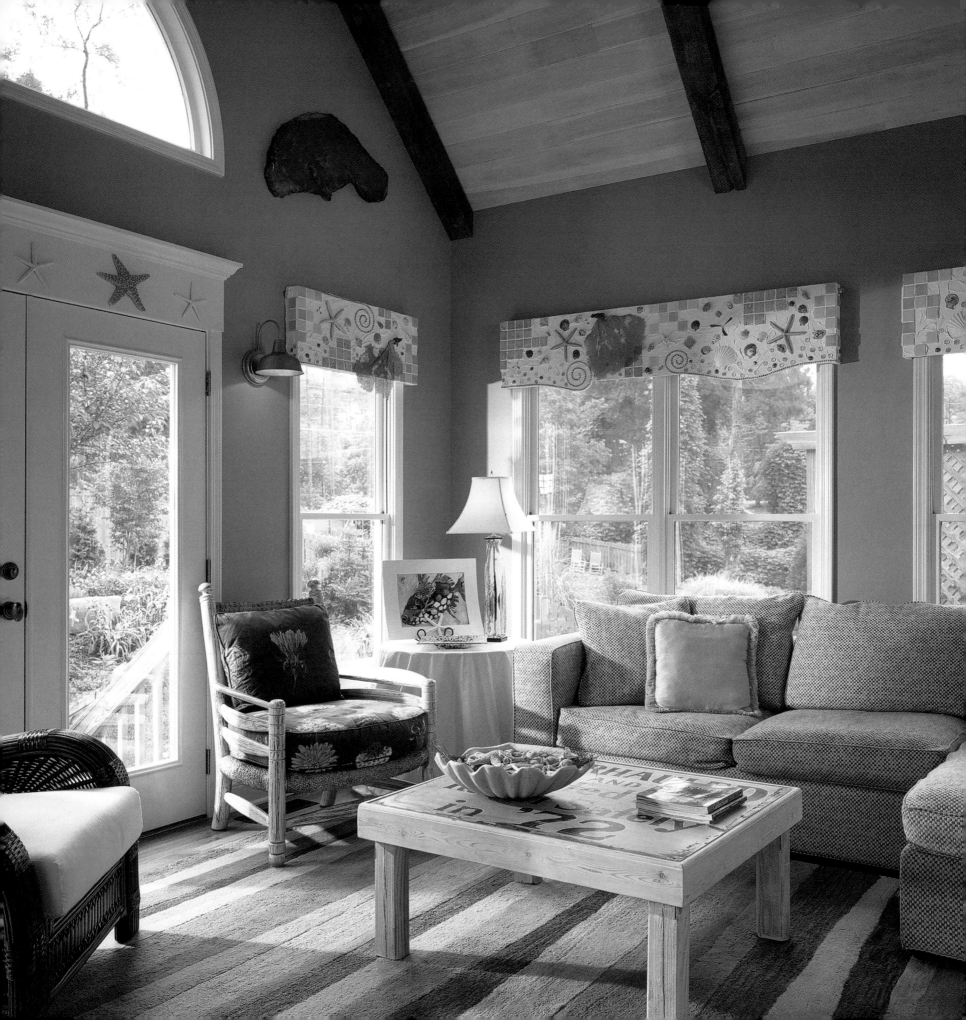

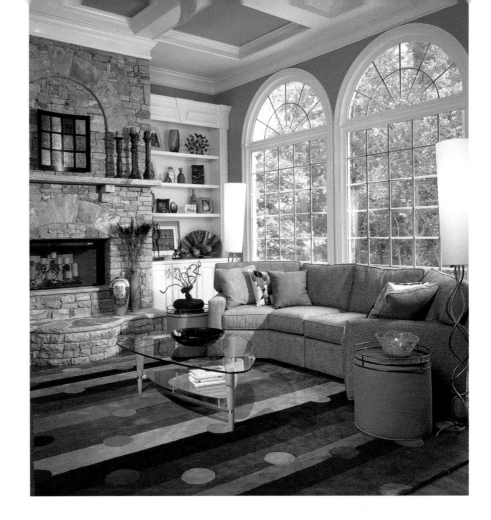

LEFT To create a seaside theme in this sunroom, LaWayne embedded cornices with seashells, tile, mirror and gemstones. The cocktail table is a vintage advertising sign.

RIGHT Confident use of color highlights the architectural features of this living room.

LaWayne Johnsen

Inspirations for the Home

Though he has been an interior designer for more than 30 years, LaWayne Johnsen has only been in Atlanta since 1993. He had visited on buying trips, and it occurred to him that it would be a great place to live and work. "Even though it's a metropolitan size, it's a comfortable place with a laid-back flavor," says LaWayne, who grew up on a farm near Lincoln, Nebraska.

Now he has a practice in Roswell, as well as a retail store, Inspirations for the Home, featuring an array of art and accessories which is managed by his wife, Carla.

LaWayne calls himself a "hands-on" designer, doing everything from conception through design, ordering and installation. "That allows me to come up with solutions that are unique. Once something becomes mainstream I try to avoid using it because I feel my clients should expect something more creative for custom work."

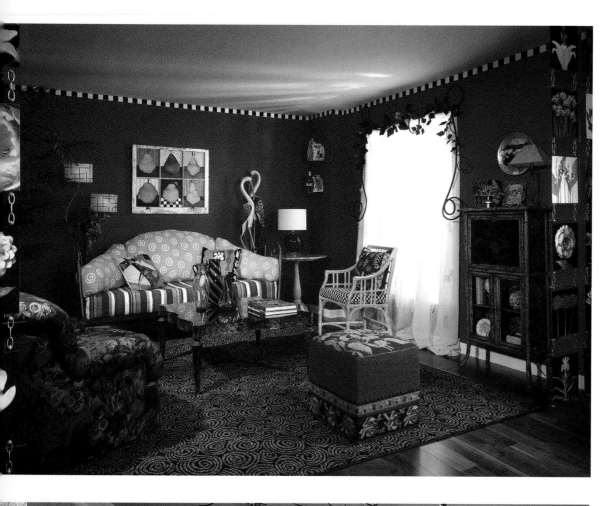

Another way LaWayne often adds a unique touch to a room is with one-of-a-kind original art. To find it, he often combs art festivals. "They're a source for fresh merchandise that can provide a look clients aren't going to see everywhere else. I especially look for the work of glass, ceramic and metal artists."

"I'm not the kind of designer who comes in sweeping his arms around saying, 'Oh, we'll make this pop, we'll make this grand.' I'm a more subdued person. I'm always asking and listening, before I ever offer ideas. My objective is never to create a 'LaWayne Johnsen Interior,' but instead to create a design that expresses the client," he says.

Though most of his clients are traditional in style, he likes to add a twist by suggesting contemporary artwork or a bold color. "The art deco style of the '20s is an inspiration," he says. "It was the contemporary look for its time. It's such a pure, clean design, and a lot of the applications work very well even today, allowing you to bring together both the classic and contemporary. I find the mix of styles most exciting, blending for a fresh look that lasts for years."

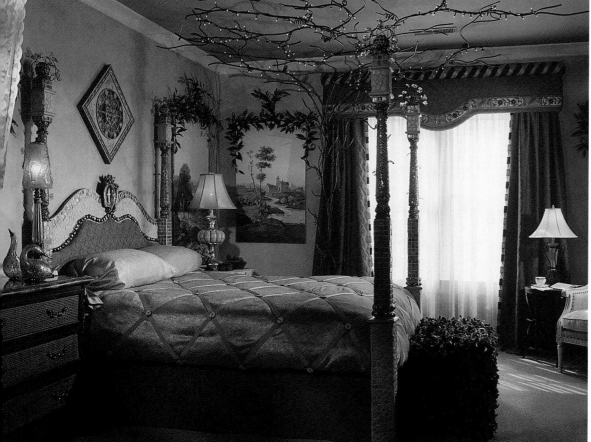

TOP LEFT A garden theme is carried through this living room through the choice of fabric and custom details such as the leafy metal curtain rods.

BOTTOM LEFT A woodsy feeling is achieved in this bedroom through touches like the wrought iron tree arching over the bed and the comforter buttons which are slices of tree limbs. The window treatment incorporates an embroidered priest's stole, found at a London flea market.

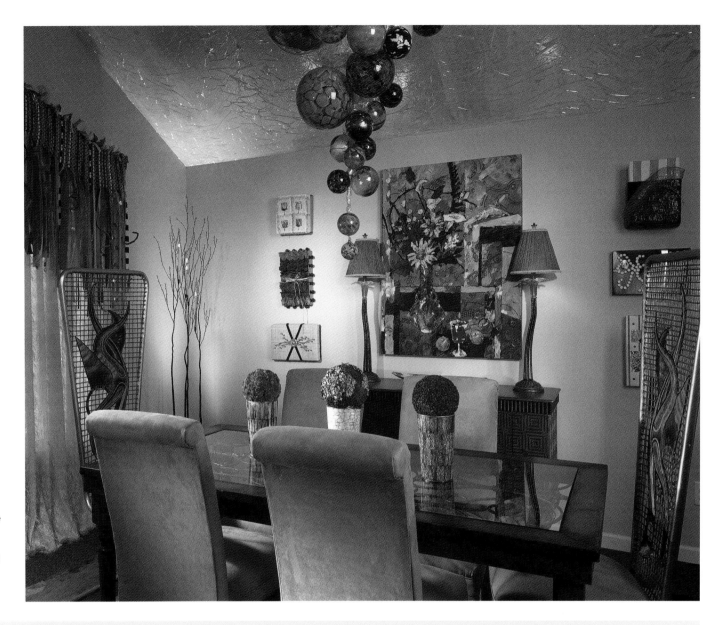

RIGHT Dining room with ceiling covered in iridescent cellophane. The "Art Boxes" on the wall are gift boxes the artist husband creates for special occasion gifts he gives to his wife. Cascading chandelier is created by suspending glass blown balls.

More about LaWayne ...

WHAT COLOR BEST DESCRIBES YOU AND WHY?

Ocean Blue. It's calm, steady, and reflective.

WHAT PERSONAL INDULGENCE DO YOU SPEND THE MOST MONEY ON?

- Cappuccino. It's the simple things that I find most luxurious.

WHAT DO YOU COLLECT?

Architectural artifacts. I love the salvage yards. It's like digging through a treasure chest.

NAME ONE THING MOST PEOPLE DON'T KNOW ABOUT YOU.

I'm a cancer survivor.

WHAT IS THE BEST PART OF BEING AN INTERIOR DESIGNER?

When a creative idea "clicks" with a client.

INSPIRATIONS FOR THE HOME
LaWayne Johnsen
1100 Upper Hembree Road
Roswell, GA 30076
770-772-4840
FAX 770-772-4811
www.inspirationsforthehome.com

LEFT This living room view demonstrates Jill's use of understatement, and great art, to create a dramatic space.

RIGHT Dining/living room - an elegant blend of both modern and traditional with surprising juxtapositions.

JILL JURGENSEN

Jill Jurgensen Interior Design

Jill Jurgensen has only been out on her own as an interior designer since 1997. "I'm very much a young designer and I'm learning every day," she says modestly. Maybe so, but she's already accumulated an impressive portfolio of magazine features on her work—in *Atlanta Magazine, Atlanta Homes & Lifestyles,* and recently going national with a cover story in *Metropolitan Home.*

Jill grew up in Cincinnati, in a house full of early American antiques. "My mother was often out perusing local antique shops, and that's where I probably developed an interest in design. She had an amazing sense of style, and a great appreciation for fine craftsmanship and detailing." Despite this youthful immersion in antiques and traditional design, Jill's taste now runs more to the 20th century, and to just about all its periods and styles. For a time, she collected Arts and Crafts furniture. Now she describes herself as "very keen" on French art deco

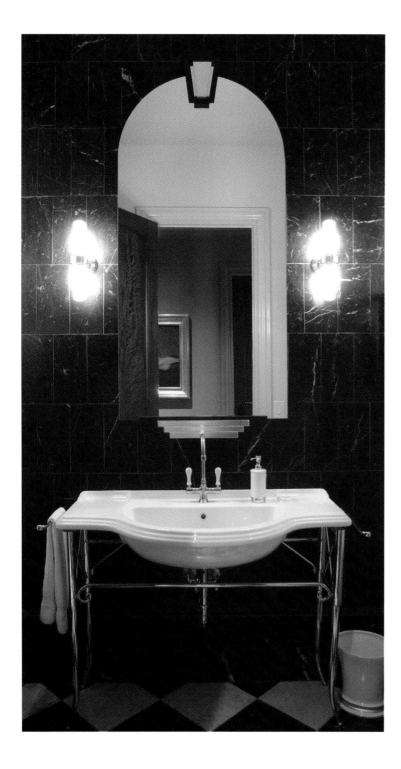

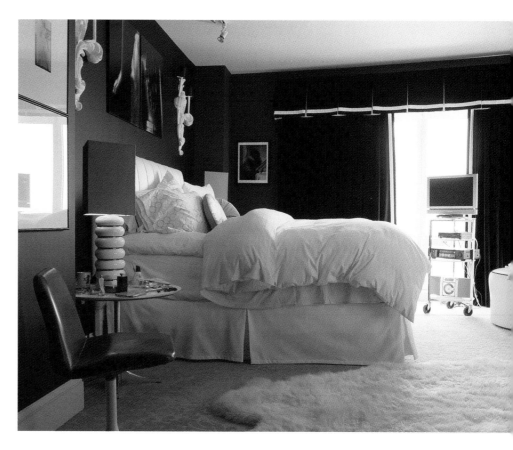

LEFT This masculine bathroom has a simple art-deco motif.

BELOW Saturated color and contrast between dark and light make this bedroom a sensual nest.

FACING PAGE Jill chose art to echo the soaring feel of this Buckhead loft.

and the swanky looks of the '30s and '40s, as well as mid-century modern classics by Charles and Ray Earmes. She also adds, "I'm very drawn to the pure, natural, organic qualities of the Japanese aesthetic." She has a penchant for combining the most unexpected styles, periods and colors imaginable... her interiors make bold statements and are often infused with a sensual, exotic quality.

When Jill is working, she knows her number one job is to listen. "You have to design for the client, not for yourself. Most people today want to be more involved in the design process, and it is great having an eager, educated client."

Jill has studied art history as well as interior design, and believes wholeheartedly that an understanding of art is invaluable in approaching composition, balance, form and color with respect to interiors. "Creating a room is like making a painting. Essentially, it's an expression of many design elements and life experiences."

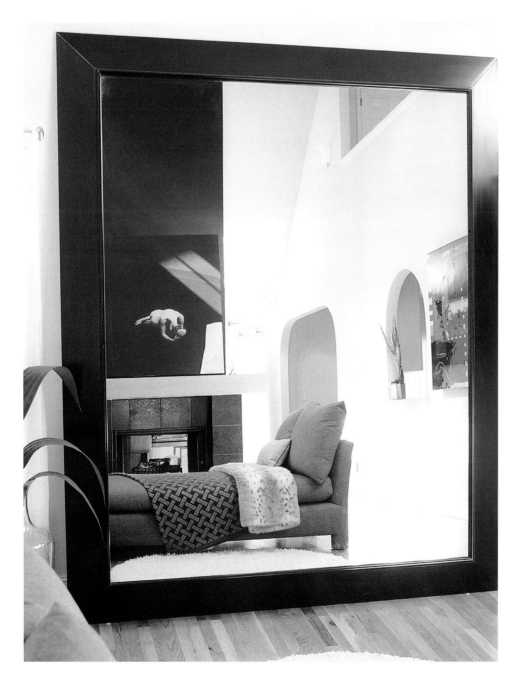

More about Jill ...

WHAT'S ONE THING MOST PEOPLE DON'T KNOW ABOUT YOU?

I'm an avid photographer and aspiring cook.

WHAT INSPIRES YOU?

Paris. Art. Color. I get excited about original interiors...those that don't follow trends or conventional design methods. A successful room is not only beautiful but it also creates the feeling of an experience.

WHAT'S YOUR MOTTO?

"Comfort is the ultimate luxury," and "When it doubt, take it out."

WHAT'S THE MOST IMPRESSIVE GEORGIA HOUSE YOU'VE EVER SEEN?

The Hay House in Macon, a superb example of the Renaissance Revival style.

WHAT'S YOUR DREAM HOUSE?

It's in the South of France. The colors, water and light are breathtakingly beautiful...just like Matisse painted.

JILL JURGENSEN INTERIOR DESIGN
Jill Jurgensen
Allied member ASID
3475 Oak Valley Road, NE, Suite 2040
Atlanta GA 30326
404-233-7108
FAX 404-364-0456

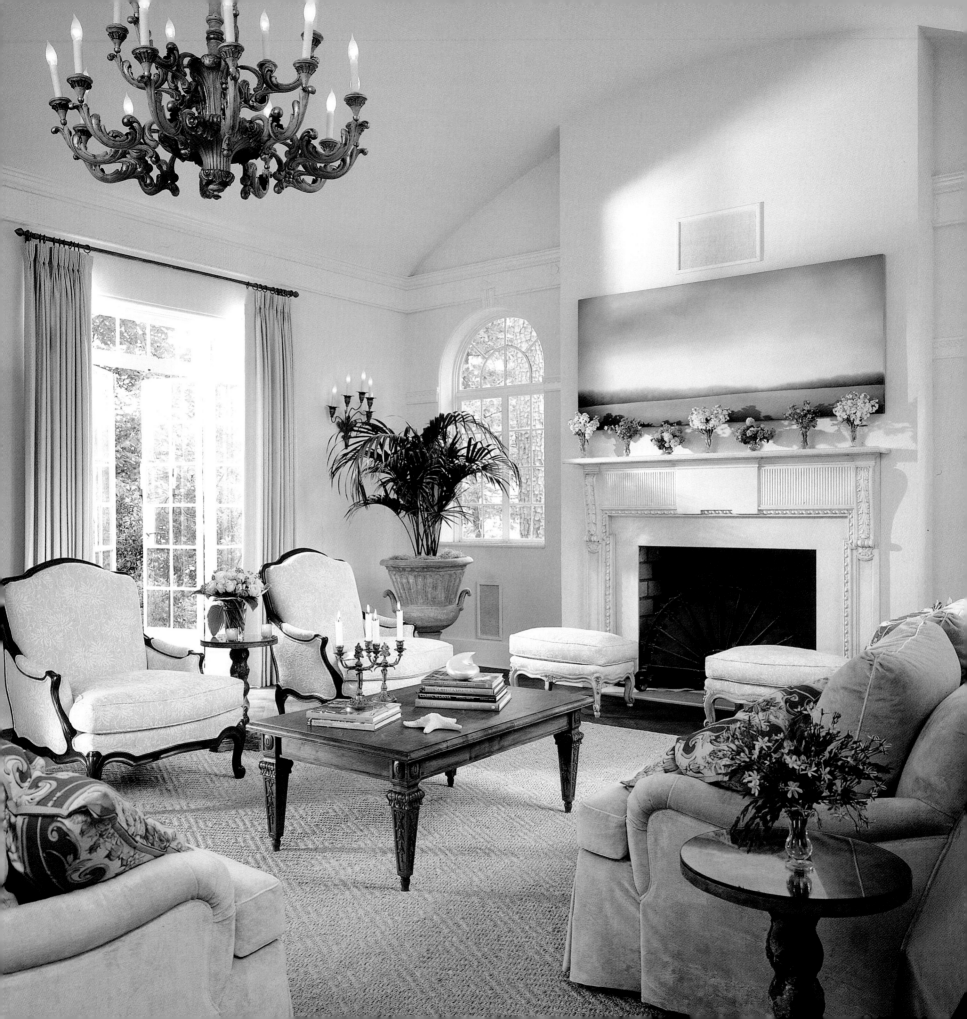

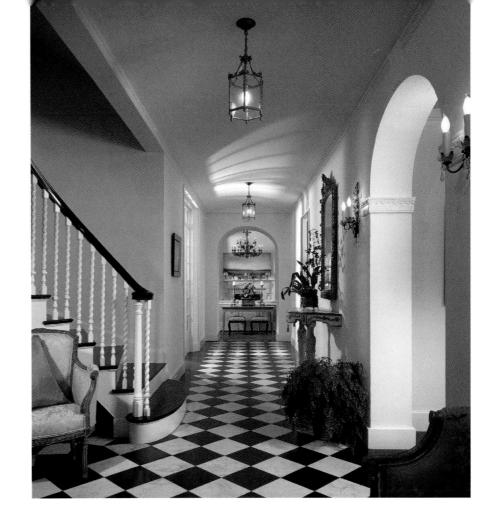

LEFT In the living room of a 1932 house by Aymar Embury, renovated by Harrison and Associates, Meridy used an Elizabeth Stockton landscape to hide a flat-screen television.

RIGHT "The bones of this house were so good," says Meridy, "that it was a pleasure to bring it back to life." Since a former owner had removed the original light fixtures, she replaced them all with antiques.

MERIDY KING

Meridy King Interior Design

Meridy King has a vision of timelessness and fun. Although she typically works on extremely lavish homes, and her husband and sometime collaborator is a high-end custom builder and developer, she argues against being too obsessive or perfectionist about design. "The thing I aspire to create is an environment that has the elegance and warmth of age and the freshness and energy of youth," she says. At the same time, Meridy is a master of the smallest detail.

Meridy tells the story of a recent client for whom she found a 17th century chandelier. "Even though it was very expensive, it was not perfect and never would be. A strength of mine is to help a client appreciate a piece for its beauty of design and its impact on the ambiance of the room."

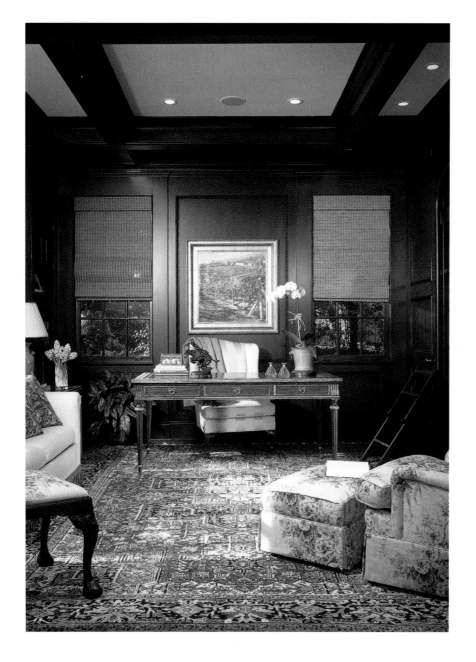

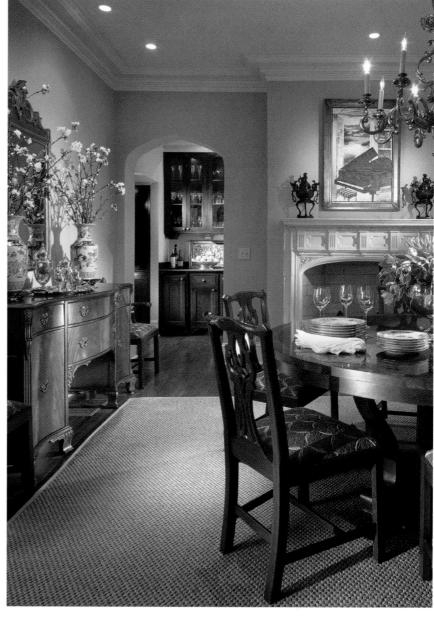

With a mother who not only helped organize the first Atlanta decorators show houses but also wrote a newspaper column, called "Peddler's Path," about shopping for antiques and such, Meridy has been around good design and great old things all her life. She earned degrees in both advertising and interior design, and worked on the retail side of both the furnishings and fashion industries before establishing her own design firm. In the decade since then, She's made a mark with her signature approach, producing spaces that are both easily livable and deeply rooted in history.

"I balance good taste and good fun," she says. Her work has been published in *Trend, Atlanta Homes & Lifestyles, Atlanta Magazine's Home,* and several European magazines.

Meridy takes inspiration from the old houses of Europe, with their patina of age and long use. "But I don't care for old and stuffy, even if it's fabulous," she says. "I love a little spunk in it, a few modernist pieces - as if a young person, maybe the princess, came into the castle."

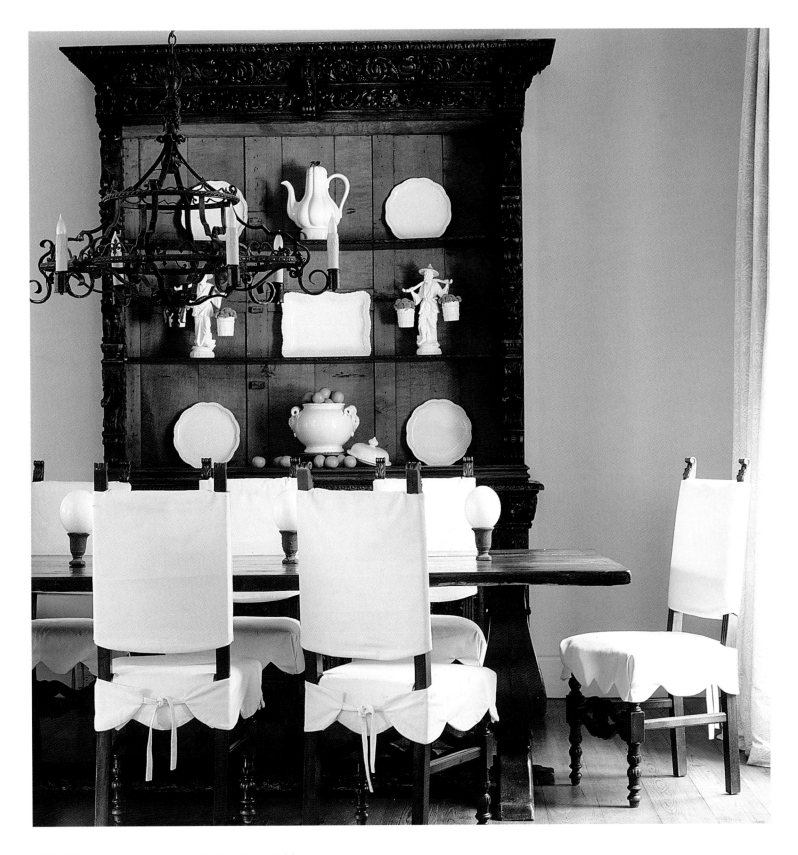

FAR LEFT Renovation architects Spitzmiller/Norris converted the dining room in this 1922 house into this handsome study.

NEAR LEFT Antique furniture and a new painting over a prominent fireplace make this dining room the warm center of the house.

ABOVE Meridy removed the doors of the cabinet to open its rustic wood interior to the room. Old chairs got new dresses in white duck.

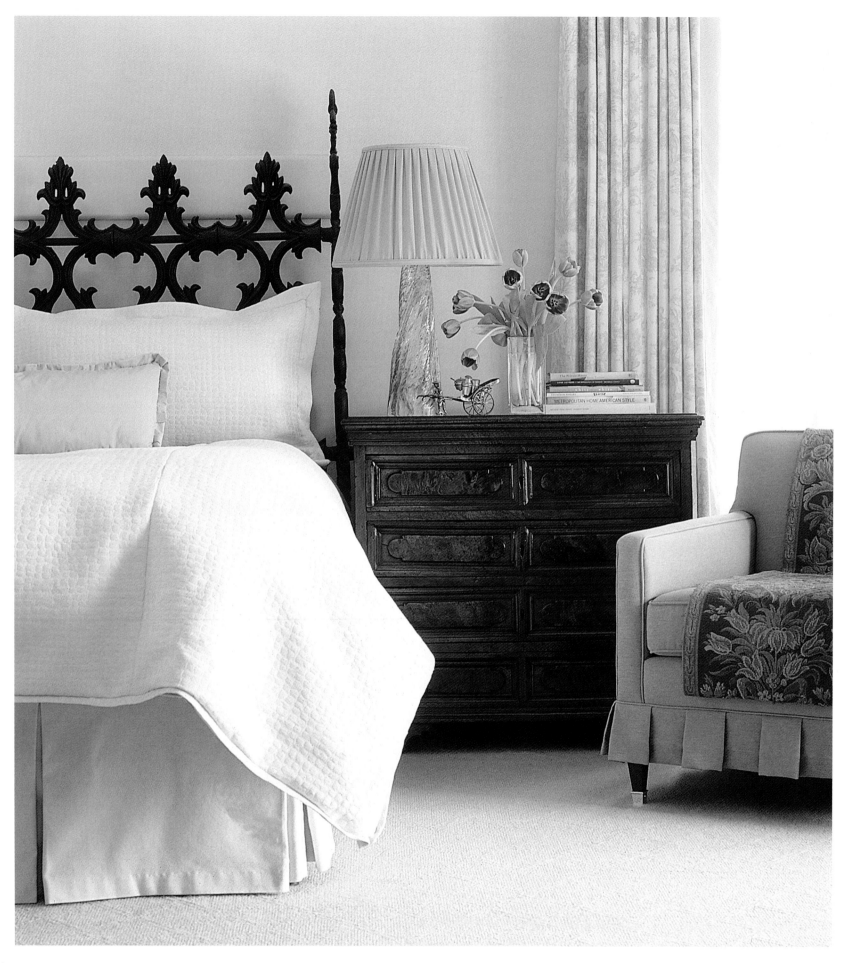

Her own home, which her husband built, is modeled after a European country house. It deliberately incorporates elements with the feel - and in some cases the reality - of great age, like real plaster walls, beamed ceilings, old mantels and doors, and stone flooring reclaimed from an English factory "that's about two feet thick. We wanted an old new house," Meridy says. What does an interior get from touches like these? "A warmth, a tenderness. Older, worn things are softer, the environment is more friendly. It's like an old car; you're not worried about that first scratch. I appreciate and like the imperfections of older furnishings and architectural pieces. I love the story they tell in a few dings. Our home is not so up tight, and neither am I. Life's too short to worry about every single little thing."

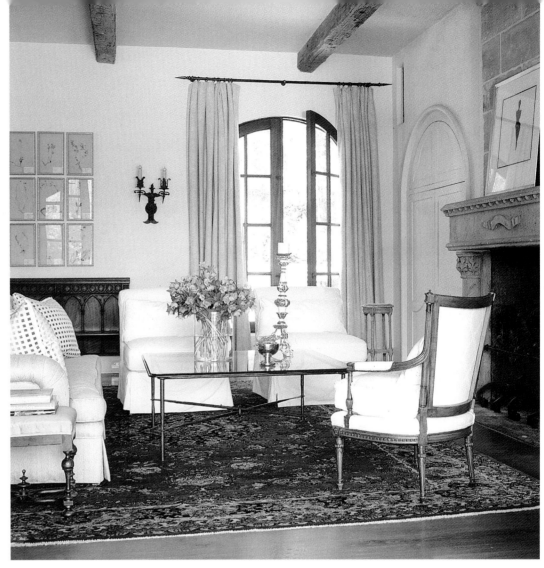

LEFT A length of old iron fencing was used as a headboard in this inviting bedroom. The 18th century chest is from Robuck & Company Antiques.

ABOVE Architect Peter Block's skill, and an 18th century mantel, make this newly built home seem antique. A Rob Brinson photograph brings in a contemporary note.

More about Meridy ...

WHAT DESIGN PHILOSOPHY HAVE YOU STUCK WITH FOR YEARS THAT STILL WORKS?

Start with a clean, simple plan; then add on.

IF YOU COULD ELIMINATE ONE ARCHITECTURAL GESTURE FROM THE WORLD, WHAT WOULD IT BE?

The two- or three-story foyer.

WHAT IS THE MOST EXPENSIVE ELEMENT YOU'VE EVER USED IN A PROJECT?

$36,000 dining room chairs for a beach house—and a $10,000 table to go with them.

WHAT COLOR BEST DESCRIBES YOU, AND WHY?

Blue—typically calm, relatively fluid.

NAME ONE THING MOST PEOPLE DON'T KNOW ABOUT YOU.

I was on the water ski team in college. I knew it was time to come home when I thought a boy looked OK in a tank top.

WHAT BOOK ARE YOU READING NOW?

Are you kidding? With two small kids and a design career, there's no time!

MERIDY KING INTERIOR DESIGN
Meridy King, IIDA
90 West Weiuca Road #105
Atlanta, GA 30342
404-252-3377
FAX 404-352-8012

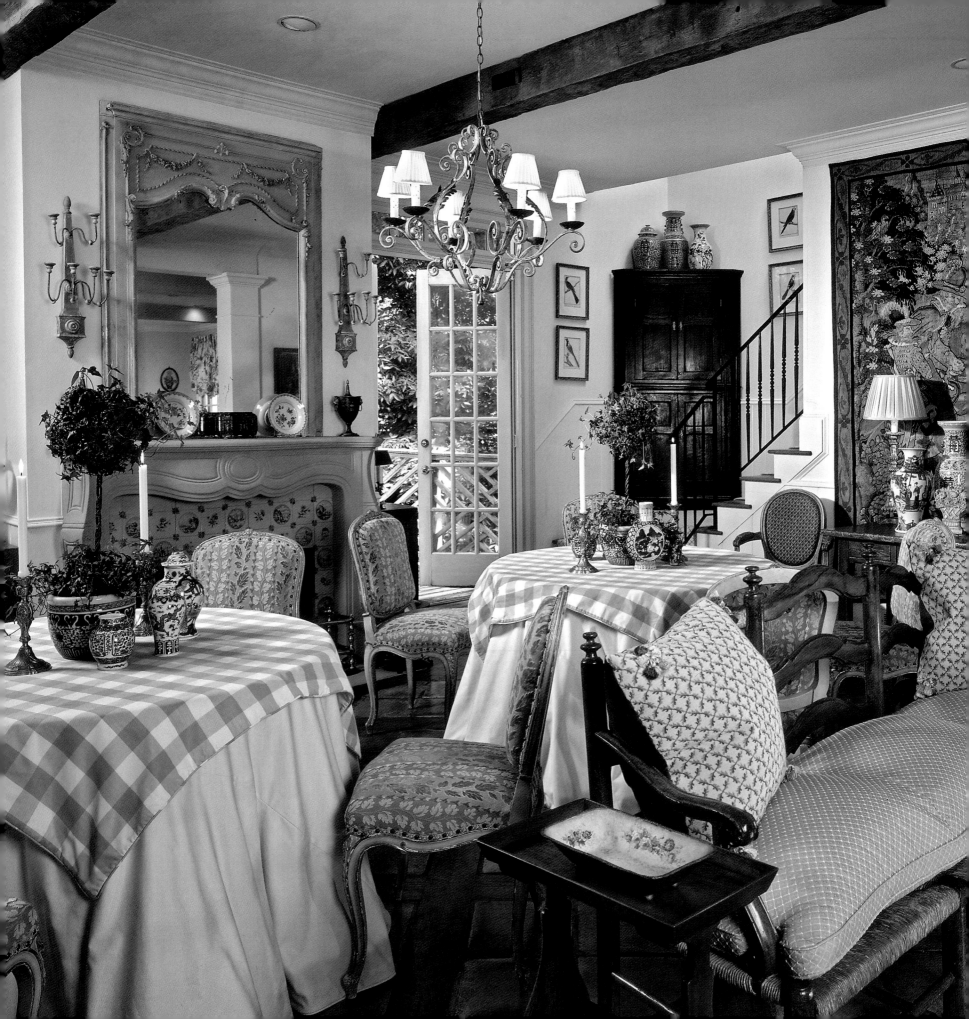

LEFT Collected antiques fill the dining room of this designer's home featuring her collection of antique blue and white export porcelain.

ABOVE An antique custom-upholstered French chair along with a client's collection of paperweights add style to this living area.

SUSAN LAPELLE

Susan Lapelle Interiors

Susan Lapelle grew up immersed in good design. Her mother was a student of interior design, and the family traveled to Europe several times. Susan attended high school at Kingswood School Cranbrook in Michigan and pursued design at Michigan State University "because it was so easy for me," she says. "I thought the career was riddled with headaches, so I went into business. Then I moved to Atlanta, hired a designer and became her assistant. And here I am, 25 years later."

Her work is generally traditional, French more than English, though she loves "this new cleaner influence that's coming in. But quality is my mantra. I urge my clients to buy the best they can afford. I like to create value for my clients, and not have them end up with a house of used furniture." For the same reason, her favorite projects are those in which she works with the architect and client, from the beginning, because the result is a well-thought-out, quality décor.

As to her clients, she says, "I want to take on their design challenges. I don't want them to have to worry about how it's going to get done, I just want them to enjoy the process."

SUSAN LAPELLE INTERIORS
Susan B. Lapelle
620 Mount Paran Road
Atlanta, GA 30327
404-705-9695
FAX 404-705-9630

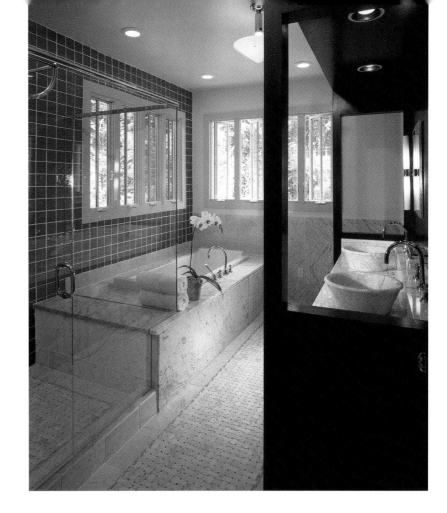

SCOTT LASLIE & MARK WILLIAMS

Laslie-Williams Architectural Design and Interiors

Scott Laslie and Mark Williams, who formed their partnership in 1998, have backgrounds that inspire confidence. Scott studied fine arts at Mercer University and interior architecture at the prestigious Art Institute of Chicago; after that, he worked for star Atlanta designer Stan Topol. Mark earned a bachelor's from the School of Architecture at Georgia Tech and studied internationally at the Ecole d'Architecture Paris-Tolbiac, returning home to work with two top architecture-design firms, Heery International and Brooks-Burr.

Those credentials ensure not only that Scott and Mark know how to transform interiors, but also that they understand the structure of buildings—and how best to alter them to make their interiors both beautiful and livable. "We have a unique combination of experience at combining both architectural and interior design with a precise and discerning eye," is how Scott sums it up.

"We build every job with careful consideration of scale, texture and contrast," says Mark. And while the look differs from project to project, all show the partners' shared taste for eclectic gatherings of objects and materials, composed with balance and restraint.

"Our style sets us apart," Mark says, "and so does our easygoing attitude. But as easygoing as we are, we have worked hard to take this art form and turn it into a business, to streamline it so that overall it is a better experience for our clients."

LASLIE-WILLIAMS ARCHITECTURAL DESIGN AND INTERIORS
Scott Laslie & Mark Williams
1024 Monroe Drive
Atlanta, GA 30306
404-685-0810
FAX 404-685-0780
www.lasliewilliams.com

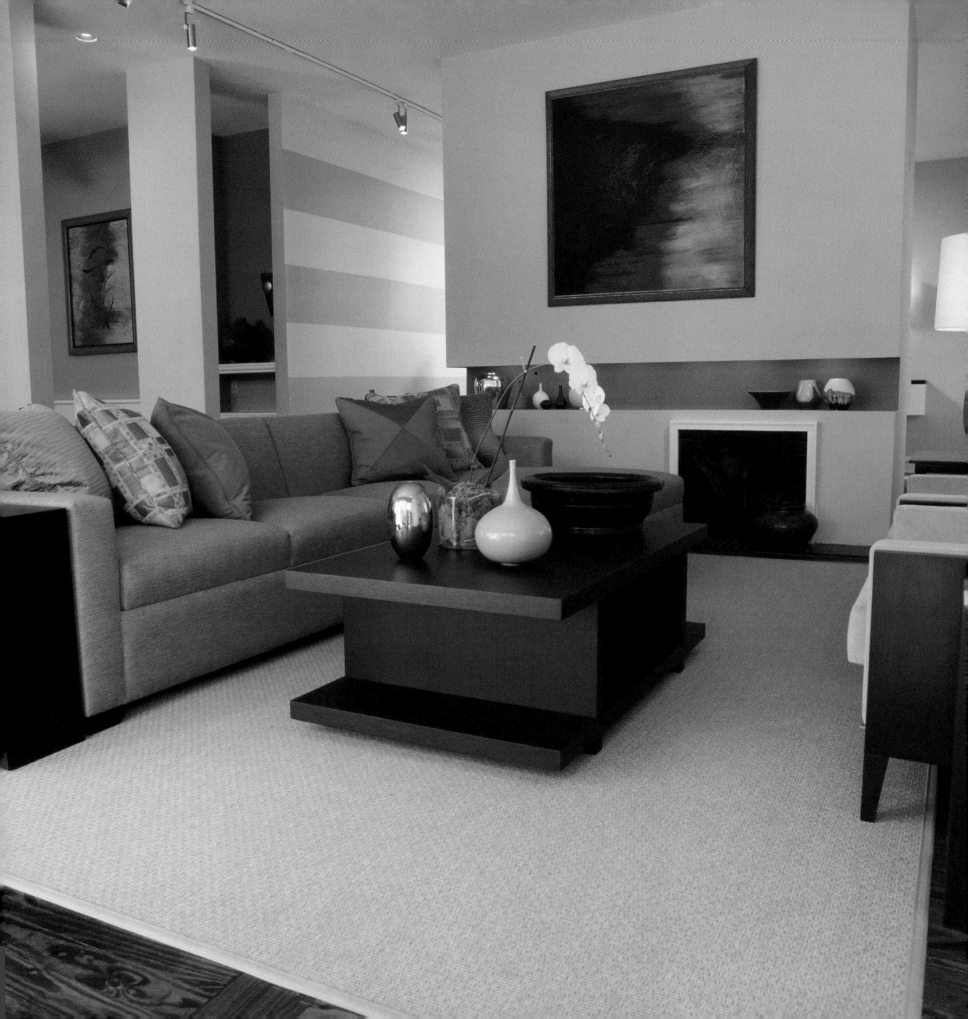

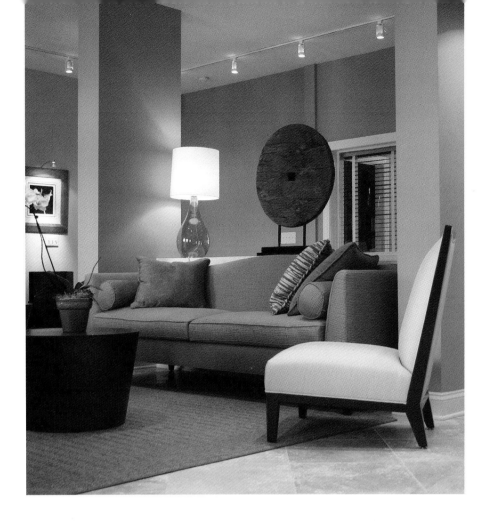

LEFT Who says contemporary has to be cold? A modern hearth literally warms this space while a combination of natural materials warms it visually.

RIGHT In this dramatic living room, Corey creates a harmonious marriage of architecture and design.

COREY MCINTOSH

McIntosh Interiors

"As a child," says Corey McIntosh, "I was always moving the furniture around...in the entire house...weekly." So it's little surprise that now, as an adult interior designer, his favorite part of the process is space planning, "the challenge of making an existing space work." That's a good thing, since what so many clients seek is just that—the reinvention of an existing home.

Although he's only had his own Atlanta business since 1998, Corey has attracted plenty of notice. His projects have been published numerous times, and he was invited to design a room in the 2005 Atlanta Symphony Showhouse. He won awards throughout his design school years, too—and also happens to be an award-winning pianist.

Corey's style is contemporary yet restrained, relying, for instance, more on texture than pattern, and more on predominantly neutral palettes that are punched up with small doses of color. His favorite designer is Vicente Wolfe. "I love the way he takes traditional pieces for upholstery, mixes them with contemporary case pieces, and then throws in ethnic accessories, exotic sculpture and art. That's my favorite mix, and it's what I aim to create. I could never imagine myself at home in a strictly 'period' room, nor in one where everything was severely modern. I feel that utilizing various textures and multicultural, handcrafted items make a room infinitely more interesting."

MCINTOSH INTERIORS
Corey McIntosh, Allied Member ASID
820 Dekalb Avenue, Suite 11
Atlanta, GA 30307
404-588-1951
FAX 404-588-1965
www.mcintoshinteriors.com

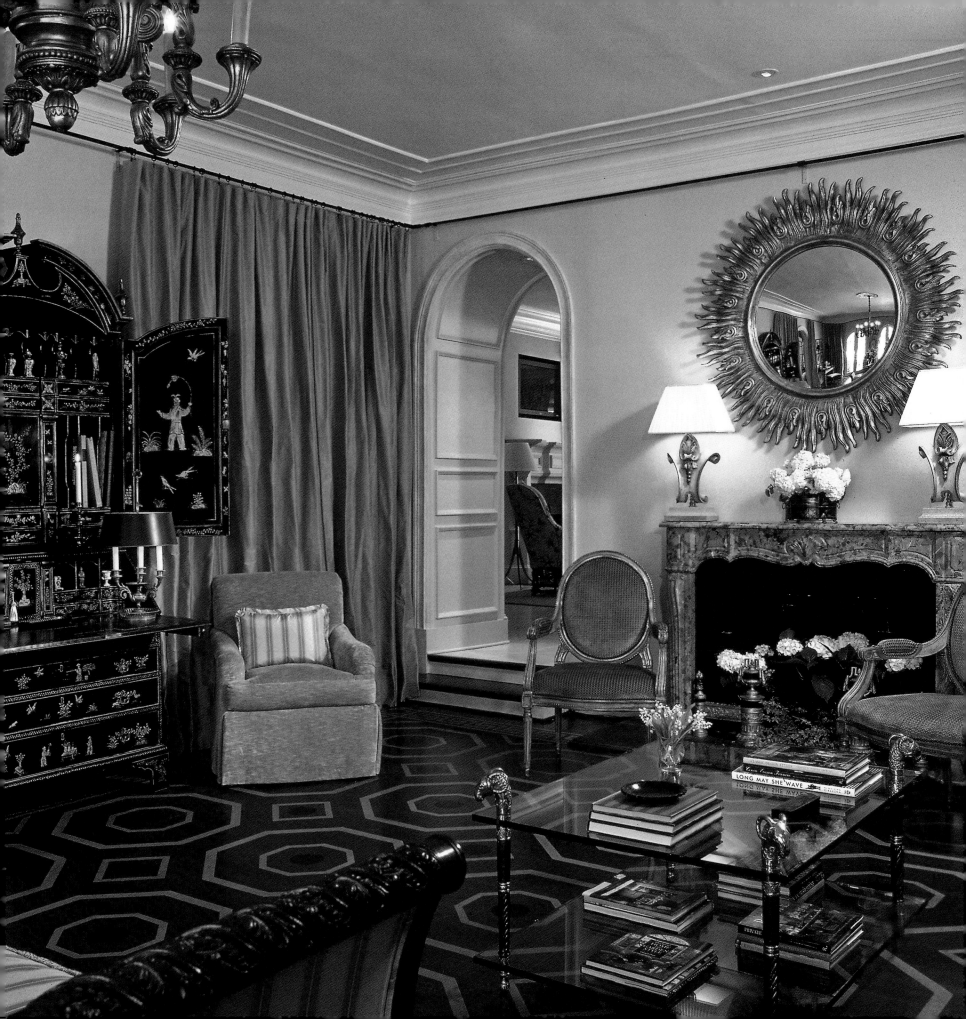

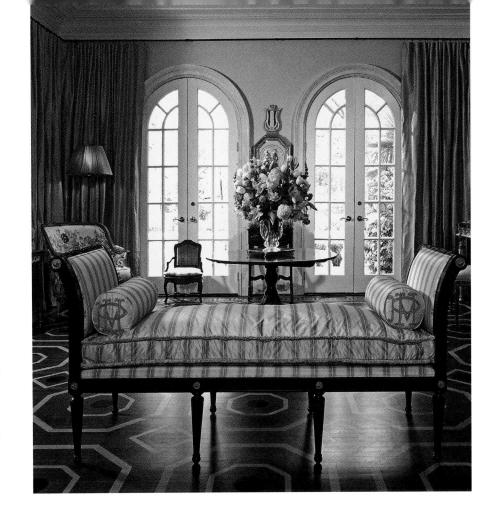

LEFT An exquisite black lacquer Chinoiserie bookcase is ornamental and substantial surrounded by floor to ceiling silk draperies that envelope the room. The floor itself is hand stenciled with an octagon motif on the hardwoods inspired by Regency England. The antique Italian marble mantle was added by the designer to complete the elegantly European tone. The sunburst mirror lends a sunny note.

RIGHT The mahogany daybed with down cushion in silk stripe provides a resting place for either end of this elegant thirty foot Living Room. The flowers on the antique center table almost foil a Swedish gilt octagonal barometer. The hand embroidered bolsters are hallmarks for the designer's initials PM.

All photos included from Atlanta Symphony Associates Decorator Showhouses.

PATRICIA MCLEAN

Patricia McLean Interiors, Inc.

Patricia McLean is a true Anglophile. When designing a show house room (she has designed seven) a European buying trip is in order. "There is a renewal that comes from traveling and experiencing new places. I love bringing things back before they have caught on here! Sourcing antiques in Europe is inspiration for custom furniture designs of my own," she remarks. Even though she is a classicist, Patricia is on the lookout for the latest and greatest. No doubt, her clients and show house visitors appreciate her fresh prospective on traditional style.

Patricia established her design firm, which has its offices in the heart of Buckhead at Peachtree and Piedmont Roads, twenty years ago, shortly after graduating from the University of Georgia with a degree in Interior Design. She has served as a board member of the International Interior Design Association and has been nominated as Southeastern Designer of the Year at the Atlanta Decorative Arts Center. Her work has been

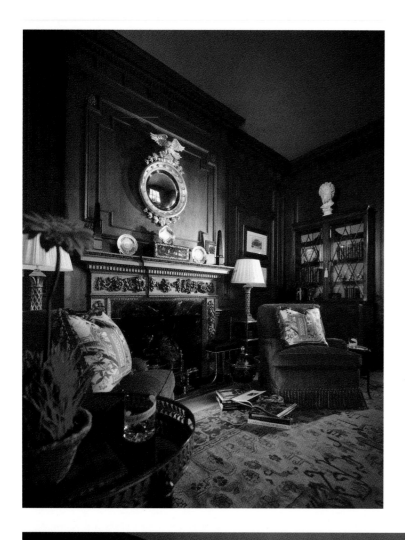

published in *Antiques International*, *Better Homes and Gardens*, *Southern Accents Traditional Homes*, *Atlanta Homes and Lifestyles*, and *Atlanta Magazine* among others. She has written articles for publications including the *Atlanta International Home Furnishing Market Guide* and was nominated for an award on an article co-authored about London.

While Patricia pays attention to the needs of her client's contemporary lifestyles and desire for functionality, clients have a great appreciation for her classic design principles and timeless style. She considers scale the most important element of design and believes is the most easily missed by the untrained eye. Color is completely subjective and she holds that there are no ugly colors, just poor combinations. Patricia considers one of her greatest assets the ability to memorise and carry colors in her head. She considers fabrics her friends because they can completely transform any space. Sound architecture is the springboard for good design and she enjoys overseeing new construction as well as renovation.

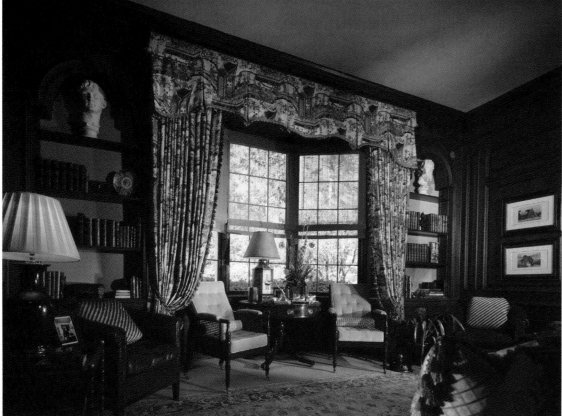

TOP LEFT The designer scheduled appointments with her favorite antiques dealers and traveled to London and Paris to furnish this handsome paneled Library. The antique Oushak rug set the palette of bittersweet and honey-the perfect compliment to the warm wood tones.

LEFT Known for gorgeous window treatments, McLean selected a Chinoiserie scenic fabric and designed the serpentine cornice and valence combination to surround the bay window that looks out to the garden. The panels are lined in silk stripe that compliments the azaleas when in bloom. The bookcases are upholstered in gold linen velvet to add warmth and brightness.

FACING PAGE Dining in a secret garden in the heart of the home is enchanting. The hand painted silk panels were first applied to muslin so they could be dismounted and installed in a special client's new home after the show house. Two round tables seat 16. Antique Irish crystal chandelier finials were found in London and add sparkle to the Rococo style consoles with custom designed mirrors.

All photos included from Atlanta Symphony Associates Decorator Showhouses.

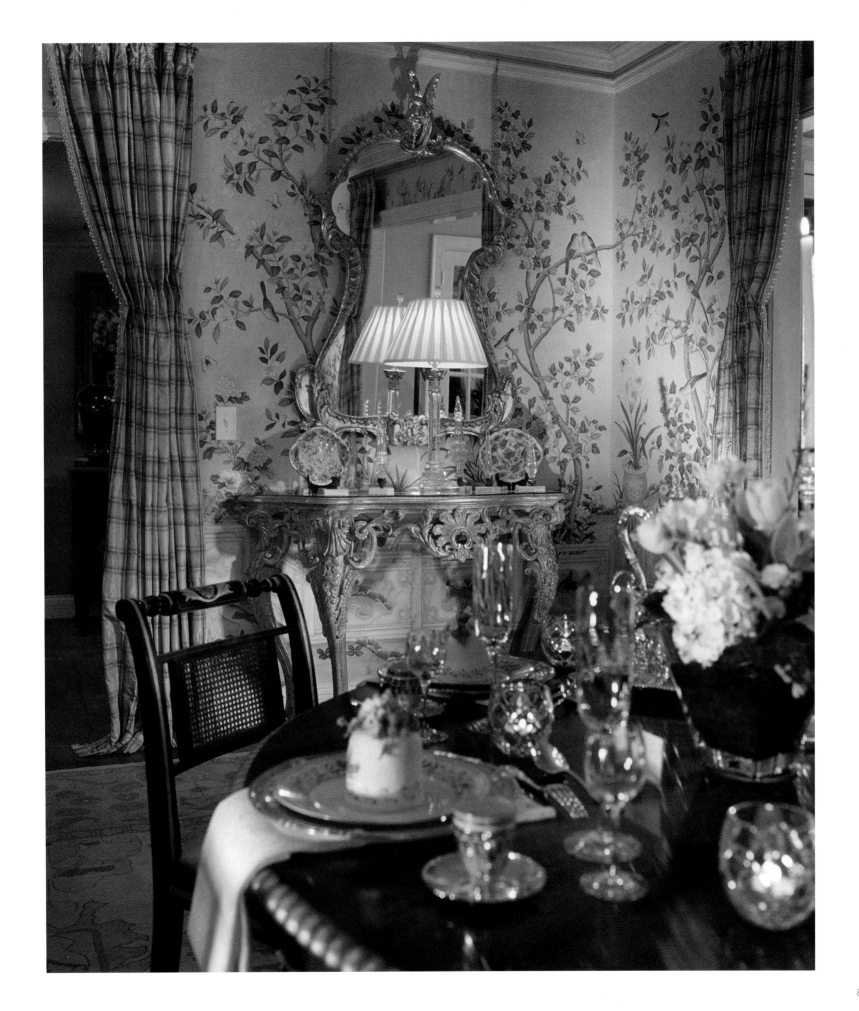

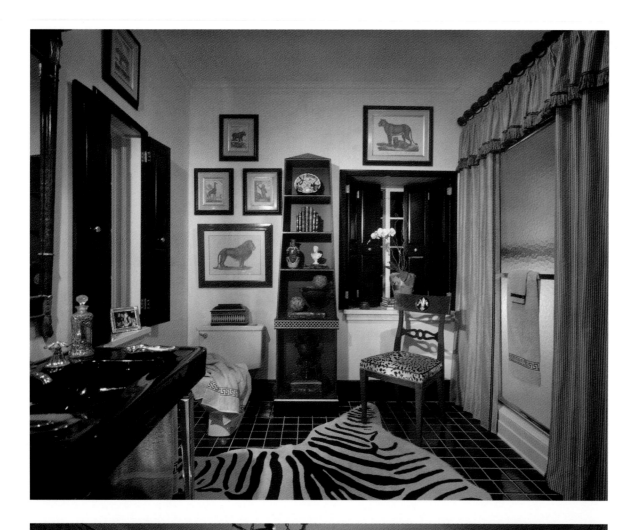

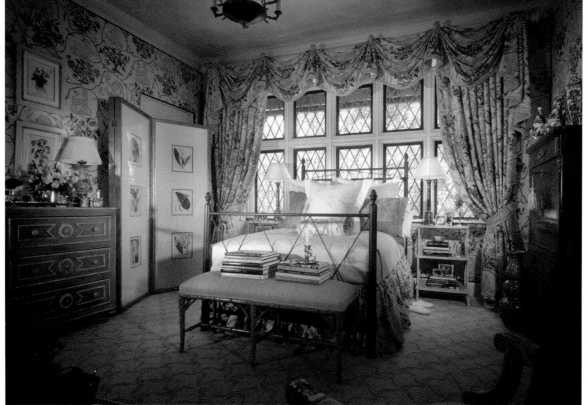

Travel is Patricia's passion and she considers it a blessing to be able to incorporate her professional life with her leisure time. A European tour while in college introduced her to the fascination of the world's great cities and their history and architecture. She never tires of learning, growing and educating her eye. She covers Design shows world wide as an independent rep for to the trade magazine and relishes the adventure of being introduced to the new lines of interior furnishings and fabrics before they are introduced in the States.

This accomplished designer loves the challenge of her work and enjoys the friendships she has with her clients. Patricia's attitude toward life is also echoed in her design philosophy. Tricia, as she is known, has real joie de vivre which her clients and colleagues appreciate. Her education and experience combine to insure that the firm is a Southeastern favorite. Due in part to her energy and enthusiasm, Tricia is sought after by high-end residential and commercial clients from all across the country. She designs spaces for her clients that not only look beautiful, but will be stand the test of time.

TOP LEFT Regency in feel, the animal prints and obelisk bookshelf are welcoming and enticing. The custom black full panel shutters were added for privacy, but contribute to the handsome look of this gentlemen's bath. On the floor is a cowhide stenciled to resemble a zebra that adds an exotic flair.

LEFT Inspired by a trip to Paris, this fully upholstered Lady's bedroom is a delight. The bed echoes the design of the Tudor leaded window. Custom window treatments with box pleat trim and elaborate swags accentuate the architecture. Custom stair step tables accommodate tole lamps and books. Antique botanical prints matted in silk form a screen that hides a closet door.

FACING PAGE The antique pine fireplace was installed by the designer to appear real. The tole chandelier traveled from the Marché des Puces in Paris through France, Italy and Switzerland before making it home! A mirror plateau is supported by a sterling silver stand from which breakfast is served.

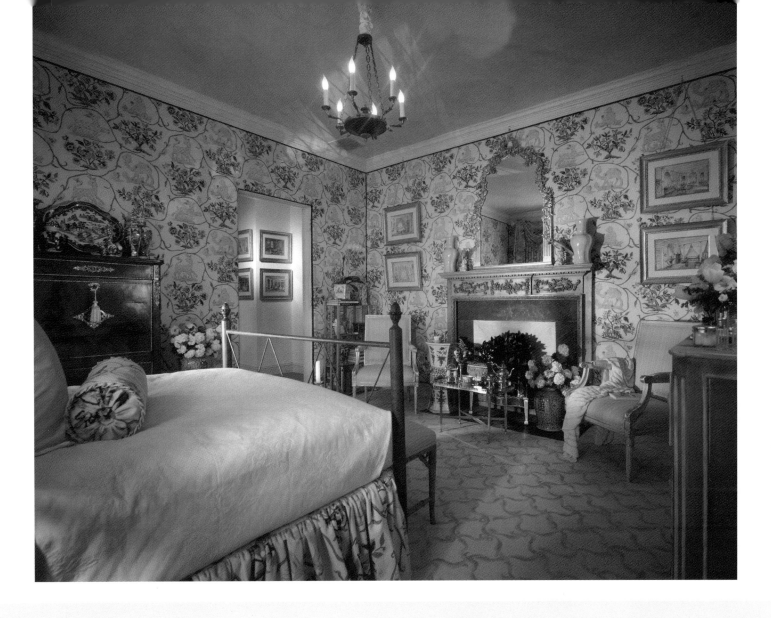

More about Patricia ...

WHAT IS THE HIGHEST COMPLIMENT YOU'VE RECEIVED
PROFESSIONALLY?

I was contracted to write a book about my own work, to be released in 2006 through
Schiffer Publishing.

WHO HAS HAD THE BIGGEST INFLUENCE ON YOUR CAREER?

My parents, who built a house while I was young; watching that process was a
beautiful introduction to design. More recently, my dear friend Lady Henrietta Spencer
Churchill, because of her impeccable taste and ability to manage her global interior
design business while touring, lecturing and authoring eight books!

WHAT COLOR BEST DESCRIBES YOU AND WHY?

Yellow, because it is sunny, and I am blonde (but blonder sometimes more than others!).

WHAT IS THE MOST COMPLICATED TECHNIQUE YOU'VE USED IN A
DESIGN PROJECT?

Hand-painted Gracie silk wall panels mounted to canvas and installed wall-to-wall in
the Atlanta Symphony Show House dining room. They were custom specified to fit
around every opening in the room, with every inch incorporating the pattern.

WHAT IS A SINGLE THING YOU WOULD
DO TO BRING A DULL HOUSE TO LIFE?

Organize a party! That is when the real
decorating begins!

PATRICIA McLEAN INTERIORS, INC.
Patricia McLean
3179 Maple Drive
Suites 8 & 10
Atlanta, GA 30305
404-266-9772
FAX 404-266-9773
www.mcleaninteriors.com

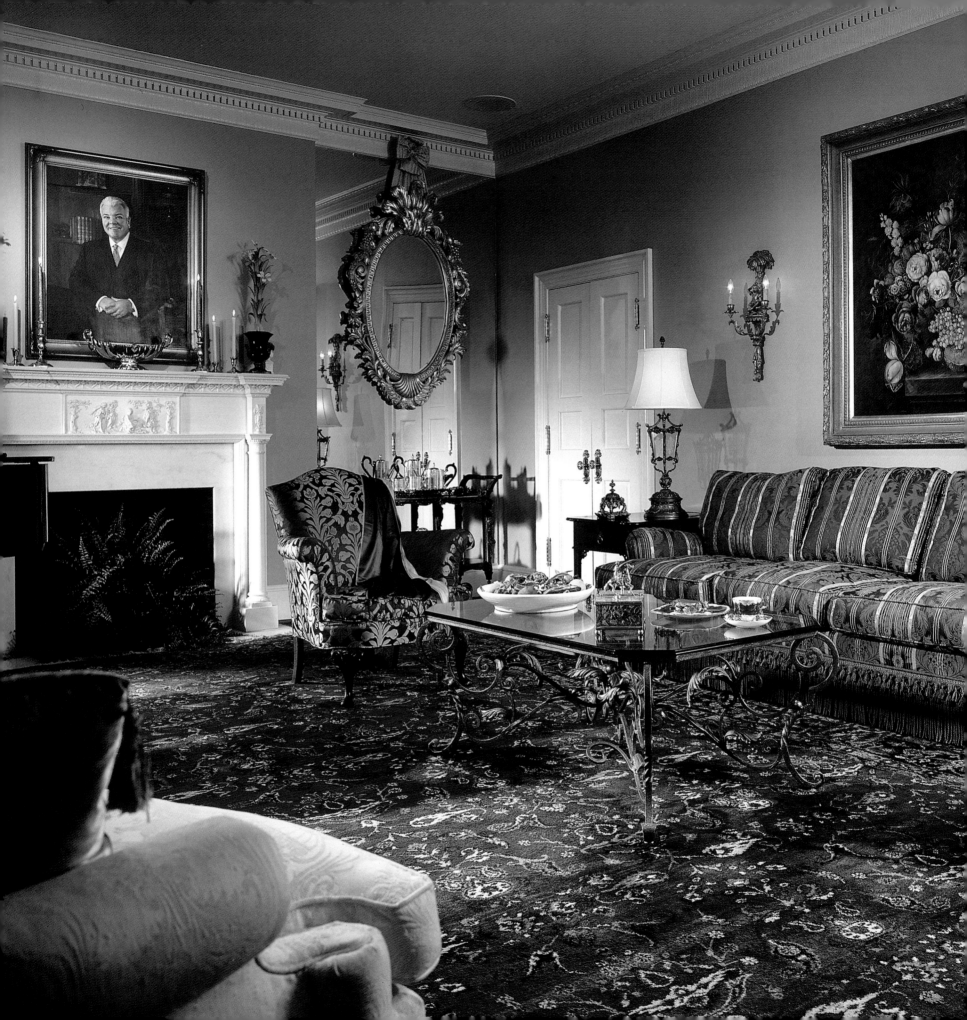

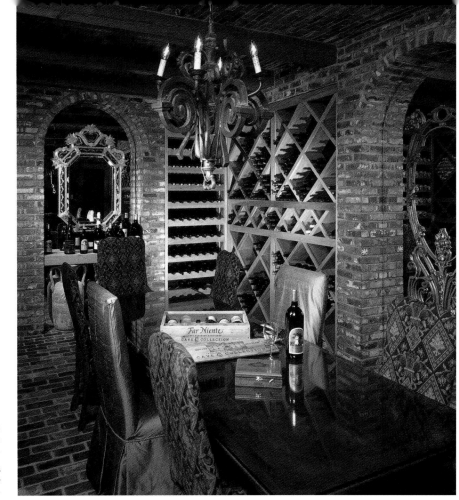

LEFT Laurie used an unconventional color scheme in the dignified Augusta home of Tim and Sam Shelnut.

RIGHT Sam Shelnut, who is a dealer in Laurie's antique market, collected the antiques Laurie used in the Shelnut's lodge wine room.

LAURIE McRAE

Laurie McRae Interiors, Inc.

During her college career, Laurie McRae was asked to project her life 25 years into the future. "I saw myself as an interior designer and the owner of an antique store," she says. She has accomplished those goals, as president of Laurie McRae Interiors, Inc., and owner of The Antique Market, a 25,000-square-foot antique mall. And in the past year, Laurie had the honor of being named to the Georgia State Licensing Board of Architects and Interior Designers, by Governor Sonny Perdue.

These pages show rooms Laurie designed in Silver Oaks, the 13,000-square-foot post-and-timber weekend lodge of her clients and friends Tim and Sam Shelnut, as well as their home in Augusta. The lodge incorporates a tremendous number of architectural elements, including Murano glass

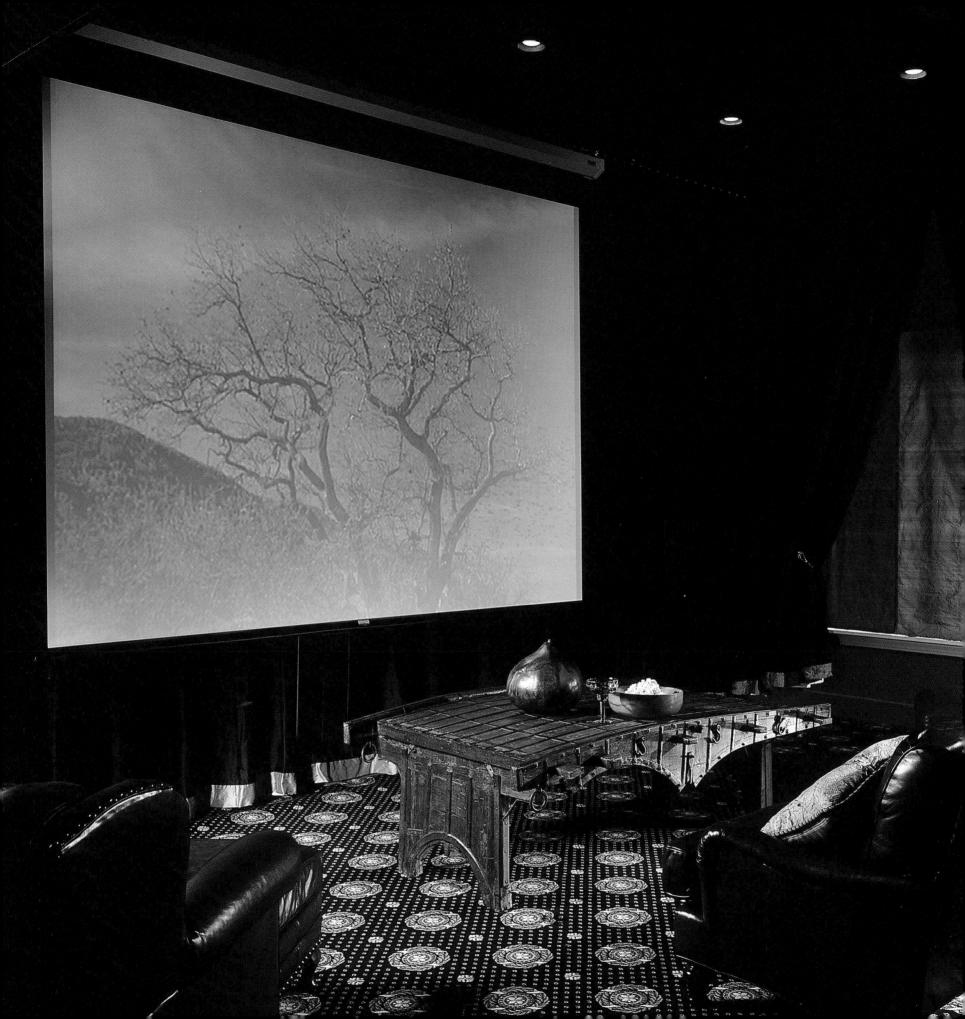

chandeliers, doors that originally had been in the St. Regis Hotel in New York (seen in the film "The Godfather"), to timbers that were part of a retaining wall on the St. Lawrence Seaway. "My job was to blend large spaces and a diverse number of items into an intimate, cohesive unit."

Laurie and her husband recently completed their own new home, built in the Arts & Crafts style to complement their collections of furniture, accessories and hardware dating from about 1880 to 1920. "Early in the project I decided that I would treat myself as I would a client, by keeping a file on all components and by project managing. Now having lived through the frustrations and deadlines, I'm much more empathetic to my clients."

While Laurie has a special passion for historic houses, she also enjoys creating from all periods and designs. "A classic is timeless," she says. "A 1950 classic can be as enduring as a 1750 classic." She is especially excited when a client hires her to do the correct things for a specific house, whatever the house asks for. "So often people will renovate an old house and it will end up looking like a new one. Modern functionality is paramount, but I enjoy working in the right period."

LEFT The Shelnut lodge media room is fully draped in black silk to enhance its acoustics.

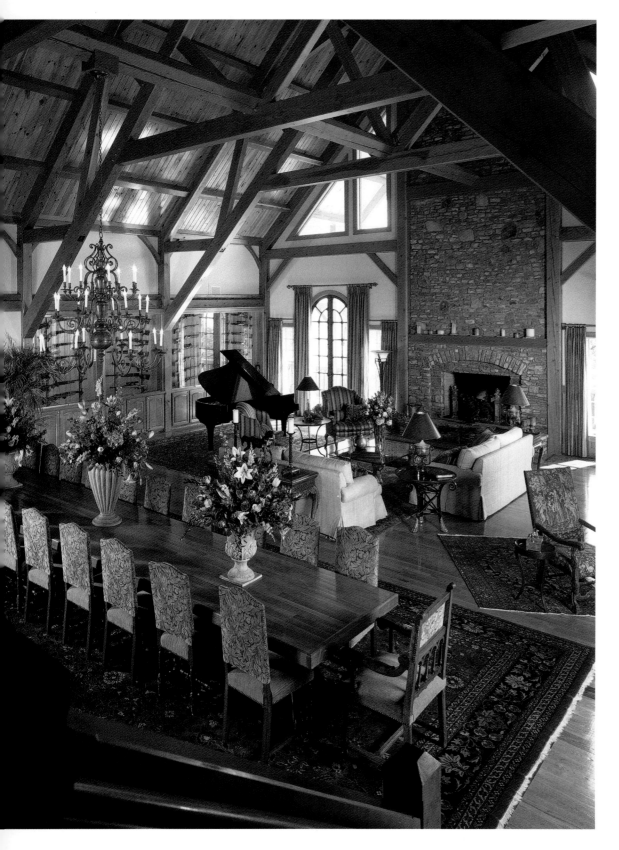

Laurie's passion for antiques is apparent when you ask how she would pamper herself—and she starts talking about her antique-buying vacations through the United States and England. Laurie is especially partial to old textiles like embroidery and needlepoint. "I like to buy them, and to sell them," she says. "Having an antique mall, I don't have to own anything for long. I have the satisfaction of appreciating something and then passing it along to another owner. A breeder of Airedale terriers, she compares this to finding a good home for her litters of puppies. "I am most at peace when I am outdoors with my dogs or heading down a country road on my horse," she says.

FAR LEFT The Shelnut's weekend getaway is baronial in scale and furnishings, yet casual in feel.

LEFT Laurie specified amethyst marble flooring for Sam Shelnut's bathroom, for a feminine feel, and mounted Italian wood sconces on the mirrors.

More about Laurie ...

WHAT SEPARATES YOU FROM YOUR COMPETITION?

The breadth of my experience. I am accredited by the National Council of Interior Design Qualifications and the National Kitchen and Bath Association. I am also a licensed designer in the state of Georgia. Currently, I'm in the process of becoming certified as an antiques appraiser. I work in all fields of design—residential, commercial, hospitality and healthcare—and I excel in project management and handling construction detail and deadlines.

WHAT INDULGENCE DO YOU SPEND THE MOST MONEY ON?

Antique collecting. I spent my high school graduation money on a set of Depression-era dishes.

WHAT'S YOUR FAVORITE KIND OF DESIGN PROJECT?

The total project! I continually find that I can do the best job for my clients when I am involved in the project from start to finish."

WHAT'S YOUR LEAST FAVORITE ASPECT OF BEING A DESIGNER?

The end of a project. You feel you've given birth to something wonderful—and then the owners change the locks!

LAURIE MCRAE INTERIORS, INC.
Laurie McRae
Professional Member ASID, AKBD,
Registered Interior Designer #489
3179 Washington Road
Augusta, GA 30907
706-863-5440
FAX 706-863-9520
www.theantiquemarket.net

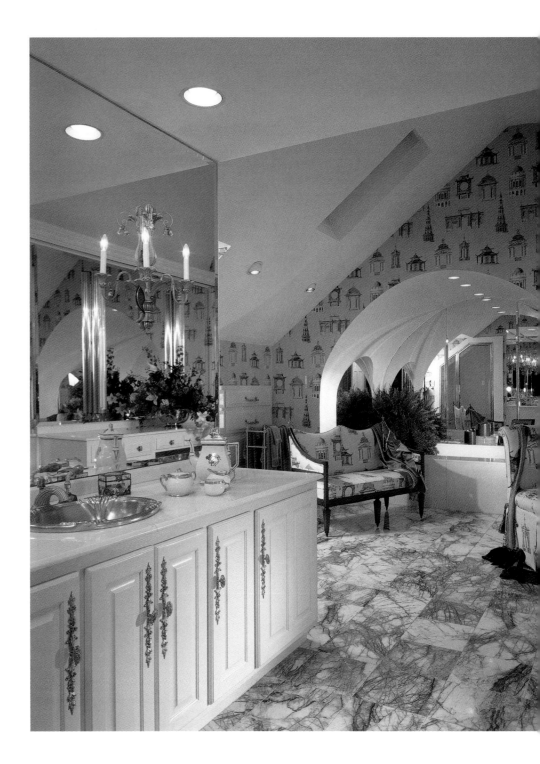

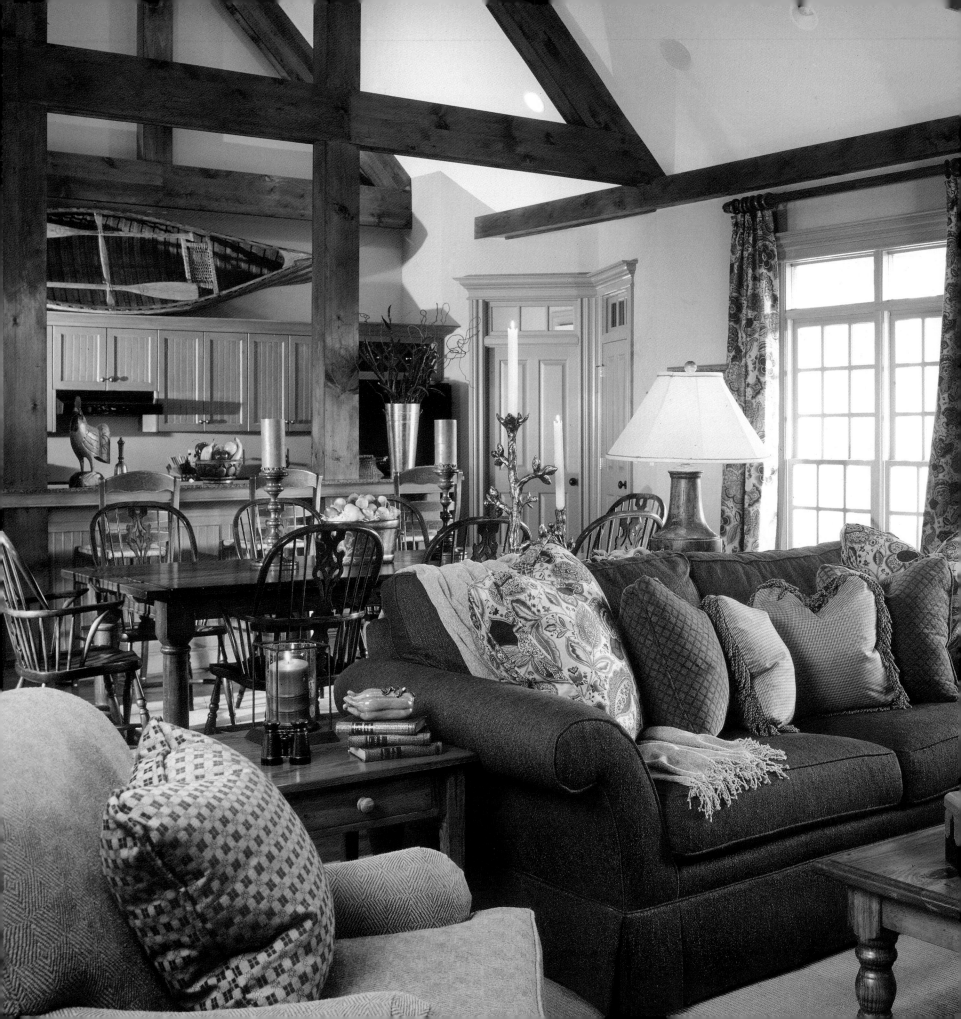

LEFT An antiqued canoe placed above cabinetry blends with the rustic lake-home design. A palette inspired from nature adds warmth to the space.

RIGHT Candlestick lamps and an antique English pine chest frame this charming entry vignette.

MARY MACWILLIAMS

Mary Mac & Company

Though her firm, Mary Mac & Company, was only founded in 2004, Mary McWilliams has been immersed in design for two decades. She managed a showroom at the Atlanta Decorative Arts Center, and then went on to a career as director of interior design for *Southern Living* magazine. In that position, aside from producing feature articles and design books, she was responsible for development, construction and interior design of all the magazine's show houses, and also hosted programs on HGTV. The ability to juggle numerous complex projects with finesse is a skill her clients can appreciate. "I am all about details," says Mary Mac, "those layers upon layers that make a house truly a home."

Mary Mac favors a traditional approach that's "timeless, not trendy. It makes for design decisions that have a longer life." In the same spirit, she guides clients to make "investments, not purchases." That's not only a benefit to them, but a source of satisfaction to her. "The best part of being an interior designer," Mary Mac says, "is creating lasting environments for the places that matter most—our homes."

Mary Mac loves the color red because it's "warm and cozy," and includes it in nearly every project. In fact, there's a Valspar paint named for her, Mary Mac Red.

MARY MAC & COMPANY
Mary McWilliams, Affiliate member ASID
305 Meadowbrook Drive
Atlanta GA, 30342
404-845-0170
FAX 404-845-0180
www.marymacandcompany.com

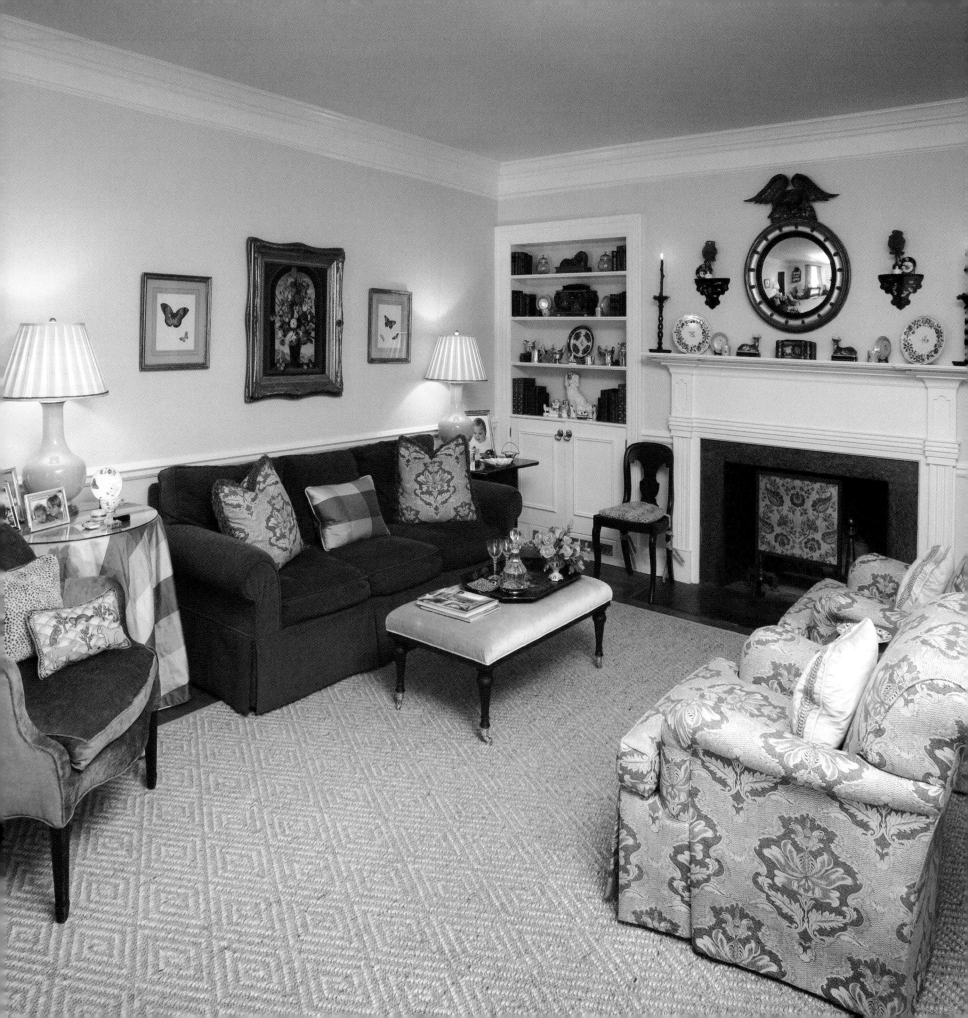

LEFT Katie strikes a traditional note in the living room of the Frank McCall house in Thomasville, with fabrics from Hodsoll McKenzie and Cowtan & Tout.

RIGHT With Osborne and Little fabrics, the sunroom at Sinkola Plantation in Thomasville seems to merge with the landscape outside.

KATIE MIDDLETON

KDM Interiors

Katie Middleton describes the style she aims to achieve as "timeless tradition, with a modern sensibility." But it's tradition that grounds her—antiques, specifically. Katie grew up in Greenwich, Connecticut, where both her parents were serious collectors. When they later moved to Savannah, where they opened a shop specializing in 18th century pieces. Katie's sister worked in another part of the antiques trade, at Sotheby's auction house, where Katie did an internship herself.

Katie's own house is filled with "English and American antiques, oriental rugs, and lots of family things such as my dad's silver baby cup and rattles." In working with clients, she hunts for objects similarly evocative of history. "I love to bring out personal things," she says, "that people have in their closets. I love having decorative china pieces on bookshelves, and old books."

Her instinctive approach is to set everything against a neutral background of muted colors. "I love and use color, but softly, and for transitions throughout a house," she explains. Her favorite? Brown, because "it's a neutral but strong color that goes with just about everything."

Before moving to Thomasville, Katie studied interior design while working for Stephanie Reeves at her ADAC showroom, Edgar-Reeves. She credits Stephanie with encouraging her to pursue a career in interior design.

KDM INTERIORS
Katie Middleton
118 Plantation Drive
Thomasville, GA 31792
229-403-0636
FAX 229-226-8179

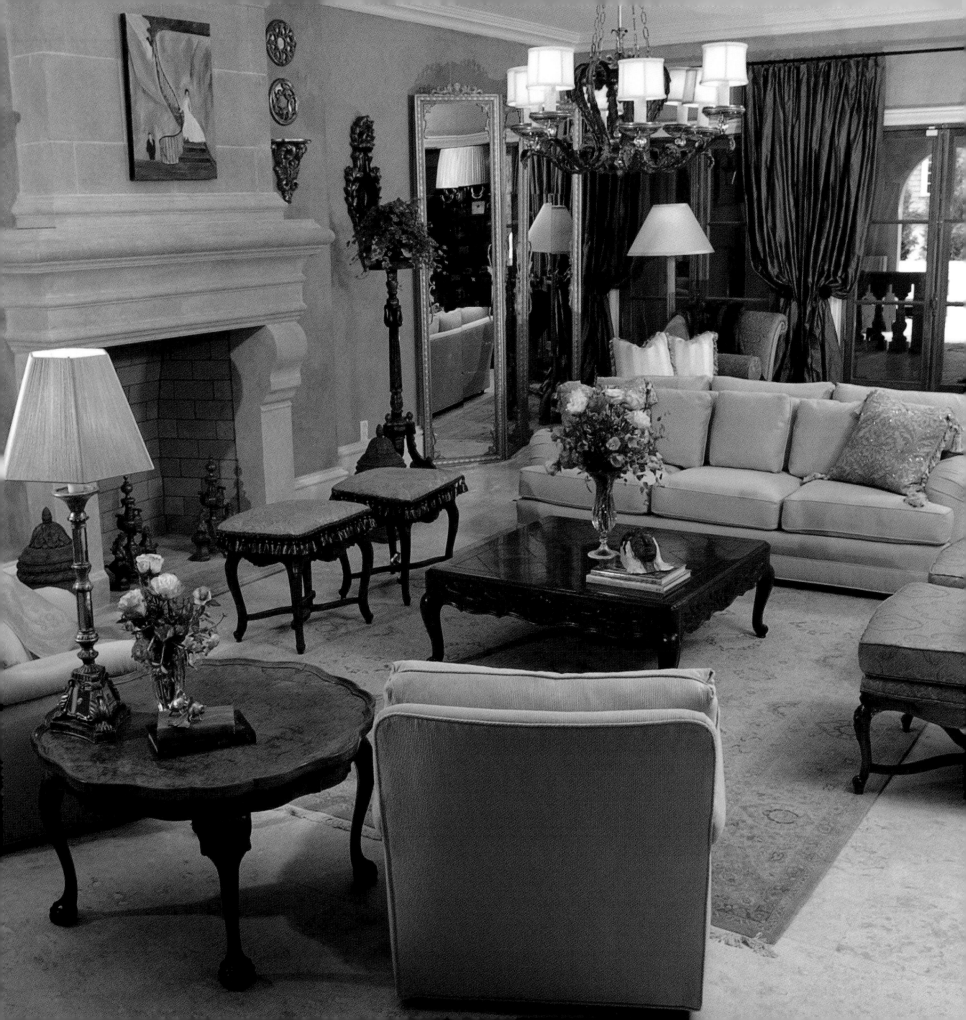

LEFT A neutral base palette with accents of celadon green makes an environment as conducive to socializing as to curling up alone with a good book. Tish designed the mirrored screen.

RIGHT This elegant bath resulted from a mix of colors and materials with a perfect Feng Shui balance - and a lady's touch.

TISH MILLS

Harmonious Living by Tish Mills Design Group, LLC

Tish Mills describes her style as "elegance with all the comforts of today's living." She believes it's important to make spaces that show beautifully and are great for entertaining, but also completely usable. "People today don't want a part of the house that kids can't use," she notes.

Tish is probably unique among area designers because of her training in the art of feng shui. That's the traditional Chinese approach to making spaces feel balanced, which she studied at the American Feng Shui Institute. These principles guide her in making choices of color and texture that subtly enhance one's experience of a room. Tish says, "People will walk into a house I've done and say, 'This feels really comfortable. I could live in this room.' Most of my clients don't

practice feng shui. But, they do love the end product. What I deliver is a room that not only looks great, but also feels great."

With her own firm since 2001, Tish has participated in several Atlanta show houses, including the Atlanta Symphony Decorators' Show House. Tish has won an ASID Design Excellence Award and has been featured in several publications for her work. Her projects range from new construction to renovation work, and include space planning and interior design.

HARMONIOUS LIVING BY TISH MILLS DESIGN GROUP, LLC
Tish Mills, Allied Member ASID
3360 Hunterdon Way
Atlanta, GA 30067
404-281-8889
FAX 770-951-1251

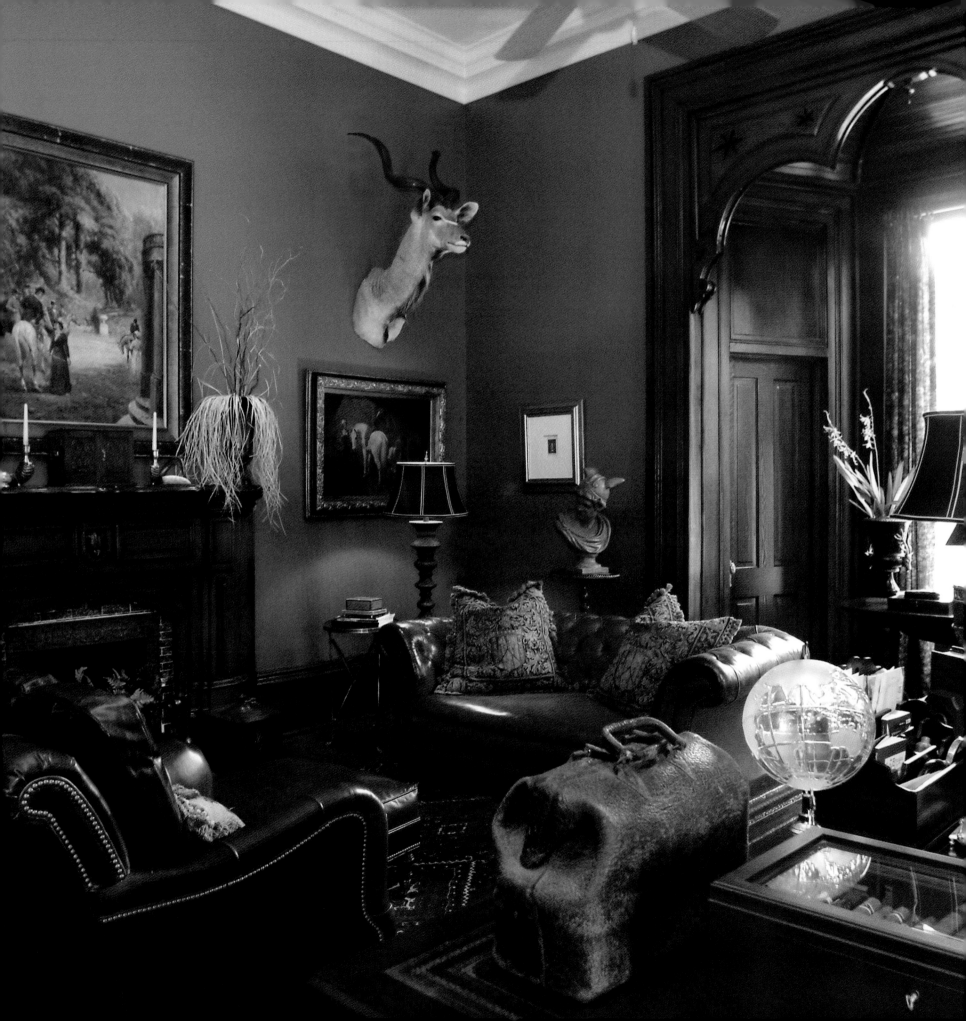

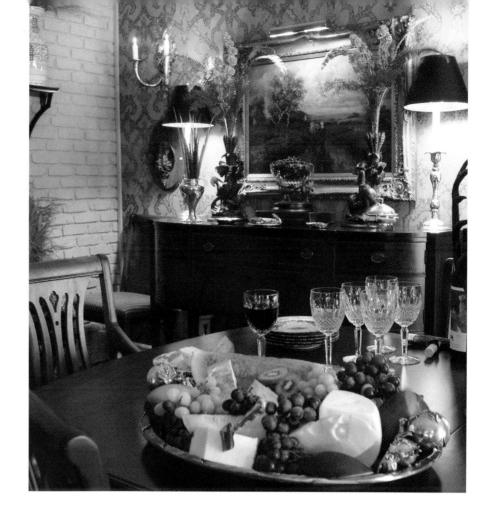

LEFT This inherently masculine gentleman's study features an original 19th century walnut mantle. The handsome English Chesterfield sofa was obtained from a New Orlean's auction house.

RIGHT A formal dining room including an early 19th century sideboard accented by black forest carved game birds, a reproduction Hearst Castle bronze, and numerous old Tiffany silver pieces.

MARK MINICK

Minick Interiors, Inc.

" I 've often heard that your decorator is just as good as your psychologist," says Mark Minick, only half joking. "Clients tell us way more information than we really want or need—as much as they'll tell a shrink, if they have one." That's why Mark believes that an ability to sort and edit all that information, in order to understand what someone really wants, is such an important part of his job. "And I have a great ear for listening."

Mark is a self-taught designer who first got a taste of the trade when he took a delivery job for a local furniture store, then moved to floor sales, which led into design. But as a native of Americus, he's been surrounded by great traditional Southern buildings his whole life. And though he has worked in many modes, the plantation style remains his personal favorite.

"I do enjoy being here in the 'deeper South'—deeper than Atlanta, I mean," he says. "I'm involved in a lot of historic renovations, and enjoy working with architects on preserving these older homes." And reviving old buildings isn't something Mark only does for a day job. He recently purchased two buildings in Americus' historic downtown, the 1907 Alison Building and the old city hall and fire station, which was built in 1887. He's begun a renovation project that will adapt them for use as both retail and residential spaces, with a top floor apartment for himself and his collections of blue and white porcelain and ornate old sterling.

"This business does consume you," Mark admits when asked how he pampers himself. "A fun day off for me is going through a flea market. My favorite is the Scott Antique Market. But wherever I'm traveling, if I see any kind of market or antique mall, I'll stop. You never know what you're going to find."

BOTTOM LEFT A den in a Harsten Lake home in Perry, Georgia. The heart pine surrounding the fireplace was salvaged from an early 1800's home in Milledgeville. The mantle is topped with wonderful 18th century Staffordshire dogs.

BOTTOM RIGHT This Mexican tiled Florida room overlooking a lake is filled with hunting trophies from around the world, including a mountain reed buck, an ostrich, and even a puffin.

FACING PAGE A receiving parlor in an early 1830's landmark home handsomely appointed with period antiques and family heirlooms.

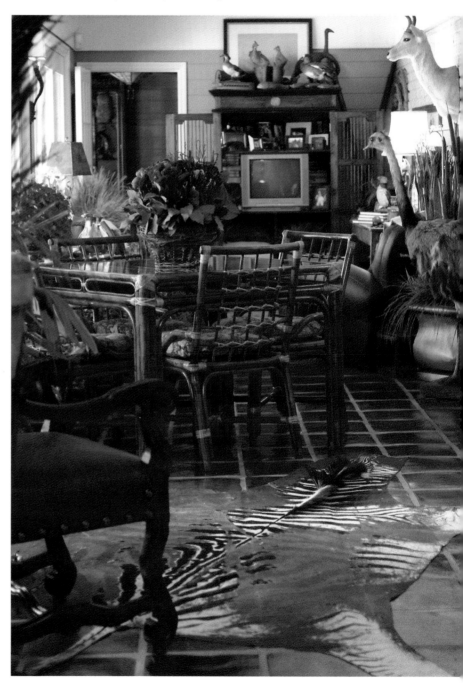

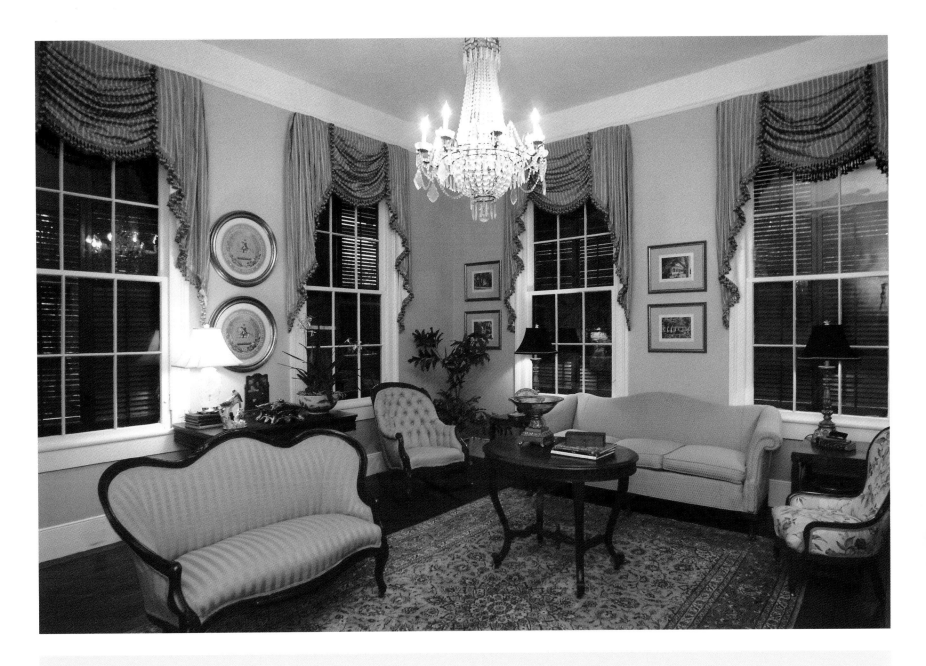

More about Mark ...

IF YOU COULD ELIMINATE ONE ARCHITECTURAL
ELEMENT FROM THE WORLD, WHAT WOULD IT BE?

Fluorescent lighting.

WHAT'S THE MOST BEAUTIFUL GEORGIA HOME YOU'VE SEEN?

Iris Court in Moultrie, a classic 200-year-old house that has undergone very little change.

WHAT COLOR BEST DESCRIBES YOU, AND WHY?

Red. I'm passionate about what I do.

YOU CAN TELL I LIVE IN GEORGIA BECAUSE...

I say "ma'am" and "sir"—and "ya'll come back and see us!"

YOU WOULDN'T KNOW IT BUT MY FRIENDS WOULD TELL YOU I'M...

A workaholic. But this isn't only my business,

it's my love.

MINICK INTERIORS, INC.
Mark Minick
109 North Jackson Street
Americus, GA 31709
229-931-0311
FAX 229-931-0312

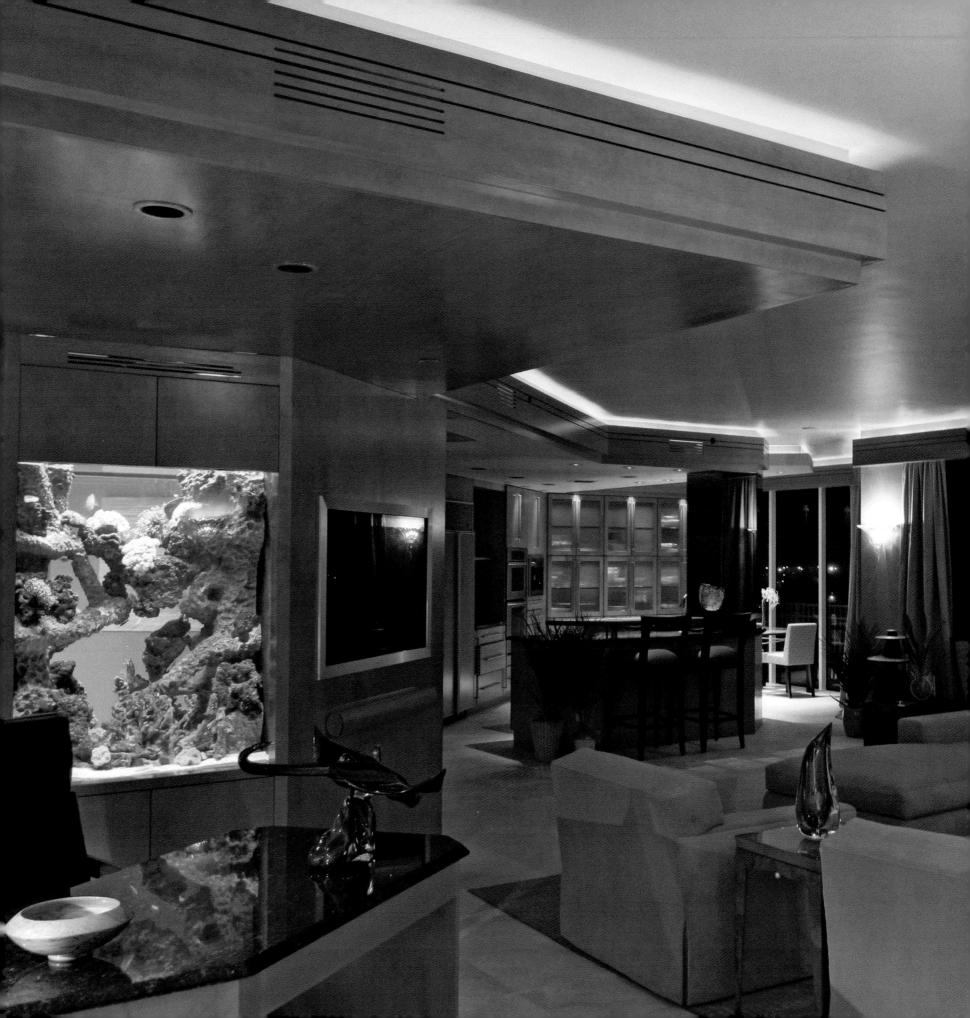

LEFT The ocean view was the inspiration for the scheme of this condominium remodeling project. Open space, custom cabinetry, and clean contemporary lines provide a serene backdrop for colorful art.

RIGHT This dressing area features a custom designed table, mirror and chair. The lamp shades are hand-painted. The nature theme is emphasized with the leaf textured walls and pine flooring.

STEPHANE MORRISS

Smith Morriss Designs

"My basic philosophy," says Stephane Morriss, "is that an interior design must work for the client. Every designer must find a way to understand what a client wants." Stephane has developed a lifestyle profile, similar to those used in business leadership training, which correlates personality traits with taste in décor.

"I believe in the Response-Motivated or Research-Based design approach," Stephane says. "People have both psychological and physiological responses to color, aroma, music, art and a connection to nature." She has every member of a client firm or family take the profile, and answer a questionnaire that reveals how they want their rooms to function. She also asks them to respond to a list of "emotional" adjectives describing how they would like for their home or office to feel.

"People really open up when they're asked, and get excited seeing their home become a part of themselves." In schools, Stephane emphasizes that the classrooms should become learning environments and in healthcare, the spaces should be conducive to healing.

Stephane is the owner of Smith Morriss Designs, a commercial/residential interior design firm that specializes in Response-Motivated design solutions for residential and corporate projects. She is a registered interior designer in Georgia and a professional member of the American Society of Interior Designers

SMITH MORRISS DESIGNS
Stephane Morriss
Member ASID, Registered Interior Designer
P.O. Box 943
Statesboro, GA 30459
912-682-2373

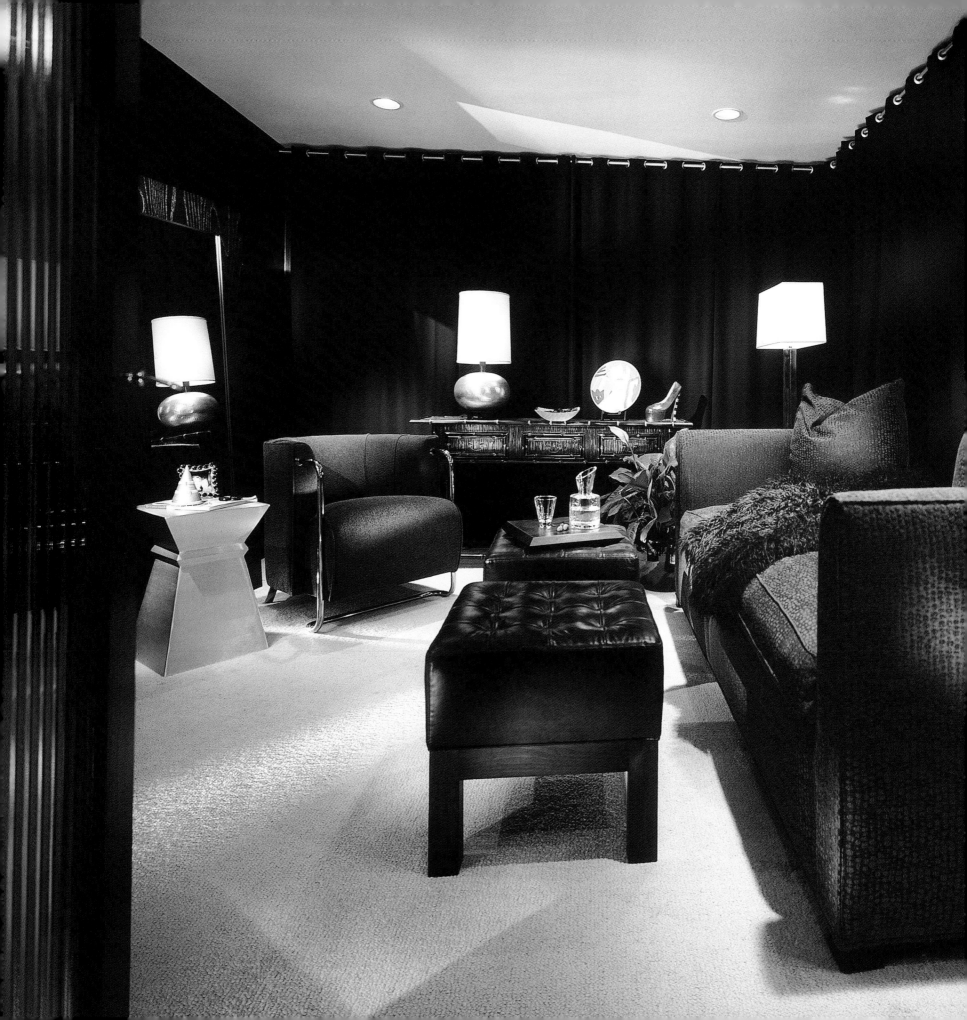

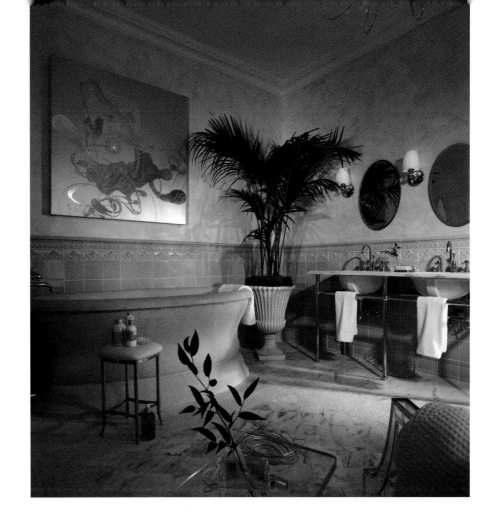

JACKIE NAYLOR

Jackie Naylor Interiors, Inc.

Jackie Naylor grew up in West Palm Beach, Florida, in a "neat home, that had possibilities" but was not particularly design-oriented. Her father, a plumber, was continually remodeling the bathrooms, kitchen and home in general. "He had vision," Jackie recalls, "and did a lot of unique things that I absorbed." In addition to that, Jackie did not realize until later in her life what an impact the elaborate architecture and lavish interiors of the grand homes of nearby Palm Beach would have on her approach to design. "Now I find I'm using so many of those elements," she says.

She calls her style contemporary, "but not hard core." She goes for comfort and warmth, not austerity. Jackie's own home, which she and her husband have lived in for 30 years, is traditional on the outside, but simple and uncluttered within. "I'm involved with so many people and design decisions," she says, "I need that kind

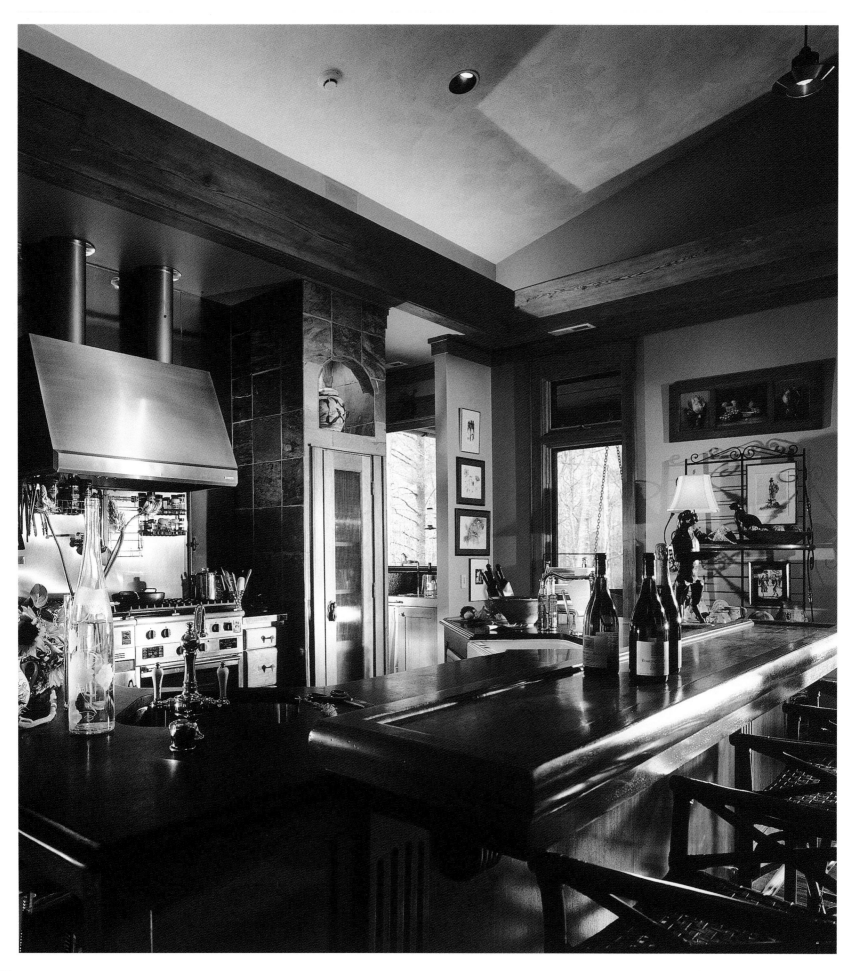

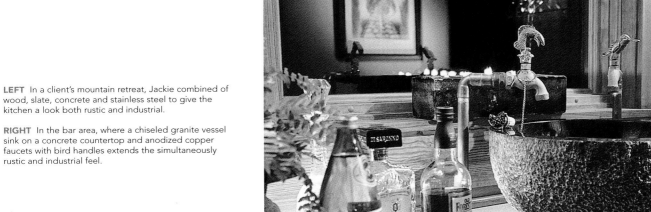

LEFT In a client's mountain retreat, Jackie combined of wood, slate, concrete and stainless steel to give the kitchen a look both rustic and industrial.

RIGHT In the bar area, where a chiseled granite vessel sink on a concrete countertop and anodized copper faucets with bird handles extends the simultaneously rustic and industrial feel.

of environment." She also retreats to their wooded backyard—the "secret garden" that is her passion and the final destination of the things she loves to collect, like pots, sculptures and bird feeders.

For her work, Jackie finds inspiration everywhere—in traveling, reading, from her peers in the field and from clients. "There isn't a day that goes by that I haven't filed a creative idea in my brain, waiting to be pulled out. I am constantly on the search for new ideas and inspirations. My reward is when those ideas can become reality and I can put them to use for my clients."

In the course of her career, Jackie has accumulated impressive credentials including certification as both a kitchen and bath designer and a professional member of ASID. Her work has been recognized within the profession through numerous ASID Design Excellence Awards, and with her election as president of that organization's Georgia chapter. Her interiors have been published in both local and national magazines, including *Atlanta Homes & Lifestyles* and *House Beautiful*, and in books.

She especially likes a client who will give her latitude to experiment, as in the recent project where she used marble, leather and stainless steel as flooring. "After the cabinets had been installed, uncovering the floors was a magical moment for all," she says. "We were speechless. It was so beautiful."

More about Jackie ...

WHAT'S THE HIGHEST COMPLIMENT YOU'VE RECEIVED PROFESSIONALLY?

Being recognized by my peers and elected ASID Georgia Chapter President for 2006-2007.

IF MONEY WERE NO OBJECT, WHAT WOULD YOU DO?

Travel. It's the source for many ideas and personal enjoyment.

WHAT COLOR BEST DESCRIBES YOU?

Purple, because I'm passionate about my work, play and life.

JACKIE NAYLOR INTERIORS, INC.
Jackie Naylor, ASID, CKD, CBD
Member ASID, NARI, NKBA
4287 Glengary Drive
Atlanta, GA 30342
404-814-1973
FAX 404-814-9030

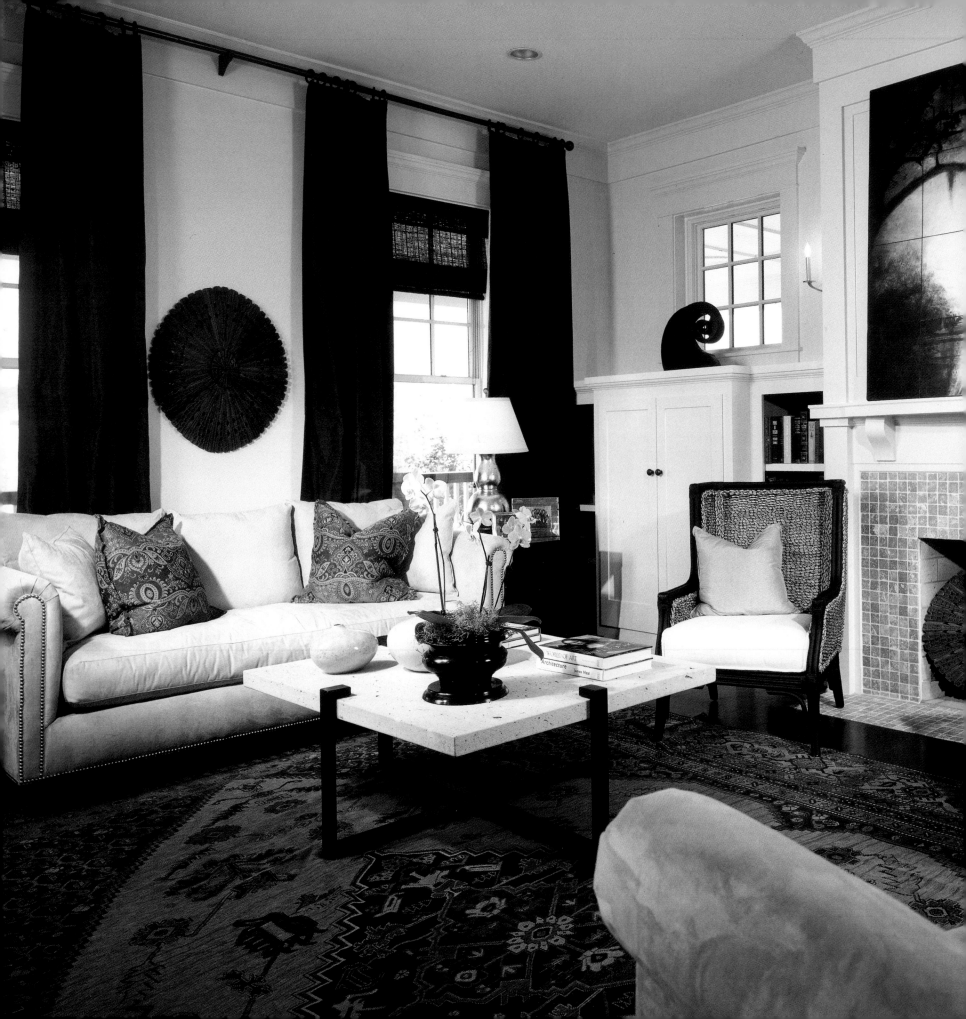

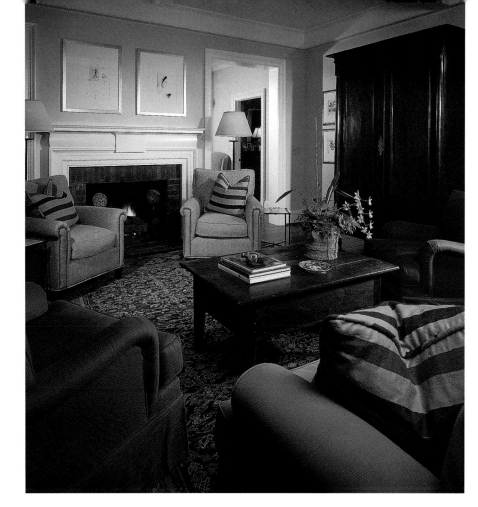

MARY MARGARETT NEVIN

Nevin Interior Design

Many designers create beautiful interiors, however, their rooms are not always comfortable," says Mary Margarett Nevin. "My interiors are eclectic, sophisticated and elegant, but they are also very comfortable and functional.

This is exemplified in Mary Margarett's own home. She combines many textures with two big leather sofas, silk and old tapestry pillows, woven pieces, old Persian rugs and contemporary art. "I don't want to be concerned if the dog sits on the furniture or if I run through the house with my riding boots on."

Though most of her clients are more established, some are just beginning to seek design services. "Investment pieces can be important, but if an alternative piece is well constructed and achieves the same effect, my clients will be offered that option."

Mary Margarett loves the creative process inherent in her work.

Inspiration appears no difficult task for her. Recently, while designing the Atlanta, Southern Living Idea House, she conceptionalized the entire first floor from a single fabric. "Being presented with a challenge holds special interest for me. Whether working with an awkwardly shaped room or an unusual sentimental piece, I am committed it making it look fabulous! "

NEVIN INTERIOR DESIGN
Mary Margarett Nevin
1791 Harper Street, Unit H
Atlanta, GA 30318
404-352-1127
FAX 404-352-0476

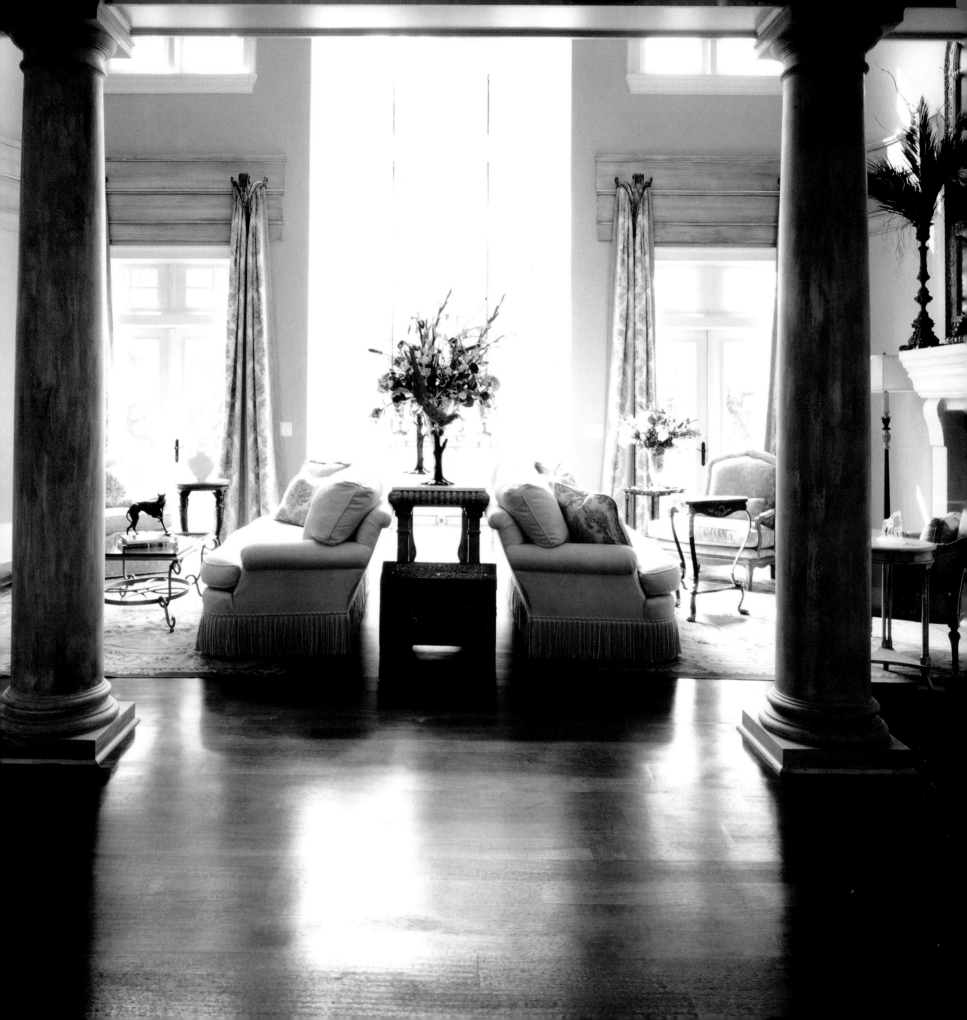

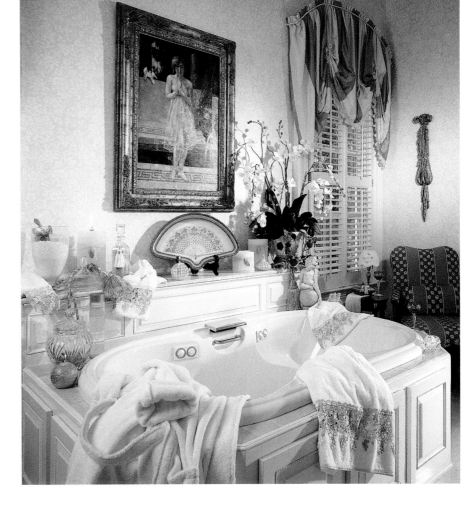

LEIGH NUNNERY

Leigh Nunnery Interiors

Leigh Nunnery grew up in a family with six children. "All we did was renovate and add on," she recalls. "That feeling of comfort, or needs being met, naturally led me into design."

Before founding her own firm, Leigh worked at Flacks Interiors. Though she does have a degree in design, she says "the greatest teaching I've received was from my two mentors—Gary Parker of Flacks Interiors, and Gary Jewell of The Jewell Touch. They taught me the love of accessories and of bath design."

Leigh does primarily high-end design of large, elaborate homes; for one client, she went to Italy to design the interior of a yacht, flying on to Istanbul to find carpets and accessories. But she describes her own home as "shabby chic, a little cottage in the woods." In contrast to all that lavishness, it's "like having a sorbet."

To Leigh, "the most important element of a project is the need and desire of the client. Her favorite kind of project is "when someone wants something very pure, true to period and authentic, and I have to do a lot of research." Her other great passion is her bed and bath accessories company, Lavendré.

LEIGH NUNNERY INTERIORS
Leigh Nunnery, Allied ASID, Associate IIDA
150 Waverly Hall Close
Roswell, GA 30075
770-650-0770
FAX 770-993-5844

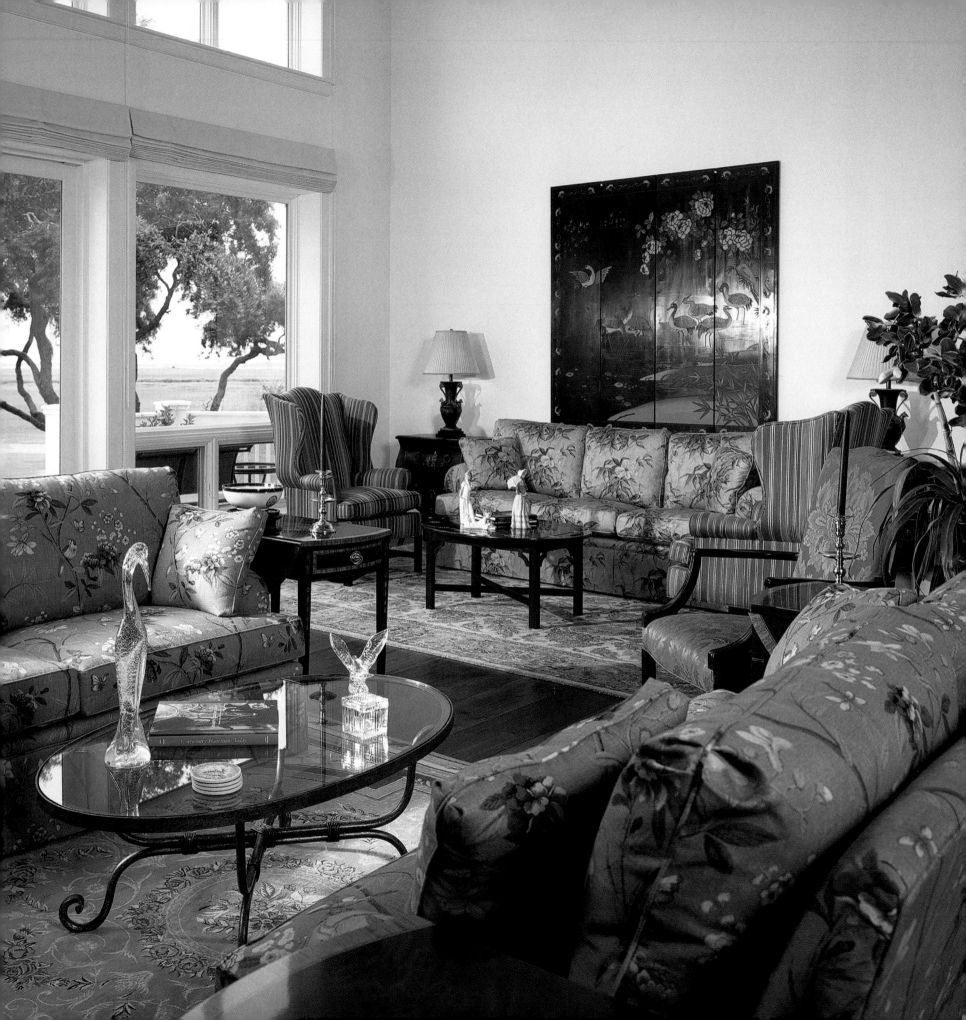

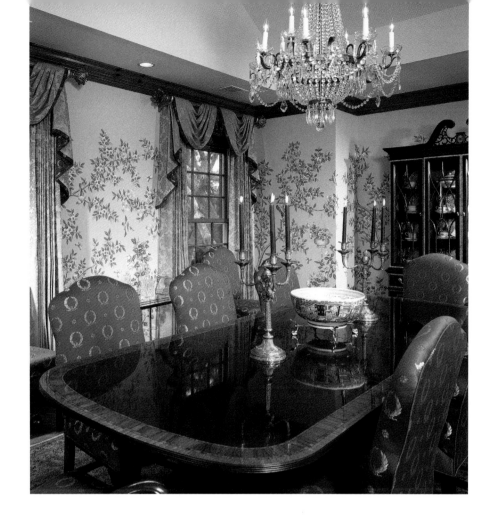

LEFT The natural colors of a spectacular coastal landscape are carried through into this airy space, which is furnished with pieces by Southwood and Councill.

RIGHT Hand-painted wallpaper and a crystal chandelier give this dining room its drama.

NORMAN OWENS

Interiors by Norman Owens

Norman Owens is a Southern traditionalist. "I can do contemporary design," he says, "but it's never pretty to me. I look to the grand houses of the South for inspiration. I have studied intensely to get to know the historic building forms that were done in Charleston and Savannah which are, basically, classical architecture." Still, he acknowledges that most people today want to have a casual, livable quality in their homes. "They like the best of the past but they don't want it quite as formal," he says.

And that's exactly what Norman provides, while taking pains to respect the architectural integrity of the house itself. "I don't do frills and ruffles," he says, preferring a more tailored look. But he also would not push a historically designed house in a contemporary, or too casual, direction. "You see these wonderful parlors in old Charleston houses with sea grass rugs and neutral colors," he says, insisting that

those elements are not historically accurate. He says that historic Southern interiors were more colorful than most of us think.

"Color is my thing," says Norman. "You will rarely see me do a monochromatic scheme. That doesn't necessarily mean all bold colors; I'll use subtle colors, too." A favorite project was a large house with a panoramic view of the Intracoastal Waterway. "We just took colors from out the window and brought them in, so that the house works in tandem with the environment. And yet the palette in each room is a little different, so that there are different moods."

Though he comes from a family in which, he says, nobody else was at all artistic, Norman just seems to have a natural talent. "I just have a natural sense of balance," he says, "and know what looks good." He doesn't limit it to interior design, either. He is also a professional silhouette artist, and the organist and choirmaster of his church.

TOP Subtle colors give this period-furnished room its relaxing feel.

BOTTOM Cherry tables and vibrantly colored Baker fabrics bring this room to life.

FAR RIGHT A classically simple Asian table and chairs give this dining area its serenity.

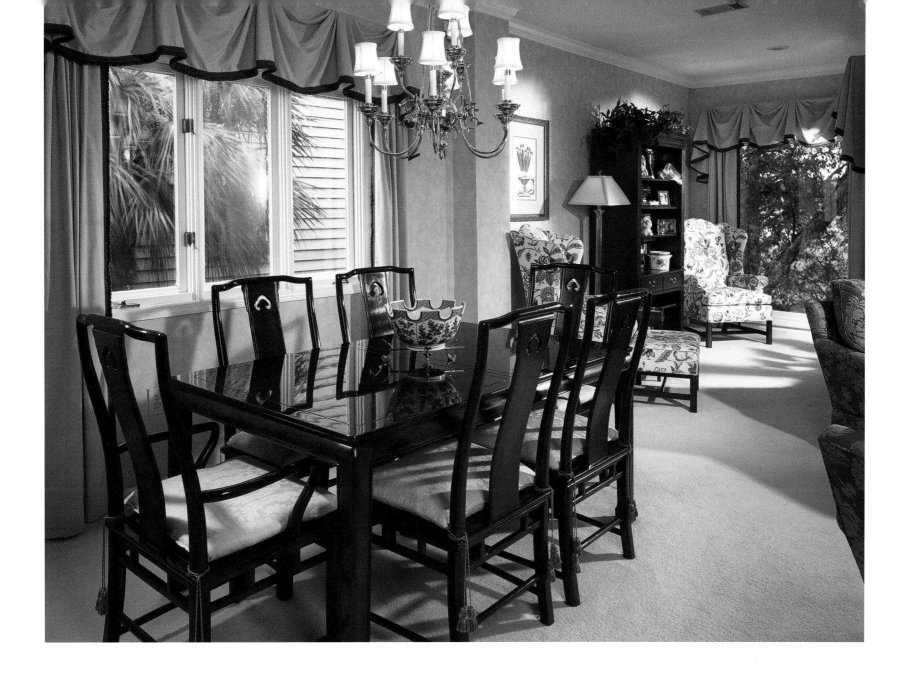

More about Norman ...

WHAT BOOK ARE YOU READING RIGHT NOW?

Charleston Architecture, 1680-1860.

WHAT'S THE ONE ELEMENT OF ARCHITECTURE YOU WOULD ELIMINATE FROM THE WORLD IF YOU COULD?

Buildings of modern design.

WHAT'S GEORGIA'S MOST IMPRESSIVE HOME?

The Owens-Thomas House in Savannah. It's classic in every detail.

WHAT ELEMENT OF A DESIGN PROJECT IS MOST FUN FOR YOU?

I love window treatments because they're right at eye level.

WHAT'S ONE THING MOST PEOPLE WOULDN'T SUSPECT ABOUT YOU?

I love to go camping.

INTERIORS BY NORMAN OWENS
Norman Owens
10 West Jones Street
Savannah, GA 31401
912-201-0605

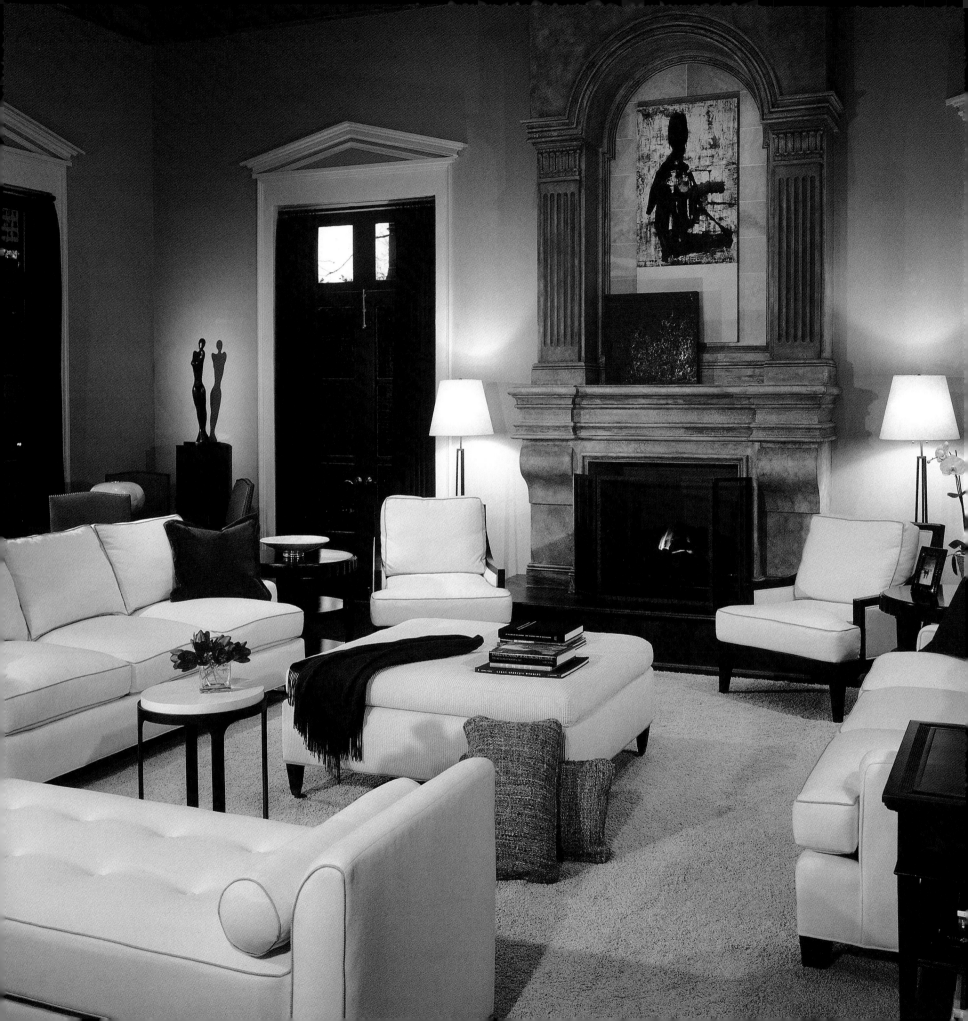

LEFT The geometric architecture of this voluminous ballroom in a historic Georgia landmark house, which was converted into a living area, is echoed in modern furnishings that add weight, simplicity and control.

RIGHT The industrial quality of this downtown Atlanta loft is further expressed in a palette of silver and gunmetal. Steven designed and constructed the steel mezzanine, accessed by a spiral staircase, to create additional living space. A custom oval dining table is paired with chairs and a leather banquette in gray.

STEPHEN PARARO

Pineapple House Interior Design, Inc.

Stephen Pararo started Pineapple House Interior Design in 1981, after earning degrees in architecture from Georgia Tech and interior design from Florida State. "Historically, the pineapple symbolizes grace and hospitality," he says, explaining the choice of name, "and the '80's were a very traditional period in design." Tastes change, and today many people are interested in cleaner, more streamlined interiors rather than Southern traditionalism. That suits Stephen fine. "Being able to experiment with various styles and trends," he says, "is one of the best parts of being an interior designer. I like them all. Design is a function of the setting. In addition to the client's taste and lifestyle, it's important to let the home and its setting speak to you about what would look best."

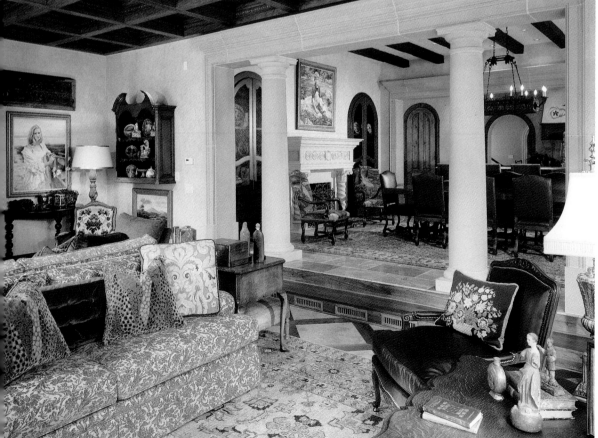

Pineapple House has grown to include five designers, 40 support staff, and a 35,000-square-foot Design Center that incorporates a carpentry room, drapery division, upholstery department and art studio. They can handle any part of the process—design, construction and interior build-out. "There are a lot of emotions and variables tied to the design of someone's home," he says. "Pineapple House understands that, and has built its reputation on follow-through." Stephen and his staff have done houses all over the United States and in Canada, and have won 19 ASID Design Excellence Awards since 2000. Their work has been published in *Architectural Digest*, *Elle Decor* and numerous other regional and national magazines.

Although he is comfortable working in many styles, including sleek contemporary, Stephen especially enjoys the historic houses of Savannah. "My favorites are the Owens-Thomas House and The Isaiah Davenport House. If you study them you can better understand the architecture of our era."

TOP LEFT A traditional design scheme gives this dining room sophistication but it remains a logical and functional space.

BOTTOM LEFT Steven and his colleagues at Pineapple House are fluent in many styles - eclectic, moderne, transitional, contemporary, rustic and, as here, the traditional.

RIGHT The spirit of Tuscany was the inspiration for this home in Ball Ground, Georgia, where antiques mix comfortably with contemporary pieces like the Lucite coffee table, which sits on a custom designed, handmade wool and silk rug.

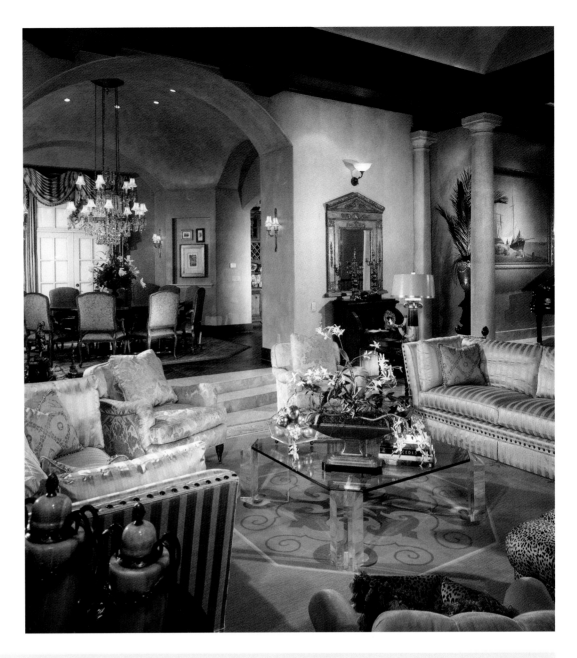

More about Stephen ...

WHAT PERSONAL INDULGENCE DO YOU SPEND THE MOST MONEY ON?

Homes. I've renovated more than a dozen and own three now—a primary residence in Atlanta, a mountain house in North Carolina, and a home in West Palm Beach. Next I'm looking in NYC!

NAME SOMETHING MOST PEOPLE DON'T KNOW ABOUT YOU.

I'm a history buff. It gives me insight into the ever-changing nature of design—and life.

WHAT COLOR BEST DESCRIBES YOU?

I consider color bias a bit odd. I love any color, if it's properly used.

WHAT STYLE OR PHILOSOPHY HAVE YOU STUCK WITH FOR YEARS THAT STILL WORKS?

Be there for your clients when they need you. As for style, that changes—and you'd better change as well.

PINEAPPLE HOUSE INTERIOR DESIGN , INC.
Stephen Pararo
Professional member ASID
Registered Interior Designer
190 Ottley Drive
Atlanta, GA 30324
404-897-5551
FAX 404-897-5244
www.pineapplehouse.com

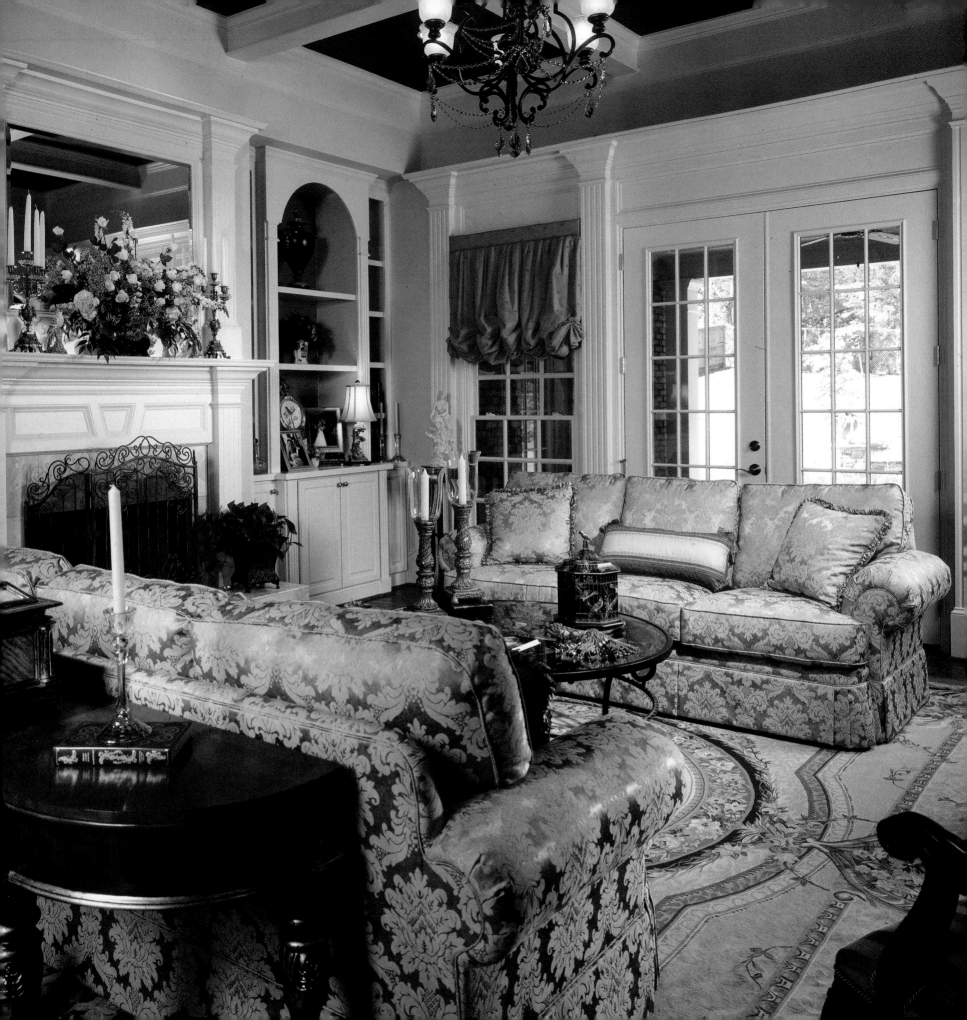

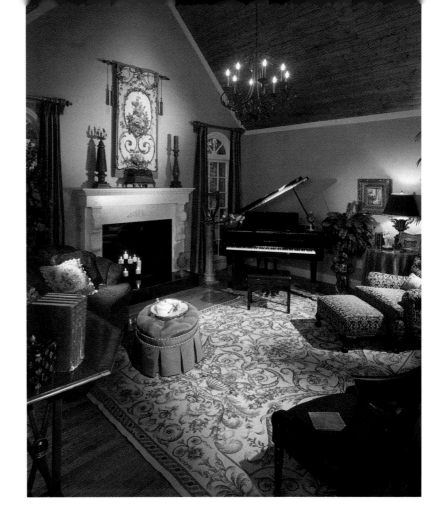

LEFT The grounding element in the plan for this room was the Aubusson carpet by Peel and Co. The damask on the C. R. Laine sofas complements its palette. Candelabras from Castilian Imports sit on a bronze and glass cocktail table by Interlude Home.

RIGHT "My client showed me a photograph that captured the essence she wanted," Vicki says, "and asked me to achieve it in this room." The transformation involved renovation, interior design and furnishing, starting with the client's piano.

VICTORIA POSEY

Legacy Design Group, Inc.

Victoria (Vicki) Aubel Posey is the founder of Legacy Design Group, Inc., a full-service interior design firm specializing in classic interior design, both traditional and contemporary. She describes herself as "the creative energy behind a group of talented artisans, carefully selected to achieve the desired results."

Vicki's company name reflects her design philosophy: Good design can become a legacy for future generations. She and her team pride themselves on working closely with clients to create unique interiors reflecting the clients' lives, styles and personalities. Their motto? "Timeless interior design, creating tomorrow's legacies..."

Vicki's career as a designer and design educator spans more than 25 years, first in her home state of Maryland and since 1993 here in Georgia. Her approach is based on a solid foundation of design theory

that is as ancient as classical Greece—the time-proven principles of rhythm, balance and proportion, along with an intuitive understanding of how one's eye moves around a room.

"We pride ourselves on working closely with clients," Vicki says. "I have sometimes been blessed with exceptional people for clients, and the relationship, being so personal, often results in clients becoming friends. When people love the final product, and feel their lives have been changed, it's tremendously rewarding."

LEGACY DESIGN GROUP, INC.
Victoria Posey
Member Atlanta Designers' Network, and
Interior Design Society
770-509-7917
FAX 770-509-5636
www.legacy-design-group.com

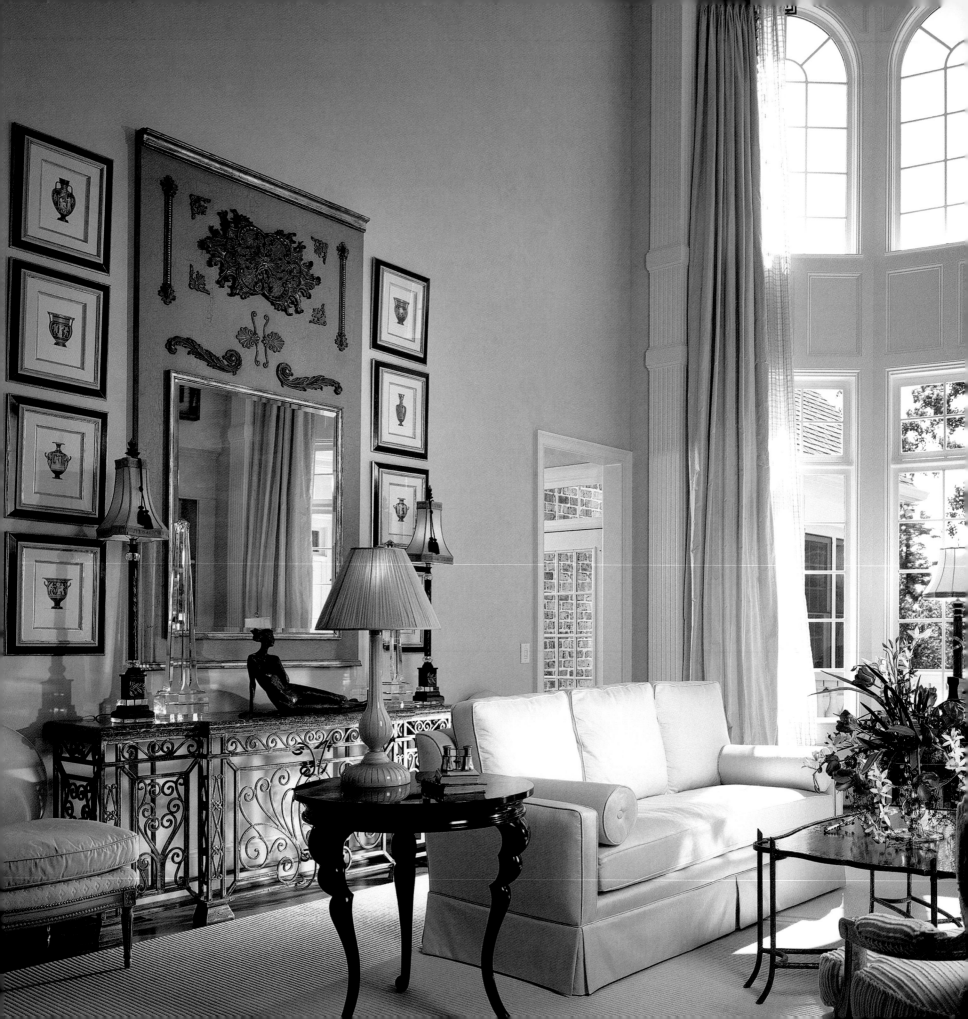

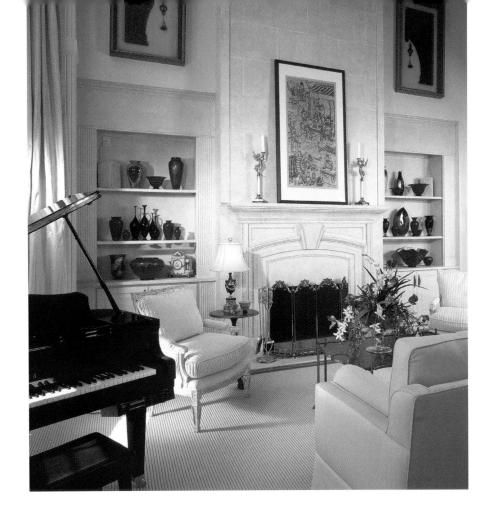

LEFT The living room of Charles and Debra Oglesby.

RIGHT Client's beautiful collection of red art glass is the focal point of living room shelves.

JUNE PRICE

K. L. McCall Interiors

June Price likes to stress the distinction between design and decorating. Design, she explains, is what underlies any successful project - "the space, the balance, the light, all those types of issues that need to be considered when you begin a room. Then comes the actual decorating - fabrics, colors, things like that. The basic principles of balance and scale always exist, whether for a traditional or contemporary room."

An Atlanta native, June fell in love with interior design as a child, when her mother's first designer came to the house. "I was just fascinated with her blueprints and furniture templates and everything she did." Since earning her design degree from the University of Georgia, June has worked on homes as varied as a log cabin in Jackson Hole, Wyoming, a historic Philadelphia townhouse, and a California-modern house in Newport Beach. "Being able to change

your style and scope has to do with good design," she says. "I'd be disappointed if you could say, 'Oh, that looks like a June Price interior.'"

June's ideal client "enjoys the decorative arts and likes to be involved in the design process. Our job is to create the background balance and scale, so that our clients' individual style works for them."

K. L. MCCALL INTERIORS
JUNE PRICE
Allied member ASID
349 Peachtree Hills Avenue,
Suite B-5
Atlanta, GA 30305
404-364-0628
FAX 678-904-8911

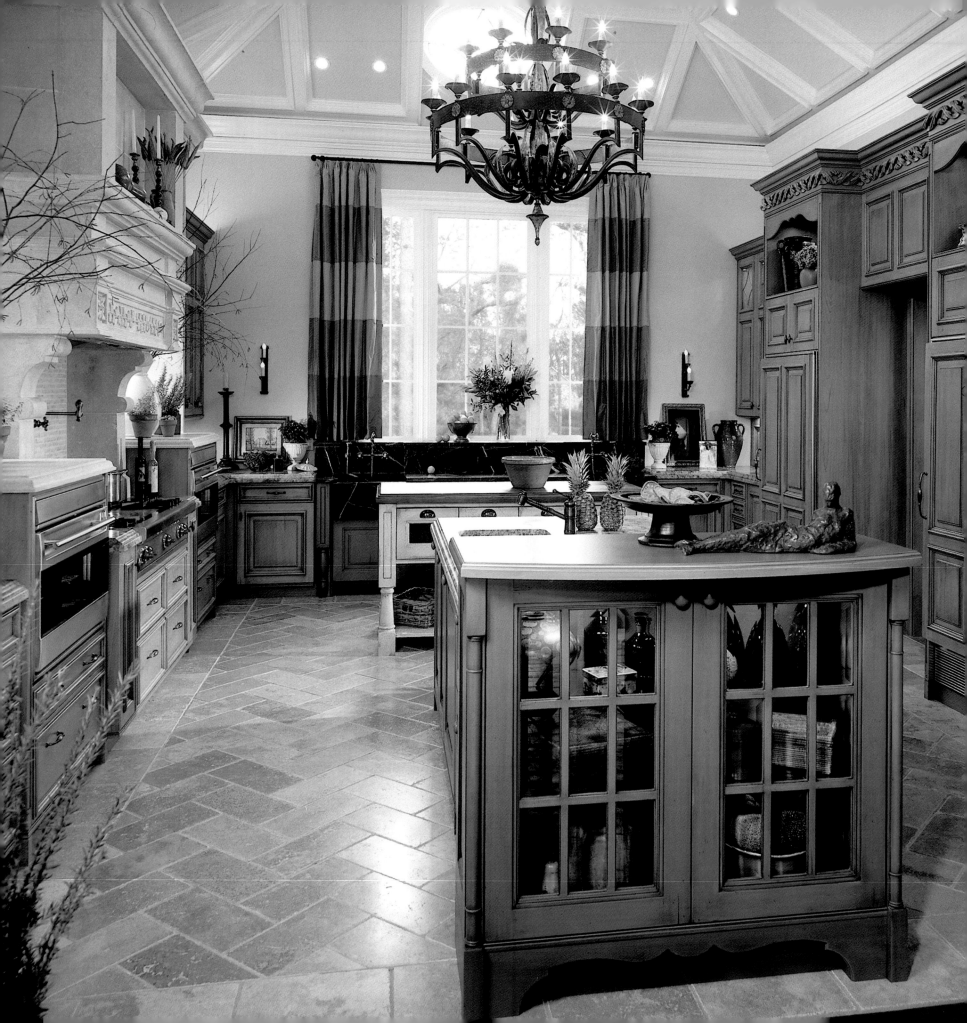

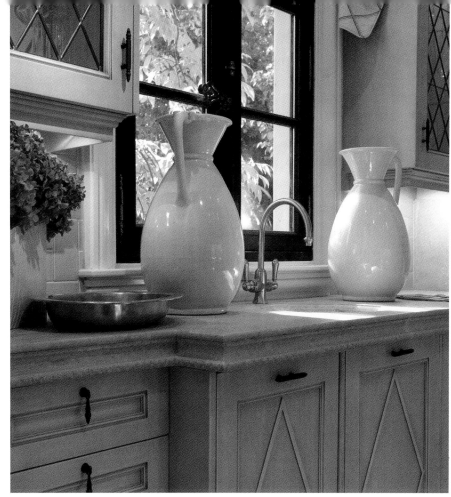

LEFT The kitchen in a grand home required the use of significant architectural elements in cabinet, hood and ceiling design. Multiple finishes and textures make the massive room intimate, functional and elegant.

RIGHT Furniture-like elements, such as this drop hardware and the diamond glass and cabinet pattern, are the key to creating spaces as unique as each client.

MATTHEW QUINN

Design Galleria Kitchen & Bath Studio

Matthew Quinn, co-owner of Design Galleria Kitchen & Bath Studio, has been an integral part of the interior design community for nearly 15 years. Along with a talented team of designers, Matthew has positioned Design Galleria Kitchen & Bath Studio as one of the country's leading showrooms offering award-winning kitchen and bath design, closets and custom cabinetry to the design community. Two of the finest lines available to the trade, Downsview and WmOhs, partner with Matthew to create timeless designs for which they are known.

Matthew attributes his company's enormous success to his commitment to excellence in every project. Recently, Matthew won first place honors in the National SubZero/Wolf Kitchen design competition and his work has been published in virtually every leading national home magazine including *Architectural*

Digest, Veranda, Southern Accents, Metropolitan Home and *Interior Design*, as well as local publications.

"My design philosophy of simplicity being the ultimate sophistication is revealed in each of our projects," says Matthew. Form and function are also an essential part of his design equation with a myriad of unexpected storage solutions. "I am privileged to collaborate with many of the country's most talented designers in the most amazing homes across this country." Simply dream it and Matthew Quinn and his team will design, create and implement your vision.

DESIGN GALLERIA KITCHEN & BATH STUDIO
Matthew Quinn
351 Peachtree Hills Avenue, Suite 234
Atlanta, GA 30305
404-261-0111
FAX 404-261-4822
www.designgalleria.net

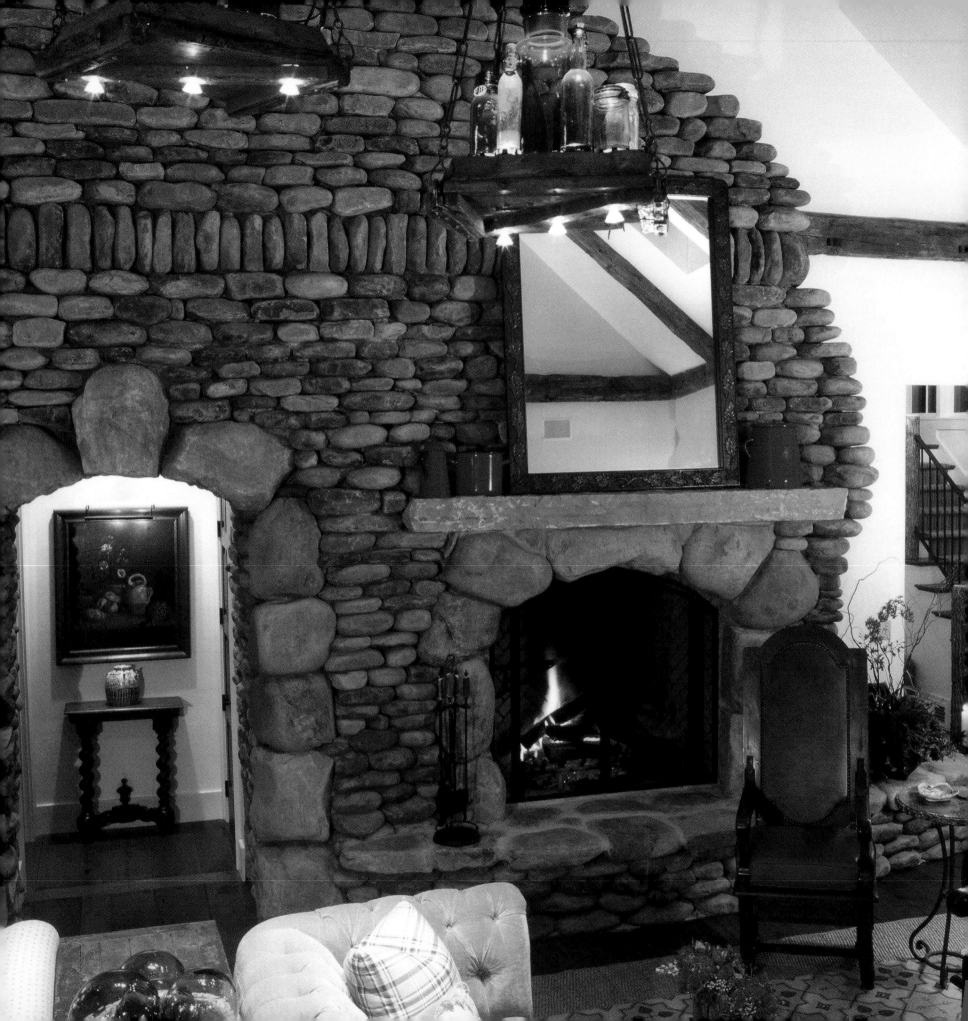

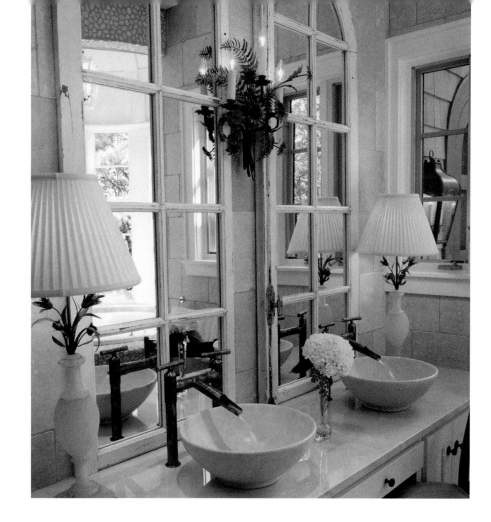

LEFT The 40 foot great room has a one-of-a-kind hand-picked river-rock fireplace that arches over a hallway into one of the guest bedrooms. Billy designed the light fixture with an antique German scale and a collection of French glass bottles lit from the bottom.

RIGHT This custom master bathroom creates a calm canvas of creams with bottocino stone sinks, antique alabaster lamps, and old French windows transformed into mirrors.

BILLY ROBERTS

Three, Inc.

Billy Roberts' design firm aptly named "Three" rises above traditional design firms by specializing in architecture, landscape architecture, and interior design. Billy says that his success has come "not only through our love of design but also from an egoless philosophy of working as a team." Three searches and finds the best and brightest talent, such as much sought after landscape architect, Kristan Moore and Kacee Pyles, an expert in preservation and historic interiors. "We distinquish ourselves by taking a step back and studying the whole residence, the gardens outside each window and how everything flows as a whole."

Billy's talent and love for design runs deep in his native Atlantan blood. His grandfather helped develop Tuxedo Park, the Atlanta neighborhood that set the Southern standard. His grandmother, Mary Lee Nunnally, to whom he credits most his talent, built and helped design the famous Nunnally house on Blackland that has been named "one of the most photographed houses in the country. Grandmom's style is timeless and I try to capture that in whatever we do." Billy describes his style as "post-classical with a modern twist," and describes good design as "something that gives definition and clarity, transcends time, and inspires generations living in and around it."

Besides his love of color, Billy enjoys working with his hand selected team of experts to bring about whatever wish a client desires. "When clients tell me they never dreamt we could achieve exactly what they wanted and more, it's the best feeling in the world!"

THREE, INC.
Billy Roberts
590 Means Street, Suite 200
Atlanta, GA 30318
404-872-3127
FAX 404-872-3128
www.threeinc.net

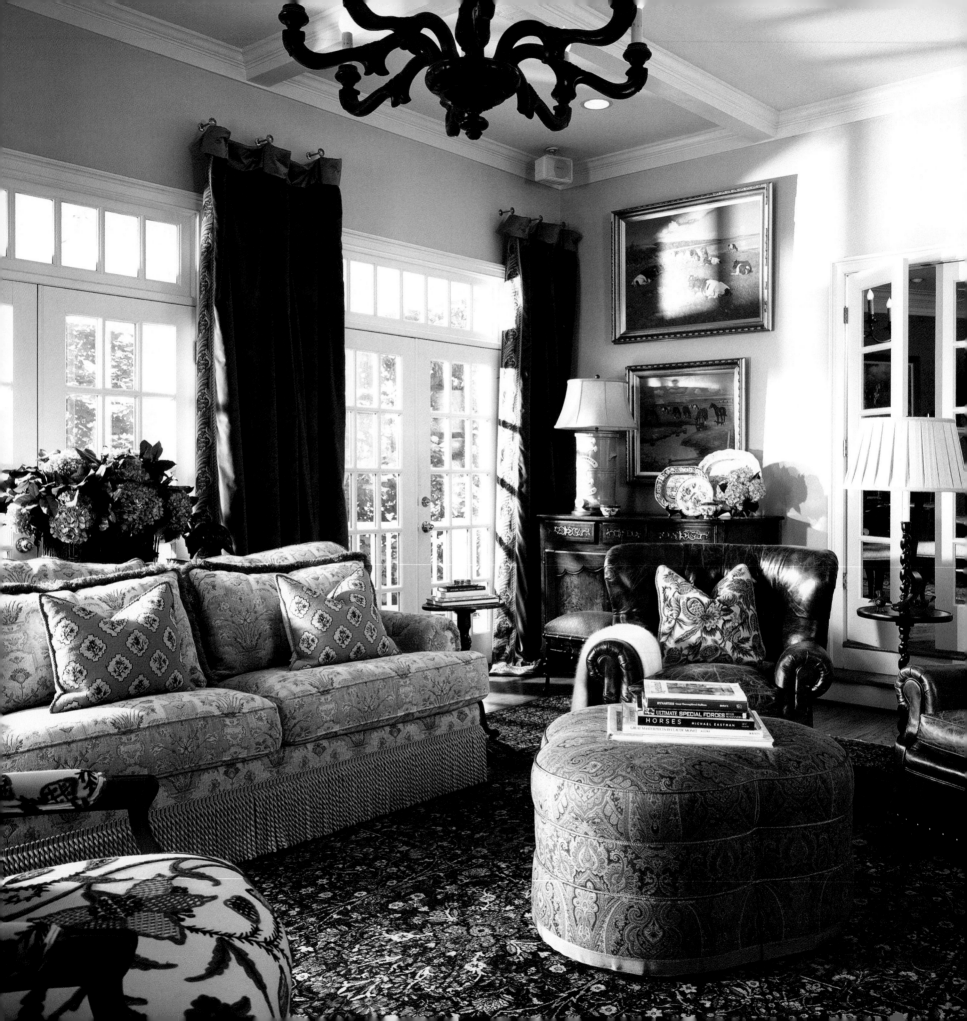

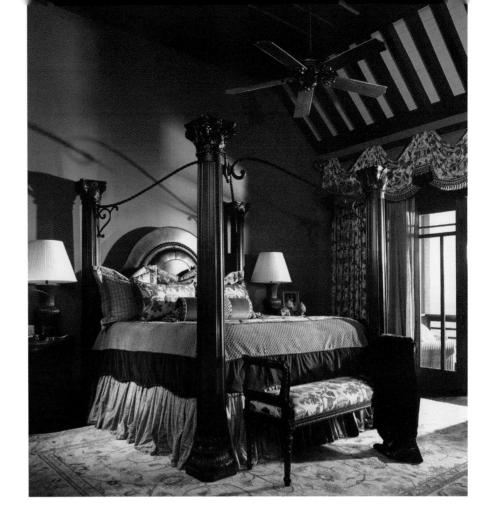

LEFT In this room, the antique rug was the inspiration for the design; the furnishings reflect the designers love of texture and pattern. Velvet draperies trimmed in a tapestry help to give the room an old world charm.

RIGHT The goal in designing this mountain retreat was to bring the outside in. This was achieved by reflecting the colors of nature with luxurious velvets and silks which adorn the room.

CLAY SNIDER

Clay Snider Interiors

"Stick with what you like," Clay Snider advises his clients, "no matter what trends come along." Clay likes to be given something definitive to work with. "A lot of designers want a client who says, 'Here's the house, just do it.' "But I like a client who brings some personality to the project."

Clay believes that personality is revealed through what people collect. He himself collects English antiques, folk art, primitive furniture and Imari china." Many of his clients have been young people who haven't yet begun collecting and don't give him a lot to work with in that sense. "I always encourage them to start collecting, whatever it might be." The choices they make help give direction to the design project.

Clay describes himself as someone who doesn't make excuses—and says that details are his favorite thing. "Whether I'm working on a ground-up project or a remodel, I make sure we don't neglect something. I wake up in the middle of the night and make notes. I'm always tearing through magazines and books, not so much looking for the latest trends, but to see what other designers have done as far as details go. I want to make sure I'm always offering the best."

CLAY SNIDER INTERIORS
Clay Snider, Allied ASID
397 7th Street
Atlanta, GA 30308
404-541-9495
FAX 404-524-8927

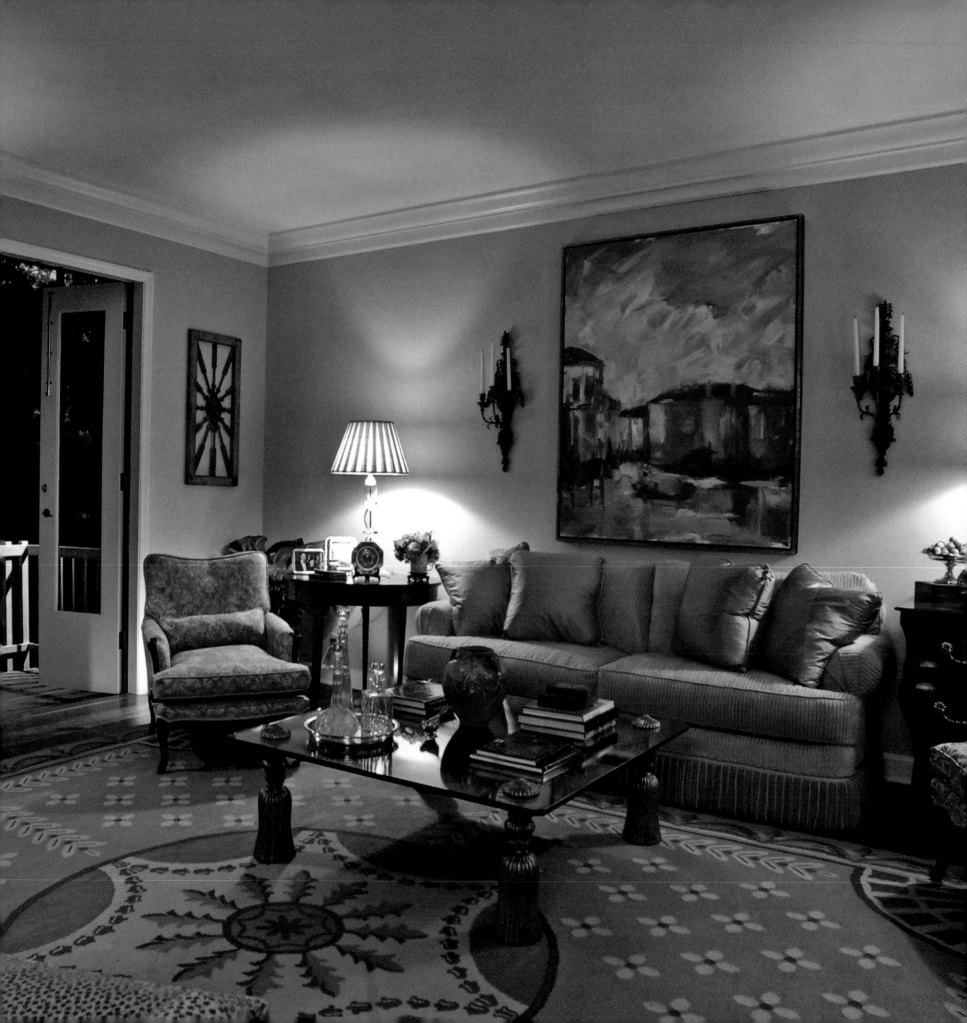

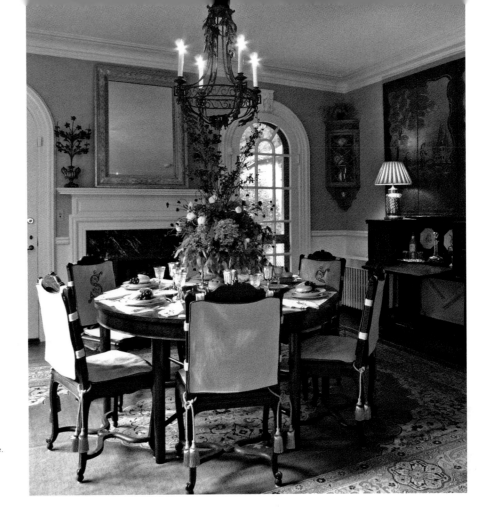

LEFT A bold Portuguese needlepoint rug inspired the rich tones Bonnie used in the home of Mr. and Mrs. Bruce Elliot. The impressionistic painting of Venice by Susie Pryor and the harlquin-pattern silk pillows pull the room together with verve.

RIGHT Slipcovered chairs lend a casual tone to this dining room, where a French screen painted with a pastoral scene hangs above a 19th century Italian coffer.

BONNIE STARR

Bonnie Edwards Starr Interiors

Bonnie Starr says that her approach to design is "less is more." True quality pieces should be allowed to stand on their own. Clutter only detracts from good pieces, and from the architectural integrity of the space as well.

Bonnie, a Macon native, decided as a young girl that interior design would be her career. She was inspired by her mother's wonderful decorator, a woman who seemed to be having so much fun with shopping expeditions to New York and lively conversations over cocktails. Bonnie decided, "I want to do that."

The interiors the decorator created for Bonnie's parents were traditional, and the time-honored style is still Bonnie's preferred one. But she enlivens tradition with contemporary flair and finds inspiration in unexpected places. She may even borrow an idea from the fashion

industry to use in a room. Some of Bonnie's favorite projects are renovations that require working directly with architects and contractors. She says, "I like the architectural part. Providing the right setting is so important. Putting even the finest things in the wrong space will cause the room to fall, but get the basics right and the room will evolve naturally."

BONNIE EDWARDS STARR INTERIORS
Bonnie Starr
102 Kittansett Court
Macon, GA 31210
478-471-7938
FAX 478-471-7799

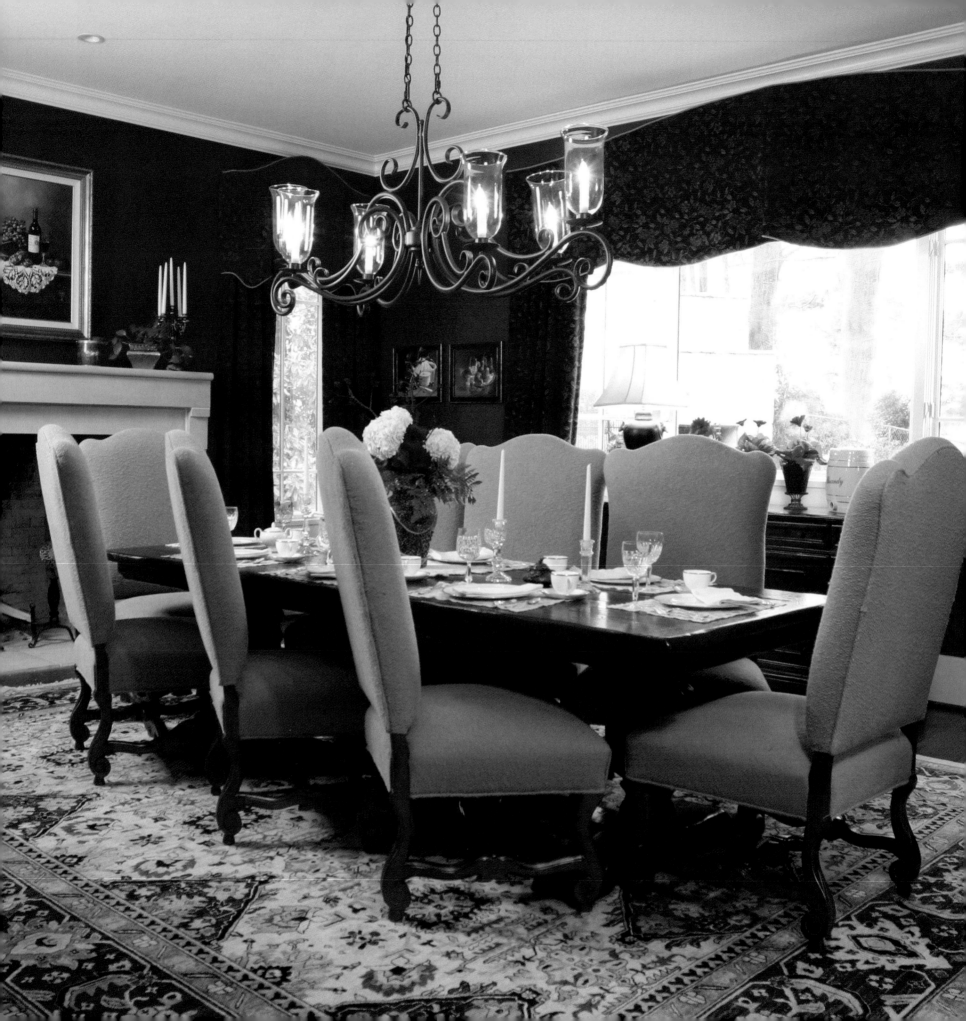

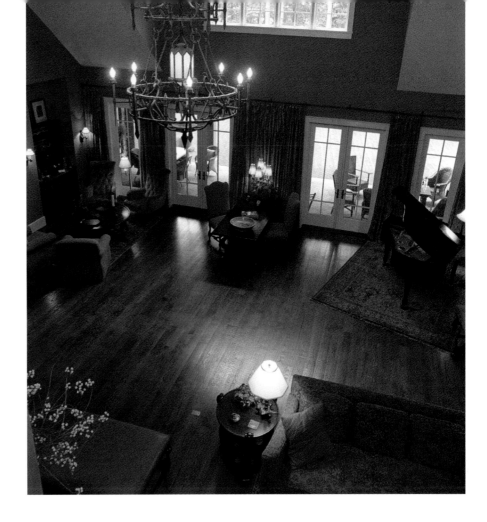

LEFT Walls glazed in Tuscan red and a uniquely vivid Pesahawar rug give this dining room intense appeal, while the Elizabethan-style trestle table and custom limestone mantel lend a sense of gravity.

RIGHT The vast Great Room of this Adirondack inspired home is enhanced by muted earth tones, crushed velvet, wool, and chenille fabrics, and boasts five distinct sitting areas. A custom wrought iron and bronze double tiered chandelier adds to the drama of this spacious room.

MADELINE SUGERMAN

Interspace Interior Design, Inc.

The synthesis of an interior design career spanning 20 years, with an academic background and bachelor's degree in fine arts, has profoundly influenced Madeline Sugerman's work. She approaches each room as a painting in progress combining the architectural elements and the clients' preferences with a strong focus on the elements of line, form, color, space, light, texture and material. It seems to work—at least according to one client, Dale Russell. "Madeline is more than an interior designer to us, she is a psychic. What makes her so special is that each room is an extension of our dreams, not just a cookie cutter design any designer can do. She listens, or maybe reads minds—we were never sure—then takes your images and creates a room that perfectly matches your tastes and personality."

From the time she was a small child sitting in the living rooms of family and friends, Madeline would visualize how to reposition the

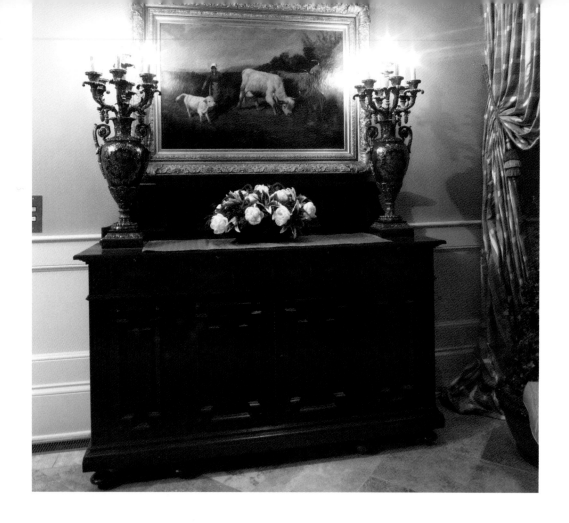

furniture, change wall colors, and even move doorways, windows, and walls. Madeline would accompany her parents to auctions, antique stores, and flea markets where she gained a passion for "the hunt" and procurement of beautiful objects. Madeline's discerning eye enables her to find the proverbial diamond in the rough as well as the finest antiques and art. She is never quite certain where a newfound treasure will be placed but somehow they always seem to find the perfect home.

Madeline's own home is a mirror image of the designer herself. A mélange of modern and antique furniture, family heirlooms, and, in particular, a collection of 18th century pastoral oils, creates her sanctuary.

As one of a select group of Georgia Registered Interior Designers, Madeline and her firm, Interspace Interior Design, Inc., provides the full range of commercial and residential interior design services from the conception phase to the final details, as clients Phil and Stephanie Hill attest. "From the beginning, your assistance in the design of our home with our builder, architect and cabinet maker—we have been blessed with such professional attention. The experience was not only a pleasure, but also one that carries our recommendations to any others embarking on such a project with you—the results are magnificent."

Madeline's philosophy of interior design encompasses the creation of personalized spaces that are livable, loveable, and beautiful, thereby instilling a sense of timeless harmony and enjoyment for her clients.

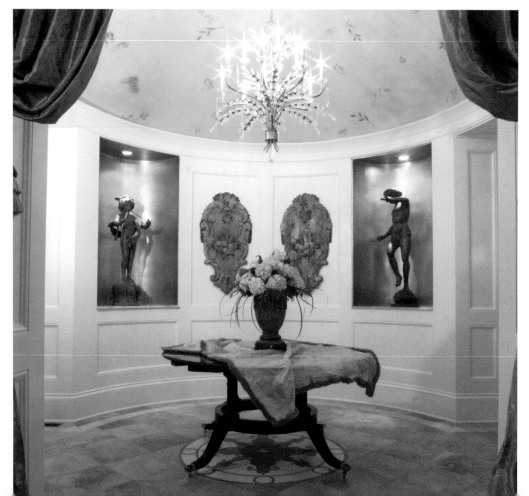

ABOVE LEFT Madeline created a classic tableau with this circa 1880 French Adams-style walnut sideboard, the pair of porcelain candelabras and "The Highland Family," a 19th century oil by Joseph Denovan Adam RSA RSW.

BELOW LEFT Silk draperies, 18th century cartouche panels and bronzes in this grand rotunda reveal Madeline's expertise at marrying fine art and antiques. The dome and niches are silver- and gold-leafed. An alabaster vase sits atop a custom mahogany English table.

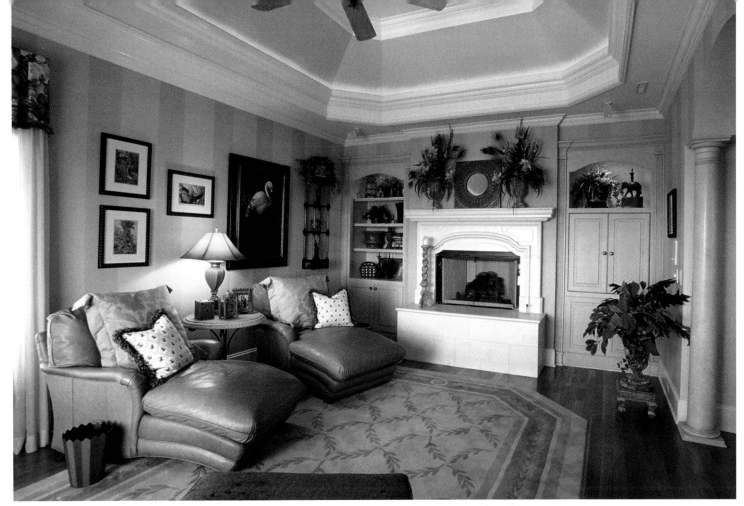

ABOVE The serenity of a private master bedroom suite is reflected in the faux painted walls of taupe and gray. The far wall is graced by a limestone fireplace with an artist applied glazed finish. An octagonal custom wool rug enhances the caramel hues of the oversized leather chaises. Original Audubon prints and antiques from around the world create a special tranquility.

More about Madeline ...

WHY DO YOU LIKE DOING BUSINESS IN GEORGIA?

Although my projects take me throughout the country and each region and/or city has a charm and character of its own, I am always happy to return to Georgia where both the climate and the people are warm and genuine.

WHAT IS A SINGLE THING YOU WOULD DO TO BRING A DULL HOUSE TO LIFE?

Paint it! Color plays such an important role in people's surroundings and thereby their emotions that I can think of no other single change made in a home that creates such a significant difference.

NAME ONE THING MOST PEOPLE DON'T KNOW ABOUT YOU.

I don't think people know how sensitive I am beneath my professional demeanor. This sensitivity enables me to connect with my clients on a more intuitive level, resulting in interiors that clients seem to immediately find warm and inviting.

IS THERE ANYTHING YOU WOULD LIKE TO MENTION ABOUT YOURSELF OR YOUR BUSINESS?

My projects are located throughout the United States and range from a 12,000-square-foot "Adirondack style" residence to mountain and beachside vacation homes and commercial offices. We are excited about the upcoming challenge of designing the offices of a new movie studio in Beverly Hills, California.

INTERSPACE INTERIOR DESIGN, INC.
Madeline Sugerman
Registered Interior Designer
Allied ASID, Associate IIDA
325 Morgan Hill Court
Alpharetta, GA 30022
770-623-4964
FAX 770-813-1229
www.interspaceinteriordesign.com

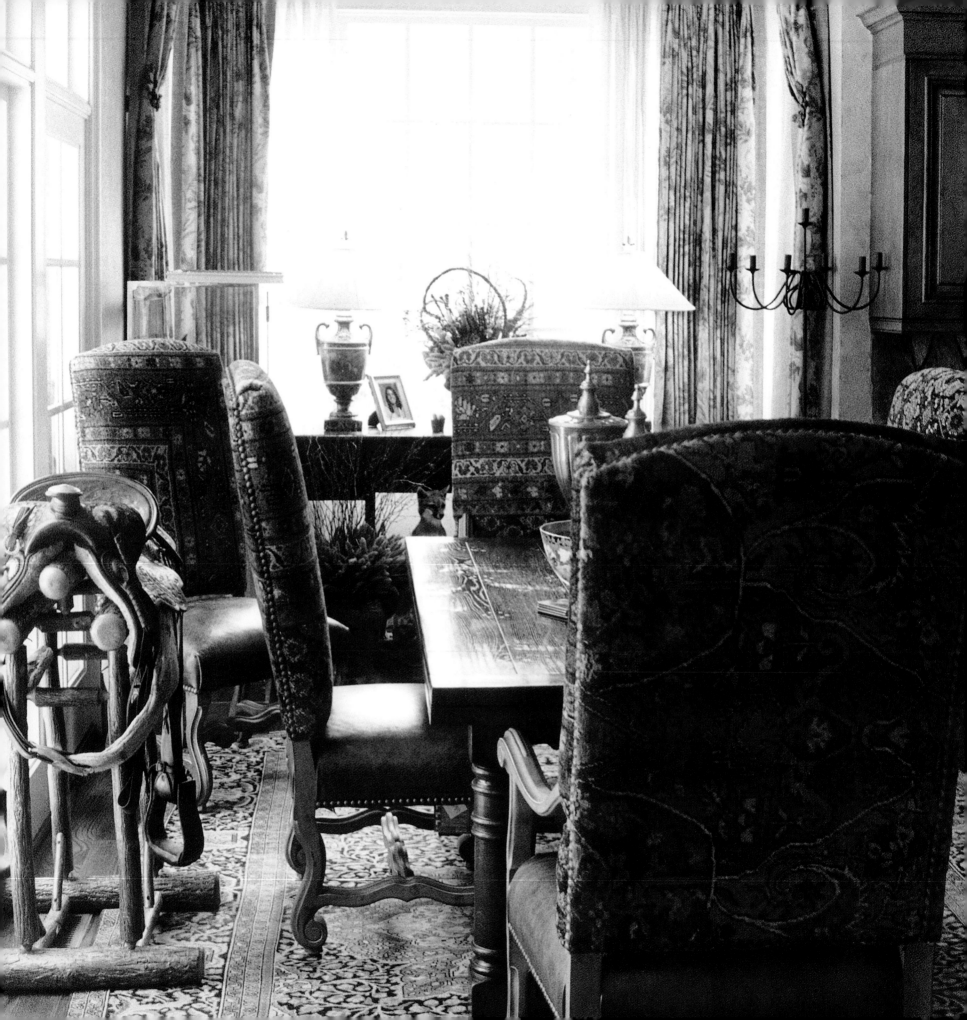

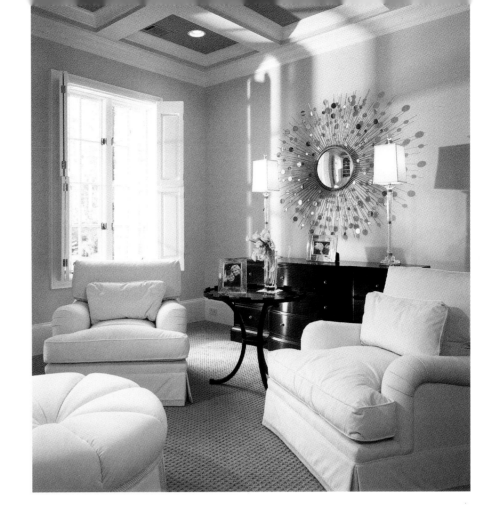

LEFT Mark sells more Ralph Lauren furniture than any other interior designer in the U.S. "It's great design, and even greater quality," he notes.

RIGHT The sitting area of this master bedroom is focused on the constellation mirror, chest and caste table by Thomas Pheasant for Baker.

MARK SUNDERLAND

Beverly Hall Furniture Galleries

Mark Sunderland is an unapologetic Anglophile. "My personal style," says the Pennsylvania native, "would have to be described as 'English cluttered.'" He's also a passionate collector of things to do with—and things formerly belonging to—the late Duke of Windsor, whom he refers to rather familiarly as "Eddie the Eighth." The walls and vitrines of Mark's house are loaded with Windsor-commemorative china, for instance, and he was an active bidder a few years ago when Sotheby's auctioned off the Windsors' things. Among other items from that sale, he proudly displays the Duke's backscratcher.

You can probably tell from all this that Mark has a quirky sense of humor. Ask him if he's won any awards or special recognition and he'll answer, "Other than being knighted last year, not much." Ask

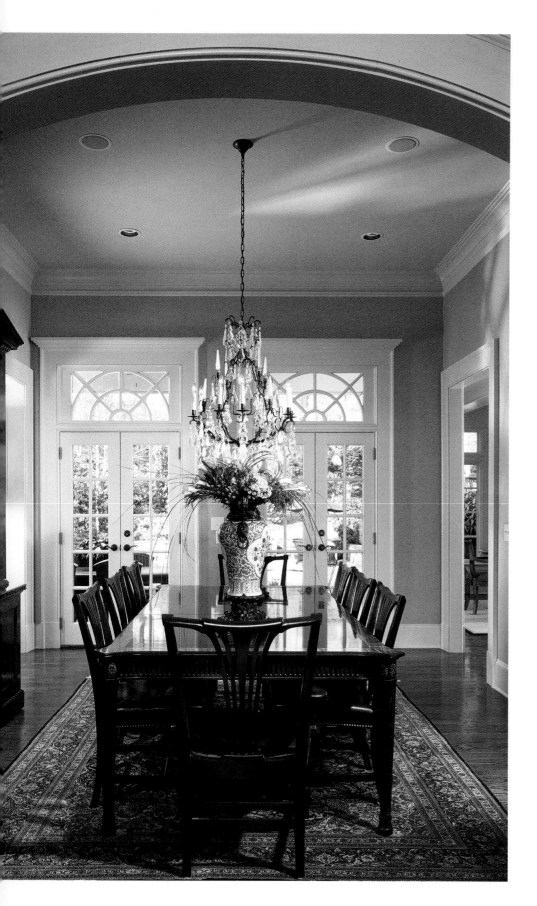

him who his hero is, and he'll say, "Besides Ralph Lauren and my father, SpongeBob Square Pants."

Mark came to interior design by an unusual route. He spent 20 years in the retail clothing industry, finally being tapped to help open the Atlanta Polo store. Two weeks before the shop opened, he was asked to take on management of its home department. "Because I was not trained to be a decorator," he says, "I found that I actually knew how to get inside customers' heads and empathize with their questions and confusions about what goes into putting together an interior."

LEFT Mark always like to use blue and white porcelain in almost every house. Here, large urns with bronze bases and lids regally hold Chris Horak's floral artistry.

BELOW A wonderful, burl-walnut reproduction secretary from Beverly Hall Furniture Galleries works well with the client's period pieces and family heirlooms.

RIGHT The furniture and lamps in this handsome dining room were designed by Jacques Garcia for Baker. The silk sheers are from Ralph Lauren.

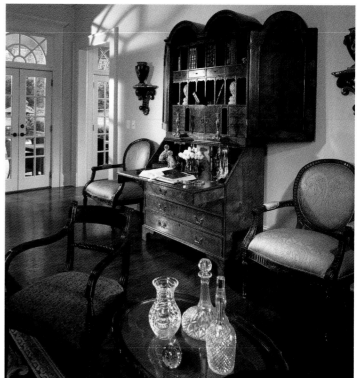

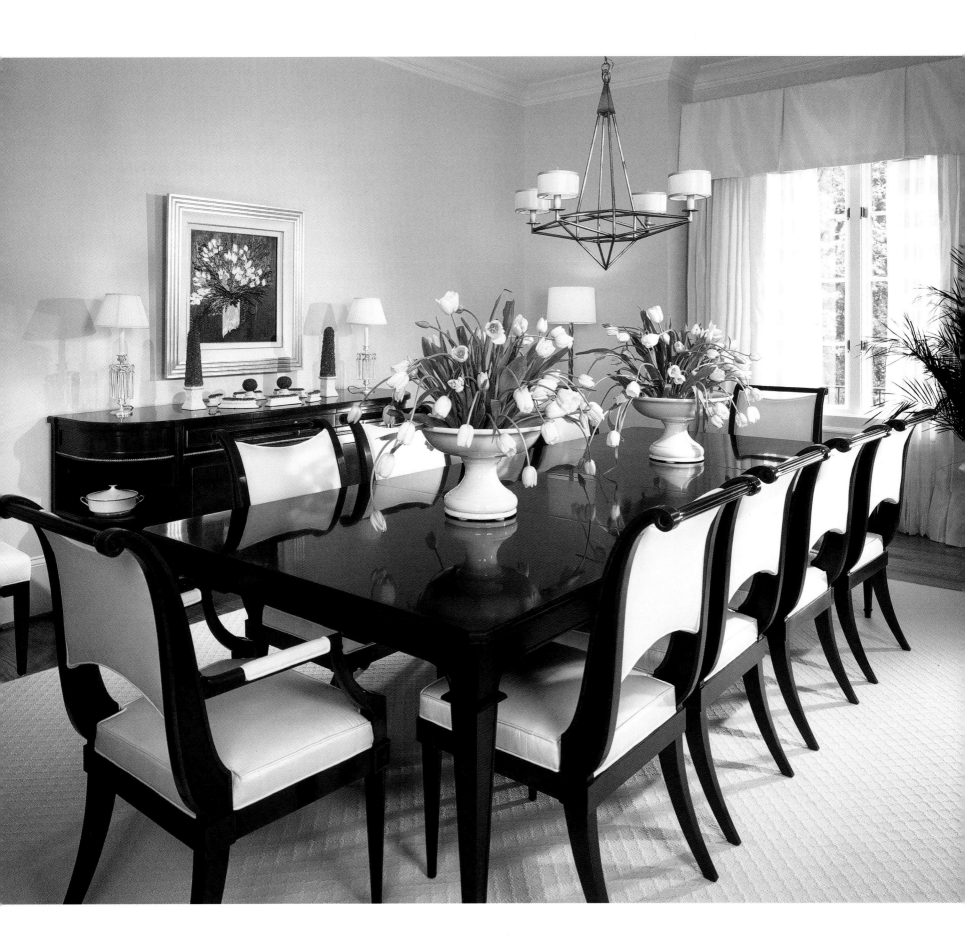

"Interior design isn't rocket science," he says, "and I feel an obligation to make it easy for clients to understand." He's also glad to be practical about priorities and budgets. Coming from a working class background himself, he appreciates value. "You might not really need to buy $150-a-yard fabric for the guest room curtains," he suggests, "and instead concentrate that punch in the public spaces where it will really be appreciated."

Mark's understanding of how people relate to clothes and dressing themselves also gives him a key to understanding how they want their homes to look. "I can tell a lot about you from what you're wearing," he says. "And I often ask new clients if I can look in their closets," to find out more. Clients who have put together collections of art are his favorites to work with, and he takes another set of clues about their desires from their collections. "I don't just match the furniture or fabrics to the art. But the art is still a good starting point. A client may not have a clue about sofas and rugs, but their art tells me a lot about what they want to see in their houses."

And surely his background in the fashion world is what lies behind his understanding that while styles appear to forever be changing, "there are always the constants. I like bringing people back to what they may think went out of style —but is actually timeless."

"As a Yankee," he says, "I can honestly say the true Southerners really care about their homes and gardens. Gentility is alive and well in Atlanta."

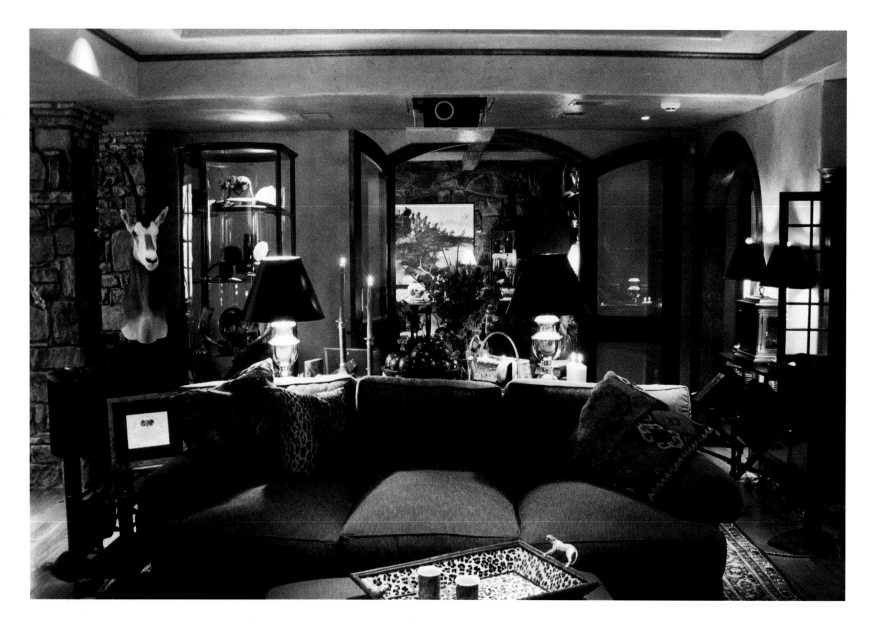

LEFT This media room is all about comfort. Marked searched high and low in England to find the perfect antique mahogany display cases.

ABOVE RIGHT "I designed my kitchen with a step down into the dining area, another step down into a sunroom which steps down again to the gazebo," Mark explains.

BELOW RIGHT Here, the bookcase, in yew, is by Trosby of England, the French bergeres are by TRS and the down-stuffed sofas are by Baker. The hand-knotted reproduction Aubusson is by Windsor Rug Galleries.

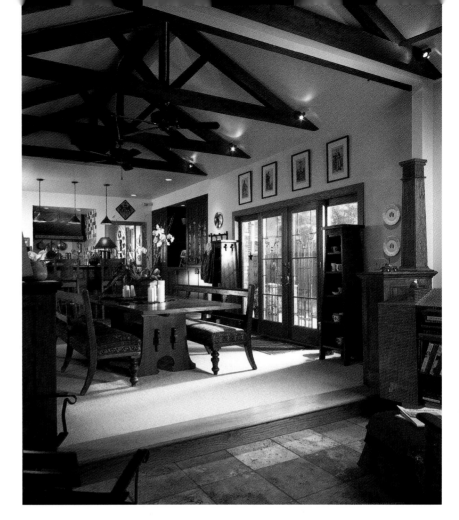

More about Mark ...

WHAT IS THE MOST EXPENSIVE TECHNIQUE YOU USE?

It's pricey, but I love applying silk fabric to the walls behind bookshelves.

WHAT'S A SINGLE THING YOU WOULD DO TO BRING A DULL HOUSE TO LIFE?

Add about 20 more lamps.

WHAT'S THE MOST CHALLENGING ASPECT OF A DESIGN PROJECT?

When she's going 18th century and he's going contemporary—and I have to play marriage counselor. But my listening skills let me find the solution.

YOU CAN TELL I LIVE IN GEORGIA BECAUSE...

I spent a small fortune on my screened-in gazebo. It's exquisitely woodcrafted, and I wouldn't give up until I located real copper screening.

IF MONEY WERE NO OBJECT I WOULD...

Travel the world on the QM2.

BEVERLY HALL FURNITURE GALLERIES
Mark Sunderland
Allied Member ASID
2789 Piedmont Road NE
Atlanta, GA 30305
404-261-7580

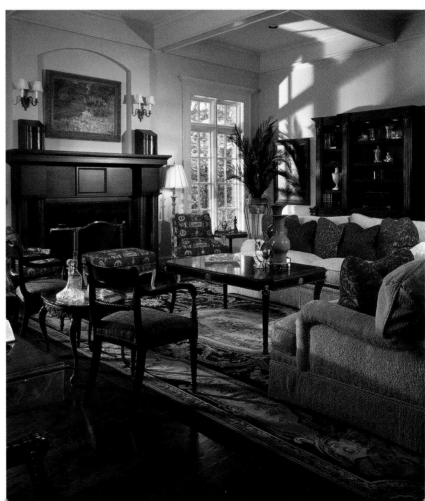

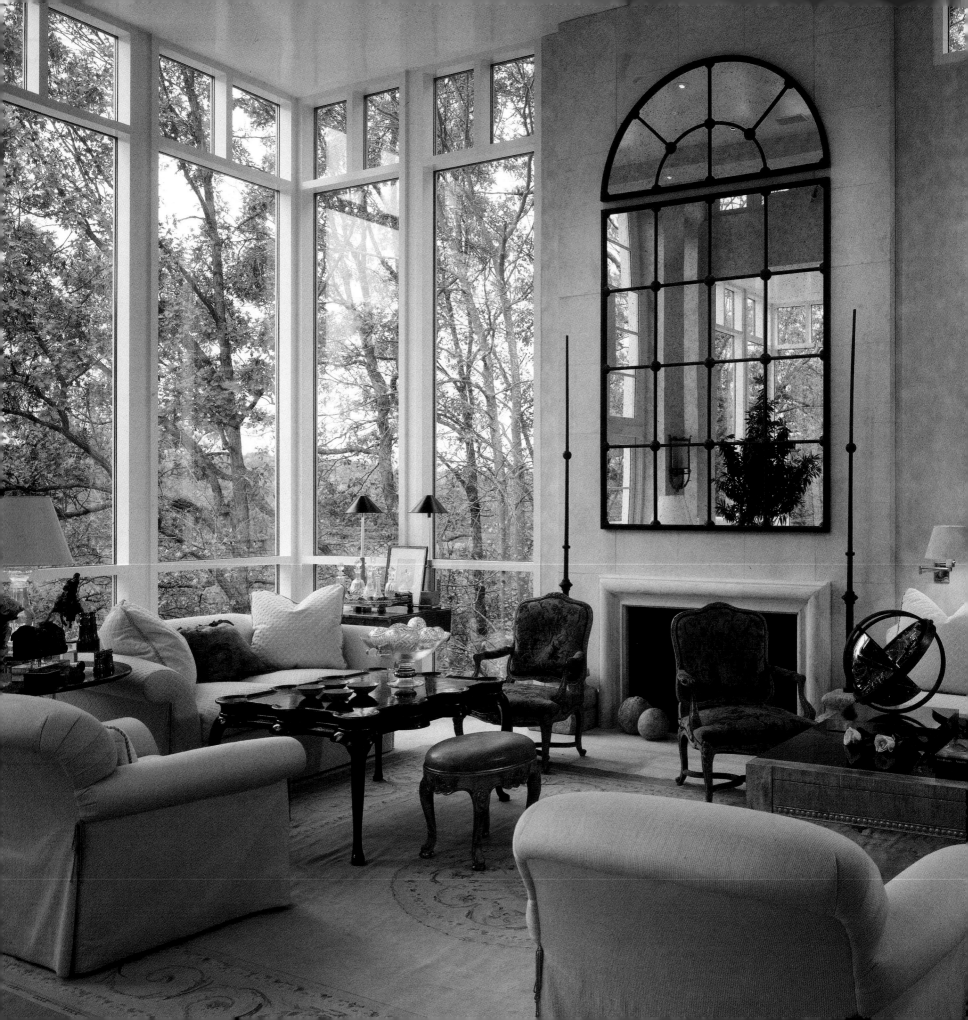

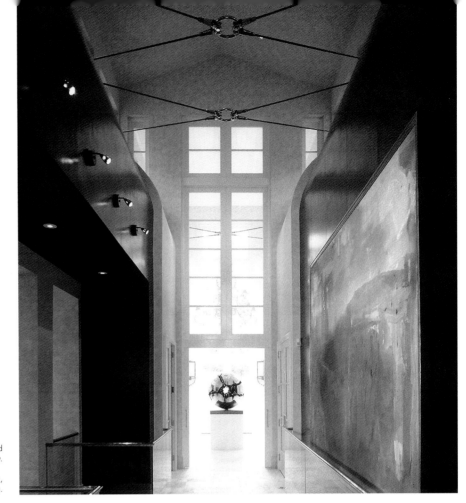

LEFT An Aubusson rug anchors this living room which is deliberately understated to show off the magnificent view of the Chattahoochee River below.

RIGHT This dramatic suspended gallery is a bridge from foyer to living room, showcasing a Pomodoro sculpture and a Helen Frankenthaler painting.

STAN TOPOL

Stan Topol & Associates, Inc.

Stan Topol spent the early summers of his career working in association with Billy Baldwin, who is considered by many to be the dean of American interior design. But more than 30 years after founding his own Atlanta design firm, Stan himself is approaching a similar level of distinction, widely acknowledged as one of the city's most important designers. He has had formal recognition, as well. *Town & Country* magazine named him one of the country's top 25 designers. He has twice been named Southeast Designer of the Year by the Atlanta Decorative Arts Center, and he is also a member of ADAC's Hall of Fame. And recently, at the inauguration of the annual Style Atlanta events, Stan was designated an Icon of Interior Design.

A native Southerner, Stan received his undergraduate degree from Delta State University, and a master of fine arts from the University of Alabama. After setting up shop in Atlanta he taught at the Art Institute

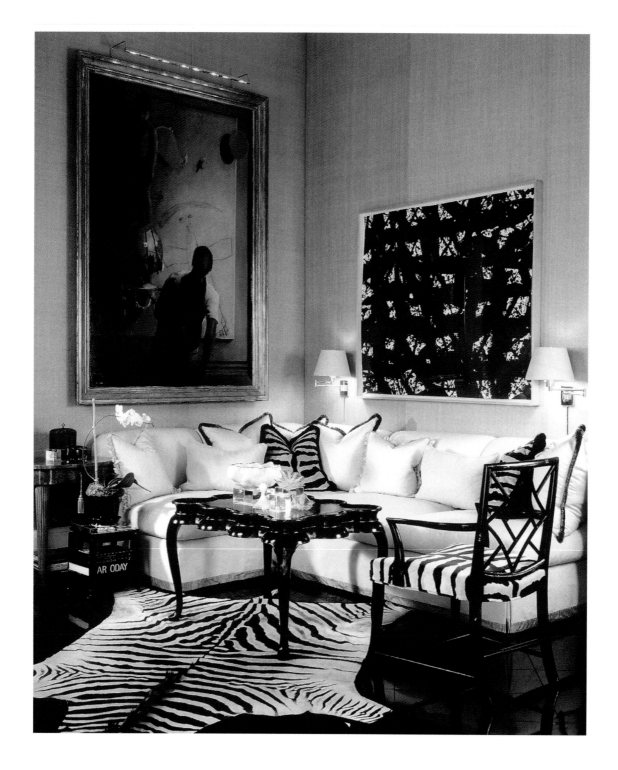

of Atlanta, heading the interior design program and eventually overseeing the institution's entire art curriculum.

"My style has been labeled 'without time,'" Stan says. He avoids following style trends or taking color cues from the mass market. Instead, he concentrates on doing whatever is appropriate to the architecture of the home and the lifestyle preferred by the individual client—and on doing what it takes to ensure the civilized qualities of comfort and conversation. "Nobody thinks in terms of conversation any more," he says. "Instead, it's how strange or clever we can be. But I think the most beautiful rooms are where everything is simple and direct, and the proportions of the furniture to the room are perfect. I always pay attention to how you walk through a room, and then sit in the room, and are able to talk comfortably, or to use a table surface without having to slump off the sofa."

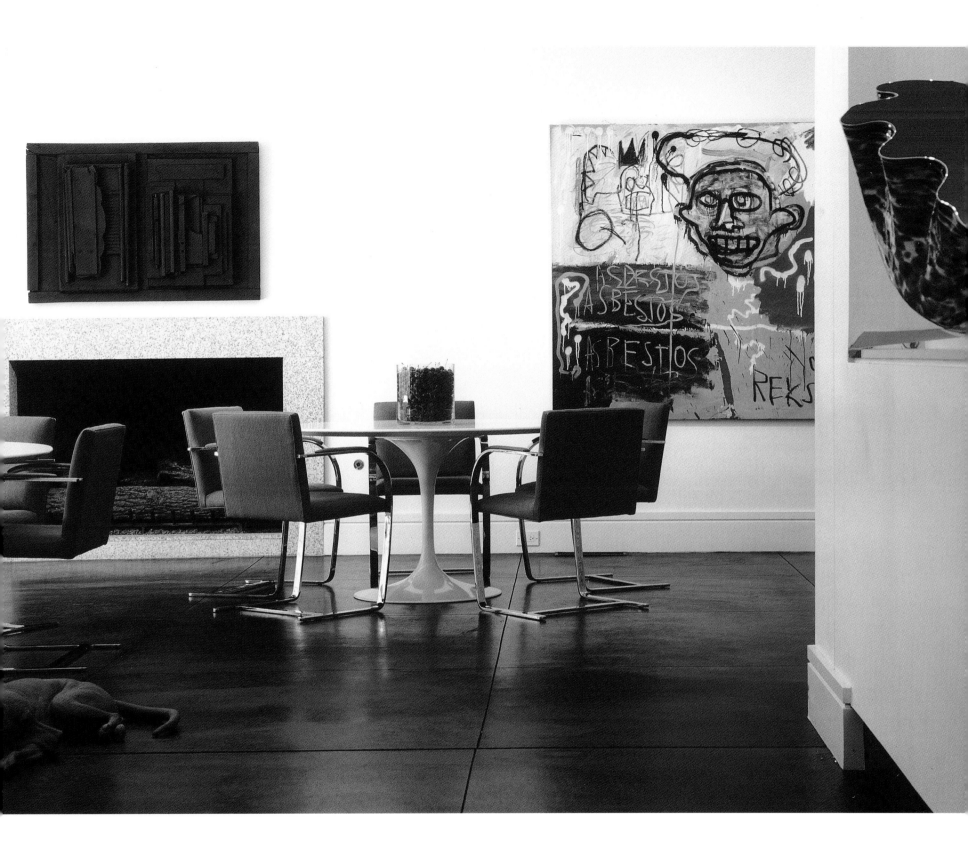

LEFT Stan designed this living room to invite conversation, with upholstered walls softening sound and highlighting the contemporary art.

ABOVE In this contemporary interior, even the furniture acts as art, typifying the understatement that is a signature of the firm.

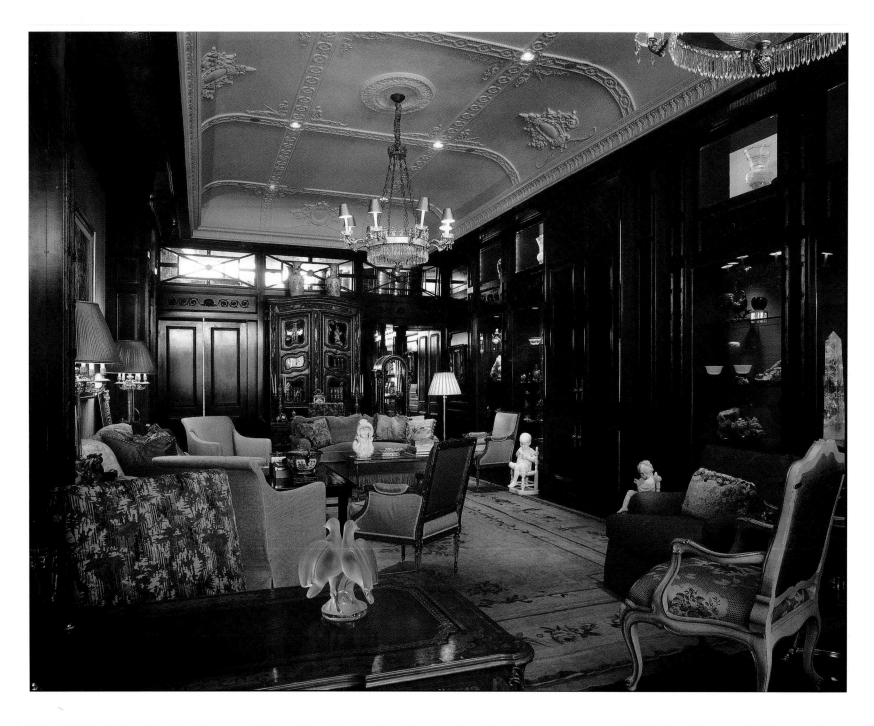

Though he has designed interiors for scores of Atlanta clients, Stan's residential projects have also taken him across the United States. These have included homes on the slopes of Park City and Beaver Creek, townhouses and apartments in Boston and New York, horse farms in Georgia, and beach retreats in Naples, Hilton Head and Palm Beach. His work has been published nationally in *Interior Design*, *Elle Decor*, *Veranda*, *Architectural Digest*, *The World of Interiors*, as well as in local magazines.

Like the rooms of his early mentor Billy Baldwin, Stan's work is marked by controlled, understated elegance and a willingness to go against the conventions—but without needing to call attention to the fact.

LEFT Starting with en empty shell, Stan created a true Beaux Arts apartment high above the city. The wall and ceiling details were his starting point for this showcase for the client's major collections.

ABOVE RIGHT For this log cabin, Stan departed from his more typical classical style to develop a uniquely personal land comfortable country home - without clichés.

More about Stan ...

WHAT PERSONAL INDULGENCE DO YOU SPEND THE MOST MONEY ON?

My animals. I love my dogs and my horses.

WHAT SEPARATES YOU FROM YOUR COMPETITION?

We treat all of our clients as if we were planning their daughters' weddings...and as we would want to be treated ourselves.

WHAT'S THE MOST UNUSUAL FEATURE YOU'VE EVER DESIGNED?

A bridge—but in the interior of a home, not over water.

WHAT DESIGN PHILOSOPHY HAVE YOU STUCK WITH THAT STILL WORKS TODAY?

I love to work my plans for a room so that people can actually talk to each other.

WHO'S YOUR OWN DESIGN ICON—AND GIVE US ONE REASON WHY.

Billy Baldwin. One thing he was insistent upon was "nothing blended." You hit the color on the head or you didn't use it.

WHAT'S THE SINGLE THING YOU WOULD DO TO BRING A DULL HOUSE TO LIFE?

Rearrange the furniture correctly to make standard rooms livable.

STAN TOPOL & ASSOCIATES, INC.
Stan Topol
1100 Spring Street, NW, Suite 400
Atlanta, GA 30309-2826
404-885-9889
FAX 404-885-9988
www.stantopol.com

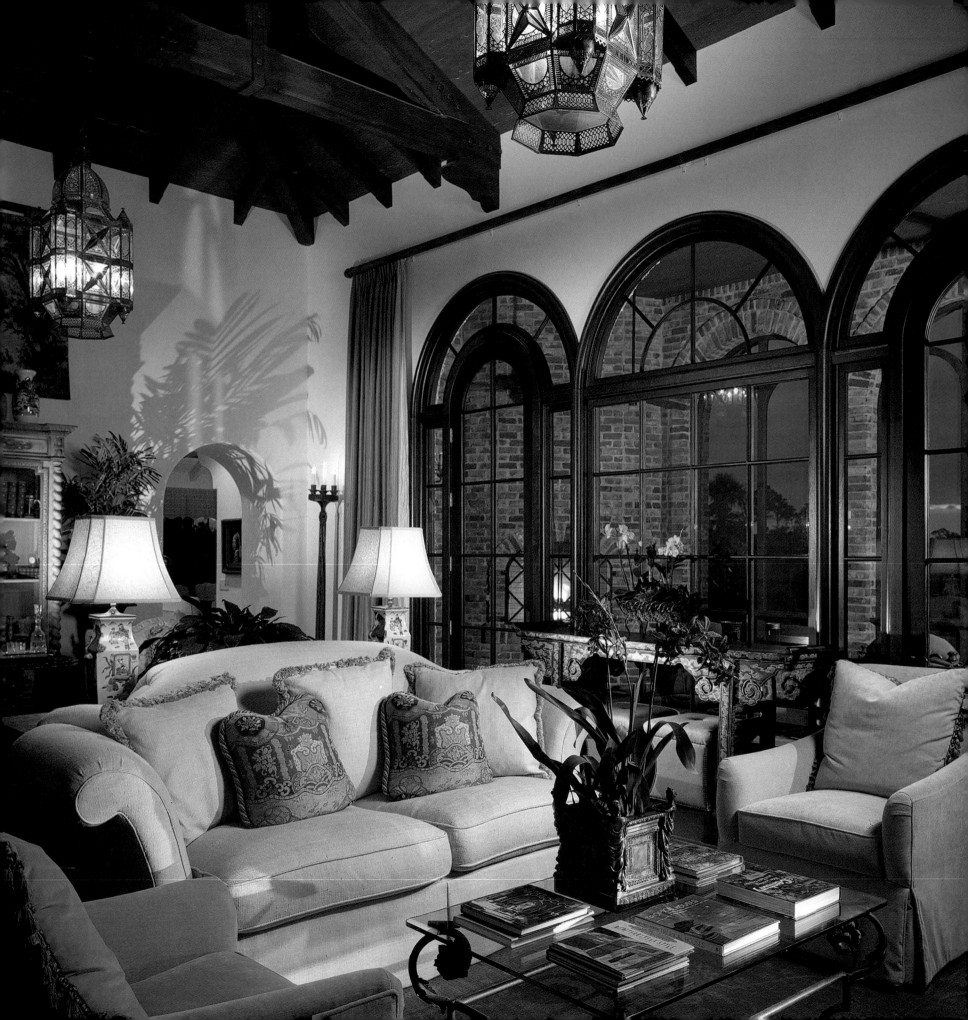

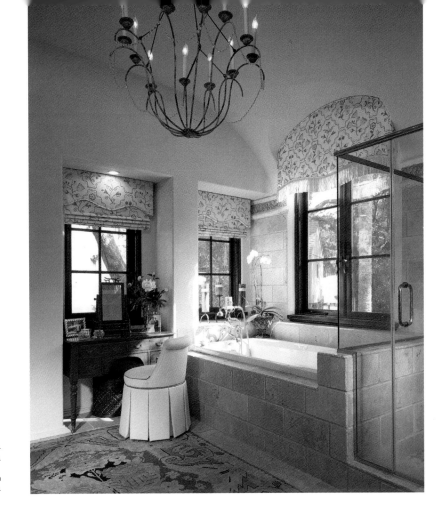

LEFT In this island home, Moroccan lanterns, stenciled beams and elegant proportions recall the work of architect Addison Mizner. The upholstery is raw silk.

RIGHT Lisa created a soothing environment in this bathroom through the use of natural-toned marble and crewel window treatments.

LISA TORBETT

Lisa Torbett Interiors, Inc.

Nearly 25 years' interior design experience, a love and understanding of an island lifestyle, and a unique ability to bring a client's vision and desire to reality combine to make Lisa Torbett a design force in southeast Georgia.

Born in Savannah, Lisa has lived in the area all of her life. "I'm drawn to the beach and water," she says, and she responds especially to white, for its reflective qualities. Since 1989, her company has been the in-house design firm for the Sea Island Company; so if you've visited the gracious resort, you've had first-hand experience of her work.

Lisa has created many other commercial and residential interiors along the Georgia coast. She won the Georgia Mainstreet Award for Ecological Restructuring and Design, for the renovation of a local bank. Broadfield Plantation, a private home for which she did the

interior design, was featured recently in *Architectural Digest*. "I especially like working with residential clients," she says, "because you have a chance to draw on their personalities. For instance, Broadfield reflects the clients' sporting lifestyle."

Aside from the coast itself, Lisa reveres Palm Beach and the dreamy Mediterranean style that architect Addison Mizner imagined for that fledgling winter colony in the 1920s.

LISA TORBETT INTERIORS, INC.
Lisa Torbett
100 Sylvan Drive
Suite 190
St. Simons Island, GA 31522
912-638-3596

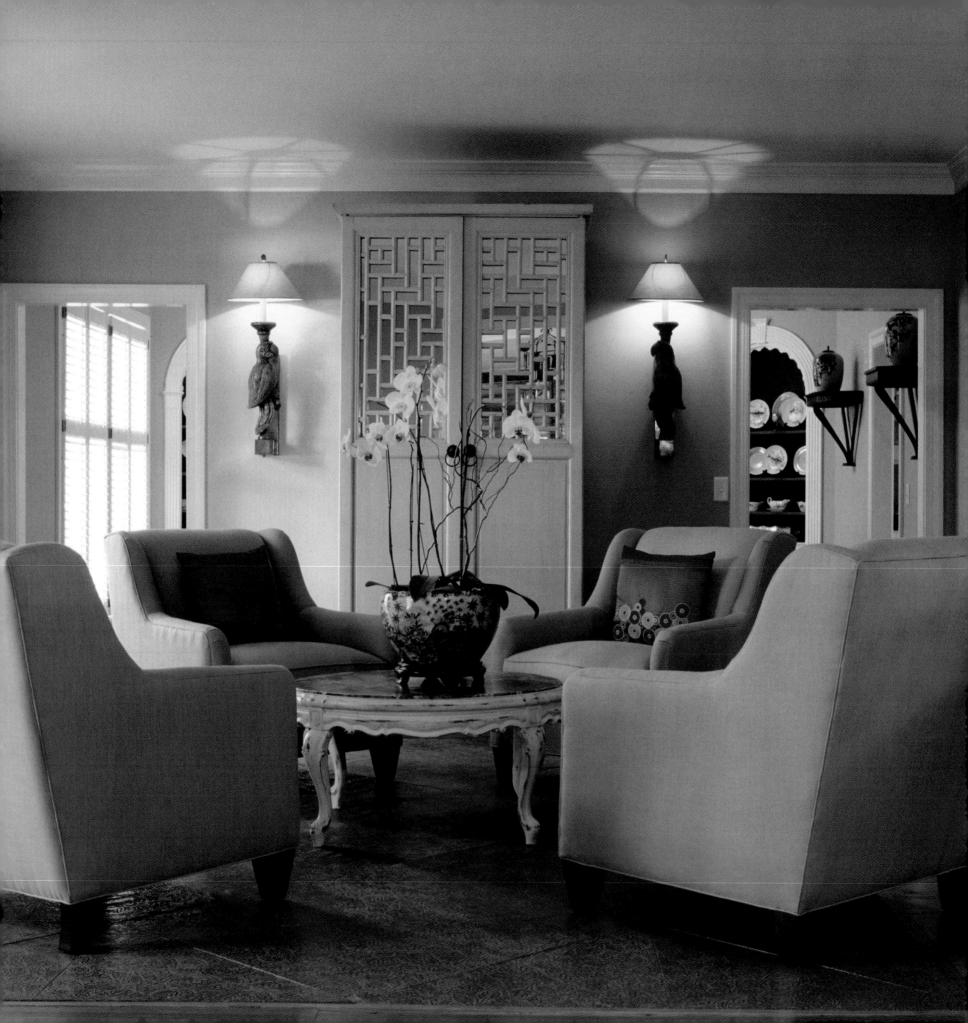

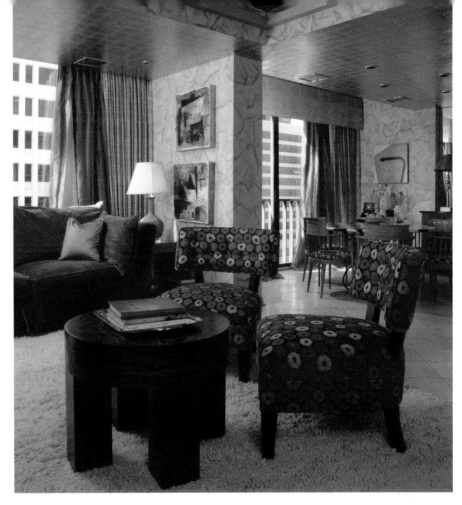

LEFT The formal living room creates a perfect atmosphere for intimate conversation. Four chairs float on an inlaid floor of tooled leather surrounded by salvaged heart of pine. Parrot sconces were salvaged from Sea Island's original Cloister Hotel.

RIGHT Living and dining spaces are open and connected in this high-rise condo. Walls are covered in torn pieces of handmade paper to create a scaled effect. Coffered ceilings are gold leafed and glow from lighting tucked into the molding.

GLENN & PAULA WALLACE

Wallace Designs

Paula and Glenn Wallace are hardly your typical designers. First of all, they have some pretty unusual clients. One of their "clients" is an international student body numbering 7,000, because Paula is the president and Glenn a senior vice president for the Savannah College of Art and Design (SCAD). As such, they oversee the redesign and reuse of existing, mostly historic, buildings. Recycling is SCAD's signature approach to growing a campus at the institution's locations in Savannah, Atlanta and Lacoste, France. They jokingly refer to their other client as the "phantom client." By that they mean eventual purchasers of numerous houses in Savannah and nearby beach communities that the Wallaces buy, remodel and decorate.

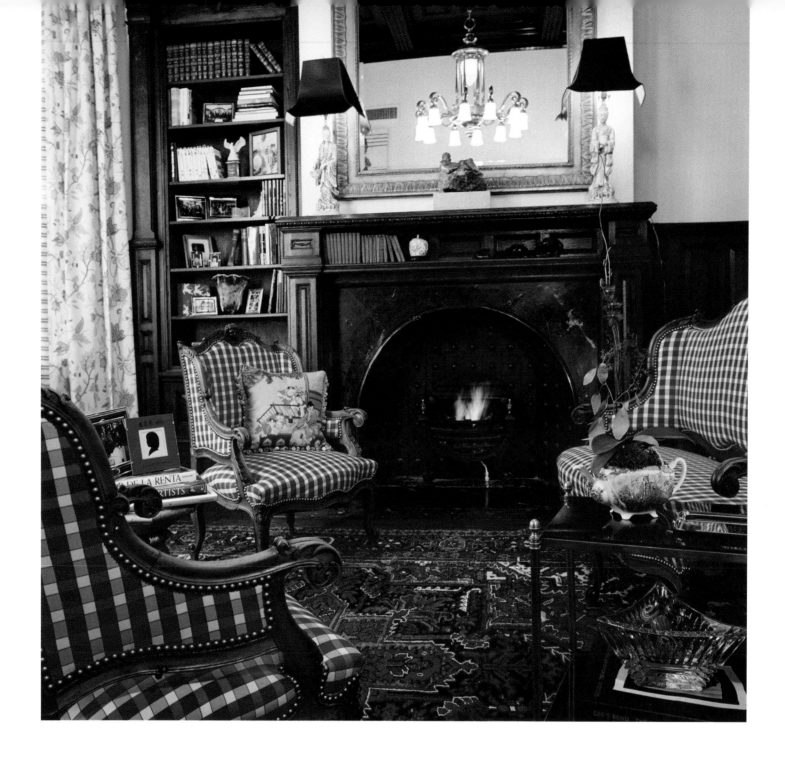

"We do take a few residential commissions," Glenn explains, "but we're very selective in that. For one thing, we don't have a lot of time. Mainly, we buy houses for ourselves, redesign and furnish them, and then sell them as a package. These primarily become the buyers' second homes, so it's easy for them to walk in and have everything in place. And we especially like to accent these homes with student art, offering SCAD students an invaluable opportunity for exposure."

The Wallaces' style can't be pigeonholed. They've done sleek modern interiors, traditional antique-filled ones, and whimsical beach houses. "A home should be intellectually engaging and emotionally inviting," Glenn says, "and our design approach is uniquely different for each house. The structures speak to us with individual voices." They're currently working to transform a highly ornate 1909 synagogue featuring many carved elements into a student center. "We've selected modern, clean-lined furniture for the project, and light will be a

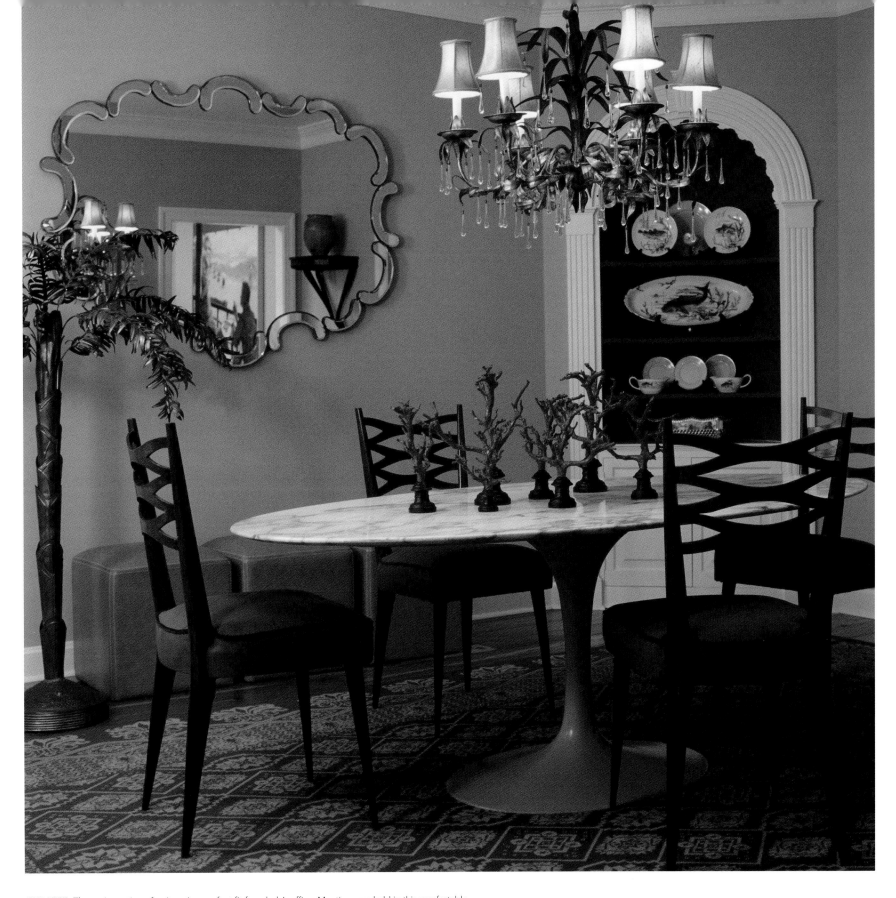

FAR LEFT The petite antique furniture is a perfect fit for a lady's office. Meetings are held in this comfortable living room setting that surrounds a marble mantel original to the structure.

TOP Mixing centuries, Paula and Glenn combined a vintage Eero Saarinen marble-topped dining table, contemporary leather stools from Home Depot Expo Design Center, and an antique mirror and chandelier from Antiques and Interiors of St. Simon's Island. They updated the traditional shelves by painting their interior in a ginger hue. The brass palm tree is from the estate of SCAD professor Ben Morris.

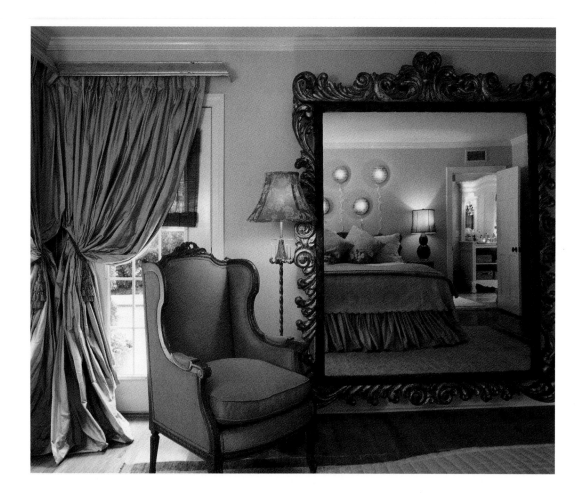

major design component. The building will have different moods that will change throughout the day."

The range of treasures the couple collects reflects their international travels and reveals their exuberant personalities. Their collections include hand mirrors, anonymous flea market portraits, wooden boxes, antique tools, alarm clocks, "rag dolls that we display in a big bowl," deviled egg plates, exotic hats and fanciful purses.

It's fairly uncommon for a husband and wife to work together as a design team, but the Wallaces complement each other perfectly. Paula is a lifelong educator, while Glenn holds degrees in business and interior design. Between them, they have earned numerous honors and awards.

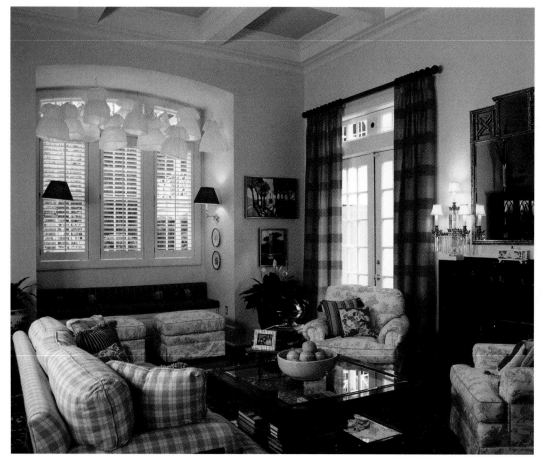

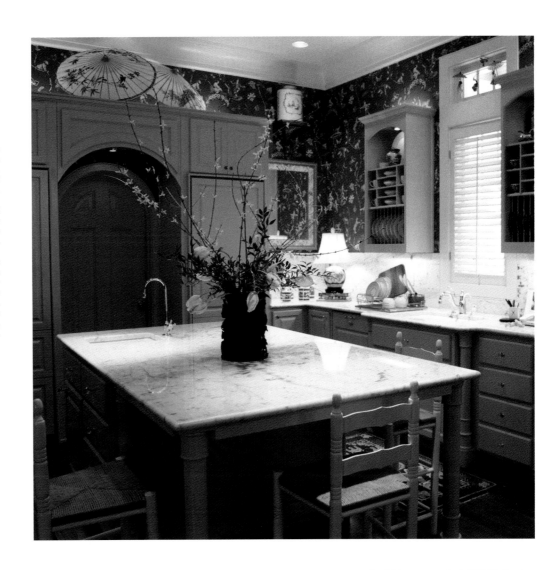

LEFT TOP An antique gilded valence was reproduced for the silk curtains and bed skirt. The large mirror, also antique, frames two-way glass that hides a flat-screen TV visible only when turned on. "Think Dots," by Katie Runnels, captures and illuminates stream-of-consciousness text.

LEFT BOTTOM In this sunny sunken living room, parchment dressed by Amanda Leibee hand from fishing lines as an inventive window treatment. The chairs and sofa are in fabric from Pierre Deus. The antique Asian mantel is from Architectural Accents in Atlanta.

RIGHT The Wallaces are not afraid of color. Open display cabinets showcase collections of antique china. The floating island houses deep drawers for pots and pans and casual seating for breakfast and lunch. Custom cabinets disguise double refrigerators, dishwasher and trash compactor. Arched antique door leads to oversized pantry with additional prep space, dishwashers, and storage. Wallpaper from Scalamandre.

More about Glenn & Paula ...

WHAT ONE ELEMENT OF STYLE OR PHILOSOPHY HAVE YOU STUCK WITH FOR YEARS THAT STILL WORKS FOR YOU TODAY?

A home should always be warm and inviting. We mix interesting antiques with upholstered furniture and modern artwork. We always have lots of books around because we're educators, and they reference the life of the mind—plus they are easy to move around to add varied heights to displays and table lamps. Every space should contain unexpected elements.

WHAT'S THE BEST PART OF BEING INTERIOR DESIGNERS?

The shopping! We maintain a grueling travel schedule, and love to scout for hidden treasures wherever we go. Often, a special find inspires an entire house.

WHAT COLOR BEST DESCRIBES YOU?

We like azure because the word sounds beautiful and because azure complements other colors—like brown, cream and green—so well.

WHAT'S A SINGLE THING YOU WOULD DO TO BRING A DULL HOUSE TO LIFE?

Lighting makes a huge difference; we favor lamps. And original art can make a house sing.

WALLACE DESIGNS
Glenn Wallace
Member ASID, IIDA, IFMA
Paula Wallace
912-525-5200
FAX 912-525-5201

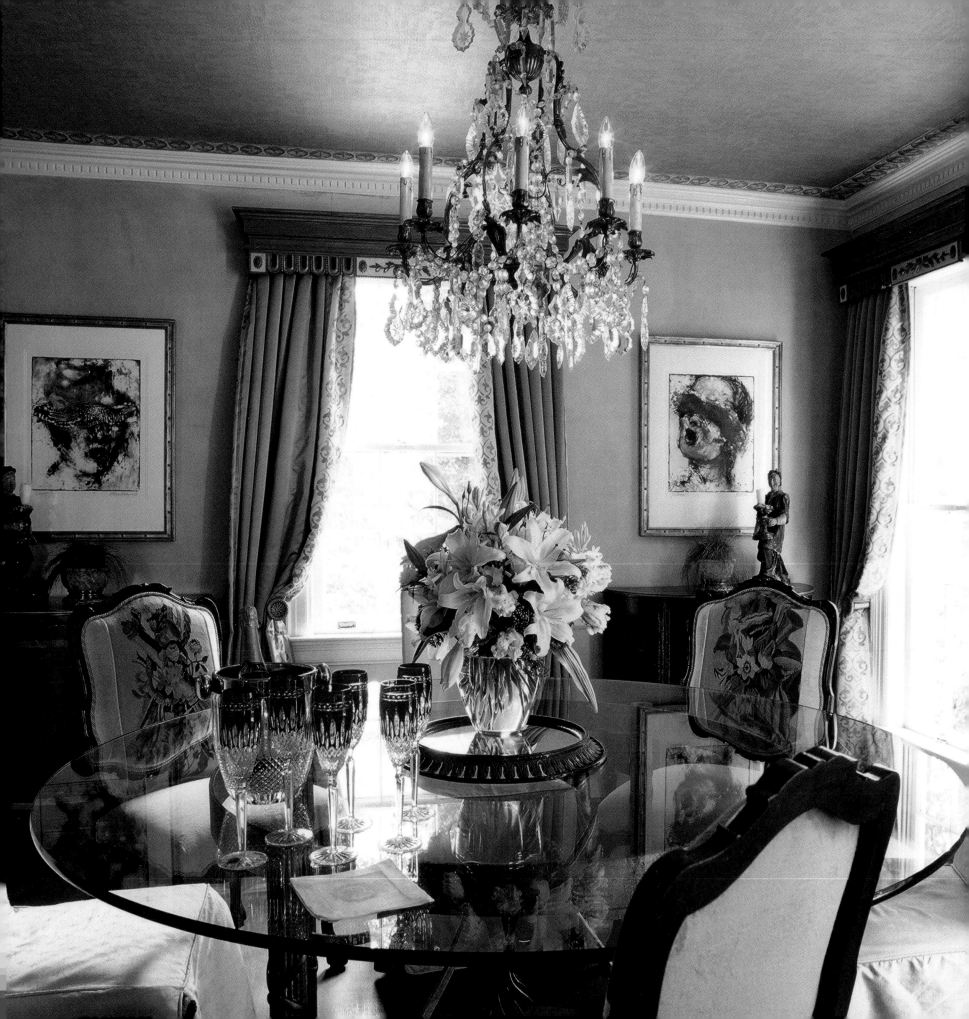

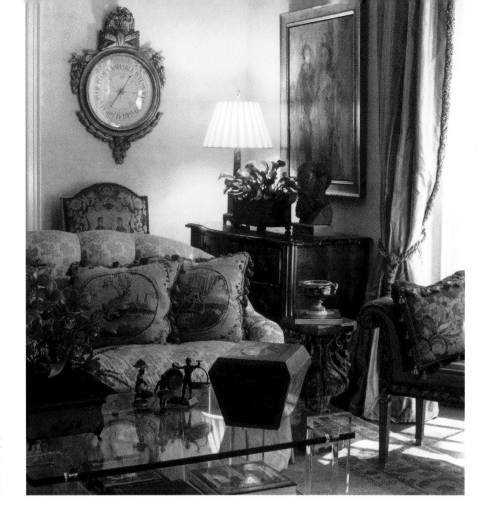

LEFT In this dining room, Carole balances historical lavishness with evocative contemporary art by Kathleen Morrison. The ceiling is done in wallpaper from Osborne & Little, the chairs covered in French tapestry.

RIGHT The sumptuous textures of 18th century French pillows and an ornate 18th century barometer find their foil in a sleek acrylic coffee table.

CAROLE WEAKS

C. Weaks Interiors, Inc.

"The classic elements of design always, always hold up," asserts Carole Weaks, who has headed her own Atlanta design firm, C. Weaks Interiors, since 1987.

But while her work is grounded in a timeless style, Carole's ideas have continually evolved. Soon after she entered the profession, her taste began to move toward mixing in contemporary art. And she began to explore alternate approaches to accessorizing than, for example, displaying traditional porcelains. "In Atlanta 20 years ago, that was all you saw. But rarely is that my choice now. And the reason that I still enjoy interior design so much is that you can bring a fresh approach, without being trendy. I have made a habit of staying abreast, and mixing things. That's where we're going with interior design right now anyway."

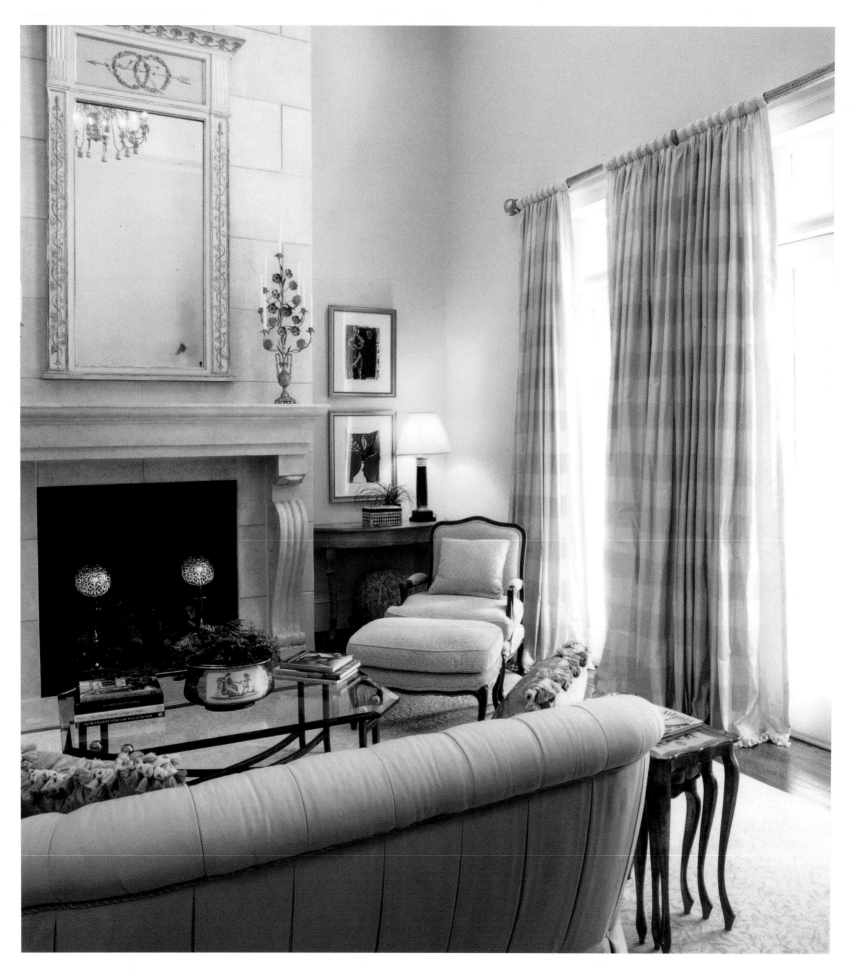

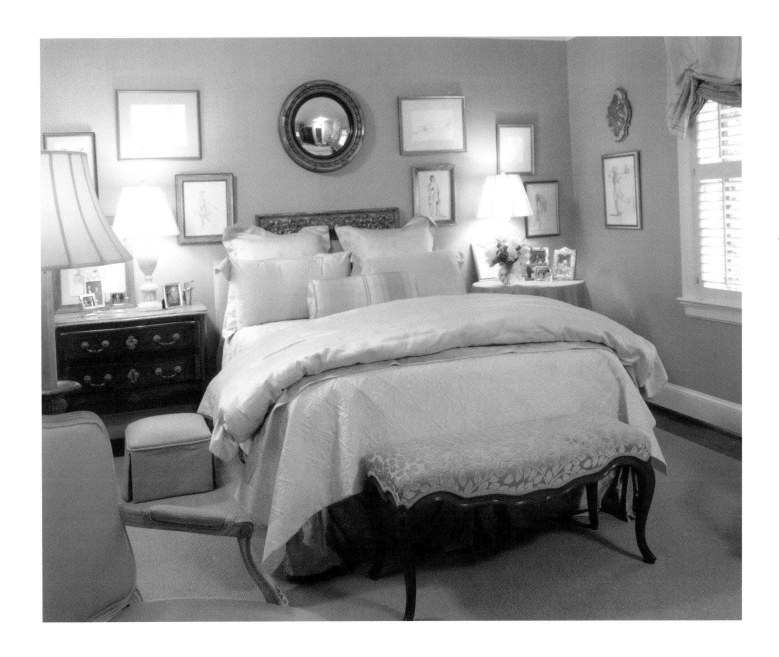

LEFT In this serene living room with its restrained monochromatic palette, Carole added interest with a 19th century mirror and pair of 19th century girandoles, all from Parc Monceau Antiques.

ABOVE The headboard in this bedroom was fashioned from an 18th century architectural fragment. The bedside commode and the bench are both French, the former 18th century and the latter 19th century.

Two things inspire Carole, or as she puts it, "set my wheels going." One is the work of certain other designers. ("I won't mention names," she says slyly, "they've already got big heads.") To her, it's not a matter of copying what someone else has done, but being stimulated by another designer's inventiveness, and then taking it in another direction. "That's what we get from books and publications, that sharing of ideas; it's indispensable."

The other is...France. She goes three times a year, on a working trip, to unearth and bring home wonderful objects. The way aesthetics infuses every aspect of French life is what she finds stimulating. "It is such a priority for that country

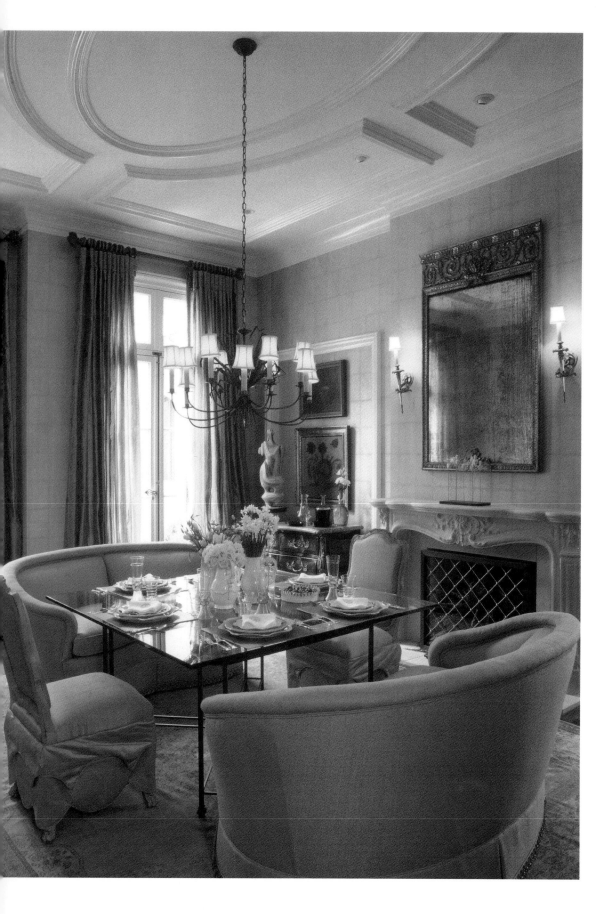

to keep things beautiful, and keep old things intact. It's hard to not soak that up and come back with all sorts of enthusiasm."

While there, she's always on the lookout for things that are different and unusual. Those don't necessarily have to antiques, as long as they're well-conceived and well-crafted, and not liable to turn up everywhere. "That's what I want for my clients' homes, and for my own." She also collects contemporary art, finding pieces both in France and here. But she knows the value of restraint. "You can cross a line where you're just buying, you're no longer collecting. You can really turn it into an obsession. You have to edit. You have to decide what's enough. Being exposed as we are in this business, we see a lot of wonderful things. Sometimes it's good to be able to say, 'I love that—but I'm not going to buy it.'"

The challenges Carole loves are the ones that tap her creativity and force her to come up with solutions, "how to satisfy both the husband and the wife, how to make a small room feel large enough. Those I welcome." The situations she dislikes are when a client wants a project done too fast, or wants to knock everything off and do it inexpensively. "With the right amount of time and an adequate budget—and it doesn't have to be unlimited—that's when I can do my best."

LEFT A custom-made Nierman Weeks dining table and a pair of sofas purchased in Paris make an unexpected ensemble.

RIGHT In a perfect illustration of Carole's delight in mixing the antique with the contemporary, a sculpture by Kimo Minton, art by Keidee Becker and an ornate 18th century French commode happily coexist.

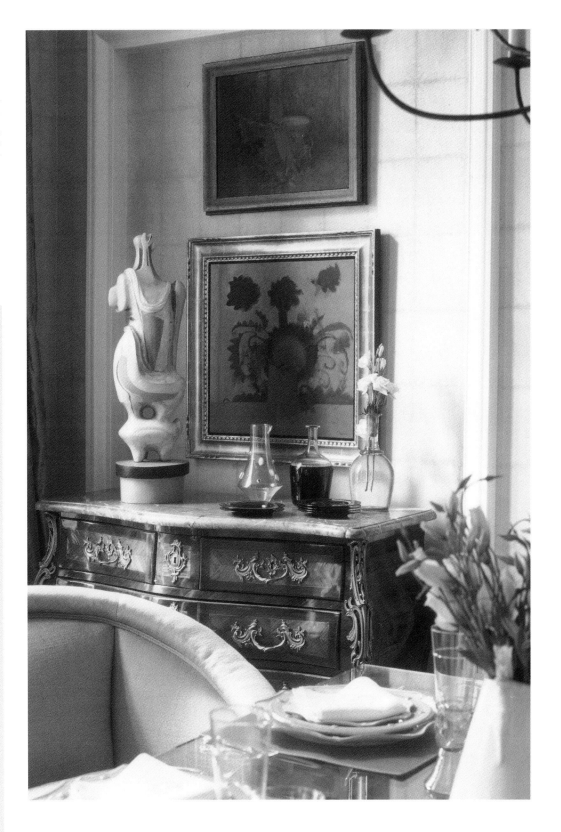

More about Carole ...

HOW CAN YOU TELL YOU LIVE IN GEORGIA?

I still have a Southern accent and say "Thank you" and "Ma'am."

WHAT WAS THE FIRST INKLING YOU SHOULD BE A DESIGNER?

When I kept my mother up till 3 a.m. telling her everything I would change in her house, which had been done really very nicely by a decorator.

IF YOU COULD, WHAT ONE STYLE WOULD YOU ELIMINATE FROM THE WORLD?

All that dreadful mess from the '50s.

WHAT IS THE MOST UNUSUAL, EXPENSIVE AND DIFFICULT PROJECT YOU EVER UNDERTOOK?

Rebuilding a house that had burned right before completion— in less than a year. It was all of the above.

WHAT IS THE BEST SINGLE STRATEGY YOU KNOW FOR BRINGING A DULL HOUSE TO LIFE?

Add art.

C. WEAKS INTERIORS, INC.
Carole Weaks
Allied member ASID
2002 Southeastern Designer of the Year
349 Peachtree Hills Avenue, Suite D-1-B
Atlanta, GA 30305
404-233-6040
FAX 404-233-6043

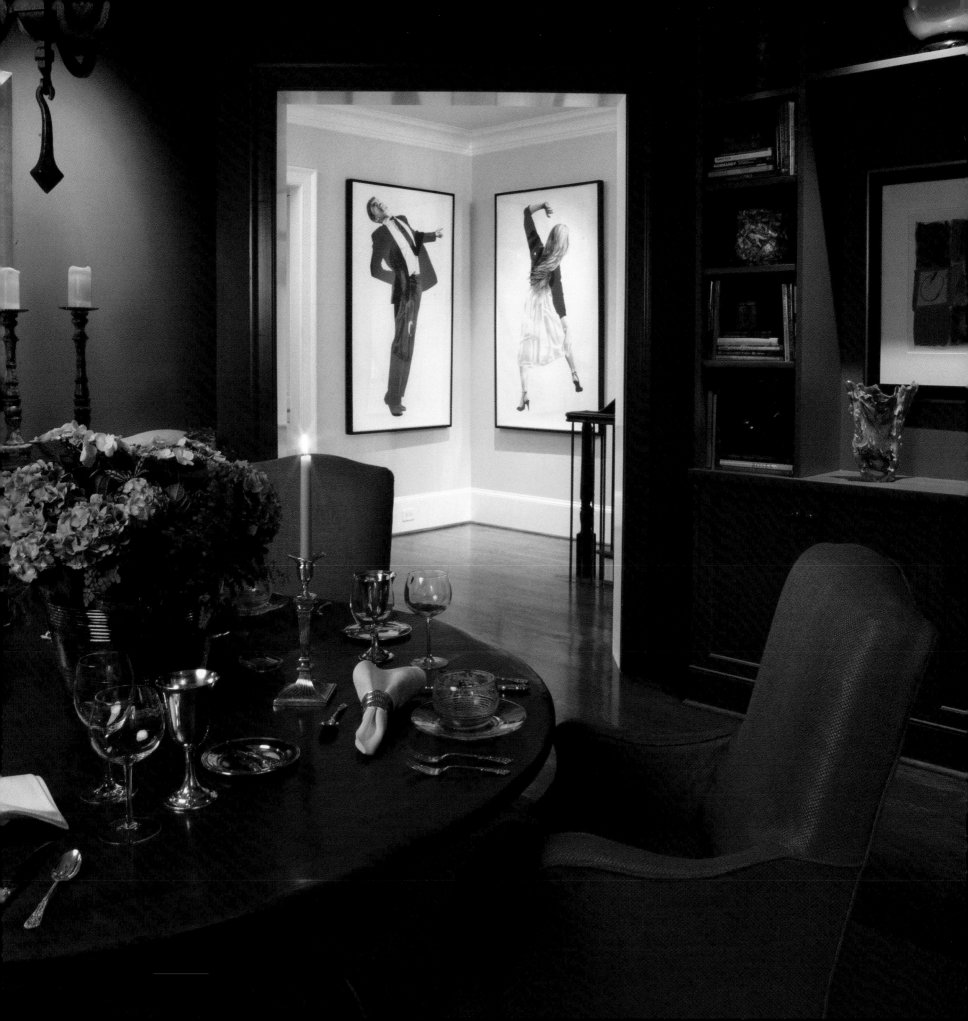

LEFT Prussian Blue engulfs a dining room that is more than a space for occasional entertaining; Reading room by day and very intimate setting by night.

RIGHT Defined by the elements of classicism, romantic arches & oyster white plaster walls marry antique Italian tile floors, framing each room as they flow one to the other.

BETH WEBB

Beth Webb Interiors, Inc.

Beth Webb believes that scale, proportion and a sense of timelessness are the heart of any successful interior, whether it's traditional, eclectic or contemporary. That's served her well in projects that range widely, from a Georgia coastal beach house, to an apartment in a landmark Atlanta building, to an estate in Connecticut, to a private rail car—and even a Palm Springs spa.

Her clients are similarly diverse. "I have a lot of appreciation for individual tastes and personalities," Beth says. "And they may begin as strangers, but by the end of the project I feel as though I have a new family."

"The two best parts of what I do," says Beth "are the creative process of coming up with the initial concept and the installation, as exhausting as always is; I love that, because you finally see it all come together. It's then you sit down in the space with your clients and enjoy!"

Beth describes her own house as "serene and tranquil, cream on cream on cream. Because there are so many details and even chaos in an average day, my space needs to be my sanctuary. If money were no object I would move to Tahiti, wear a sarong and walk the beach in bare feet. You think I'm kidding?"

BETH WEBB INTERIORS, INC.
Beth Webb
77 East Andrews Drive #206
Atlanta, GA 30305
404-467-9180
FAX 404-467-9125

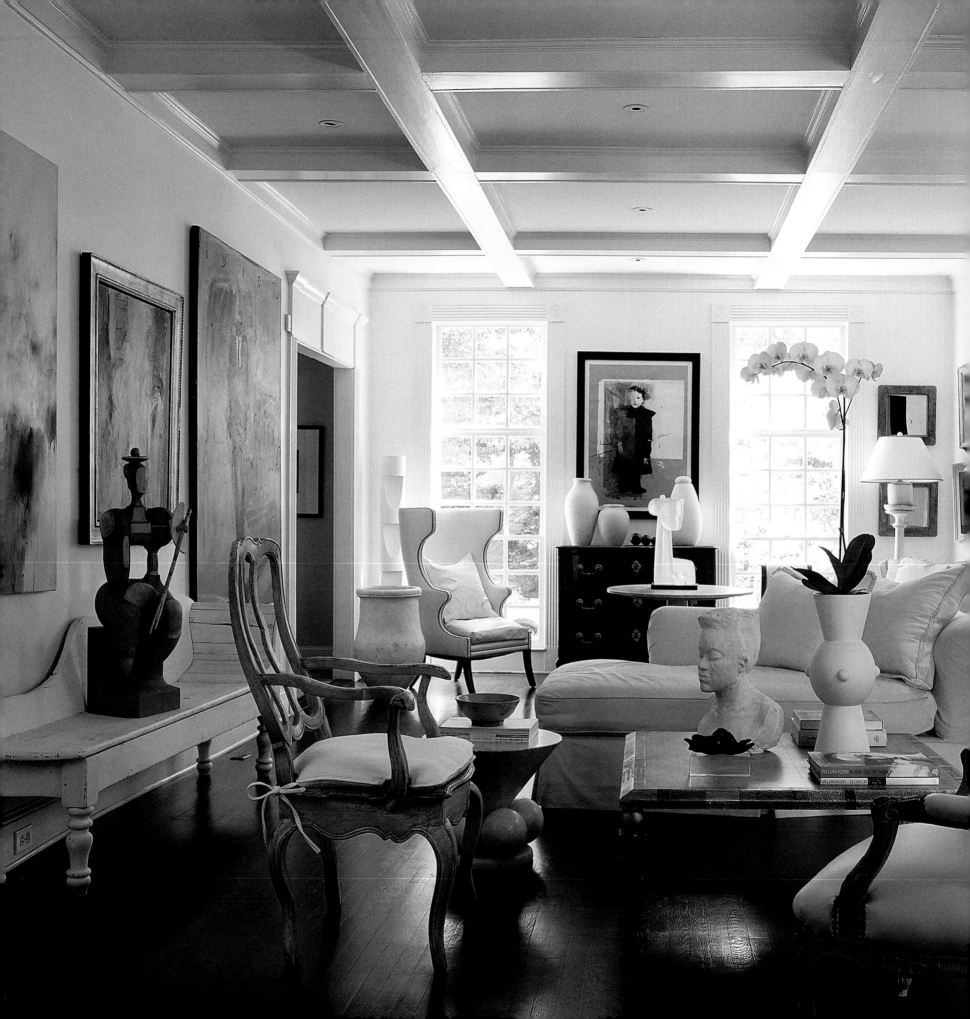

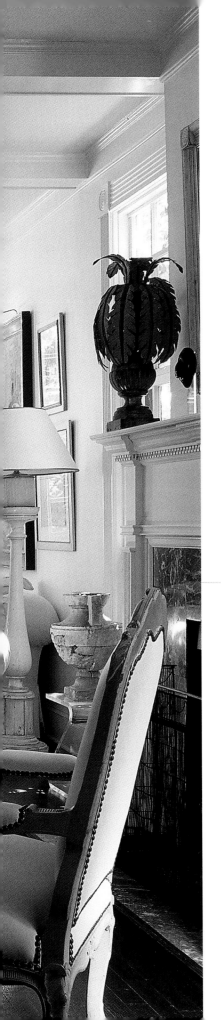

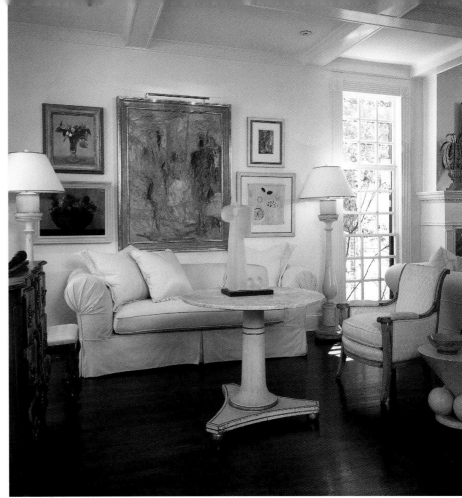

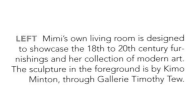

LEFT Mimi's own living room is designed to showcase the 18th to 20th century furnishings and her collection of modern art. The sculpture in the foreground is by Kimo Minton, through Gallerie Timothy Tew.

RIGHT Neutral fabrics allow the focus to remain with the art. The large painting above the sofa is by French artist Isabelle Melchior, through Gallerie Timothy Tew.

MIMI WILLIAMS

Mimi Williams Interiors

Williams is living proof of the old adage that who we're going to be in life is revealed at an early age. At 14, she was buying antique Chinese scrolls and ancestral portraits and Japanese pottery. True to her youthful passion, the spaces she designs today are loaded with art and objects of considered beauty.

Her spaces are intensively layered yet well edited, incorporating pieces that span the globe, including 18th and 19th century continental antiques as well as contemporary art and sculpture. Often the rooms are grounded by neutral palettes—but even the neutrals she uses can be forceful, such as black and white. In the same spirit, she likes strong geometry and powerful scale. "Most people tend to underscale furniture and objects," Mimi says. "Scale is paramount. I have always used my husband as a gauge," she jokes. "If he thinks it's too big, I know it is perfect."

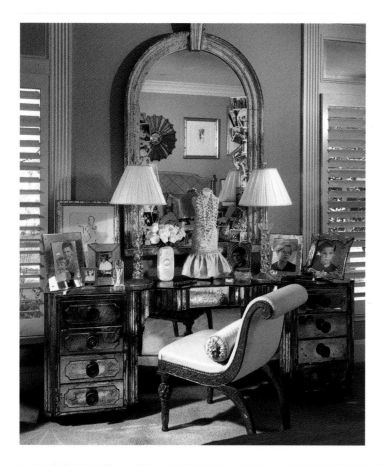

Mimi's gift is in the application of contemporary thinking while giving a strong and respectful nod to the past. She believes in simplicity—meaning the use of products of the best quality and the display of essential elements, but without unnecessary ornamentation and clutter. "How objects are placed is as important as what they are," she observes.

Mimi's own home, a 25-year work in progress, is a gracious Federal style house that began life as an Arts & Crafts style duplex, which her husband, Bennett, bought before they were married. It is furnished with contemporary upholstery, European antiques, and her considerable collection of contemporary art, in which portraits have a strong presence. It's an impressive enough assemblage that it was a highlight of a tour of homes organized by the High Museum of Art in Atlanta.

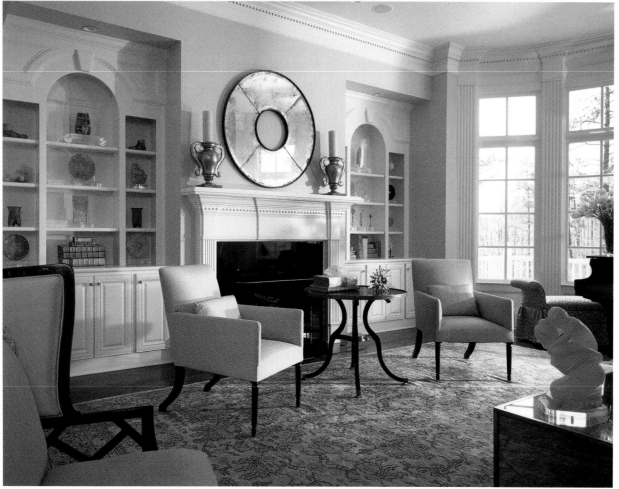

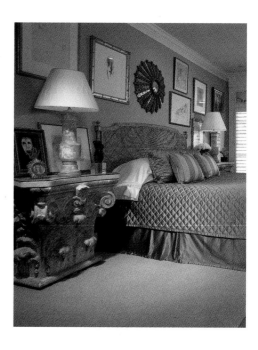

TOP LEFT For her bedroom, Mimi chose a spectacular 1930s American mirrored dressing table, and also transformed an old window frame into a mirror. The Regency-style chair is 19th century.

BOTTOM LEFT This living room was planned to showcase a wonderful collection of ancient artifacts. The furnishings are from Jerry Pair. The mirror is from Niermann Weeks through Ainsworth Noah. The 18th century urns are from Regalo Antiques.

NEAR LEFT Corinthian capitals salvaged from a 19th century Atlanta church were artfully transformed into bedside tables, and antique balusters re-emerge as lamps. The sumptuous linens are from Ann Gish, Inc.

TOP RIGHT Cool and warm hues are in pleasing balance in this antique-filled living room.

BOTTOM RIGHT In the same room, the bold architectural fragment over the mantel plays against the collection of boules.

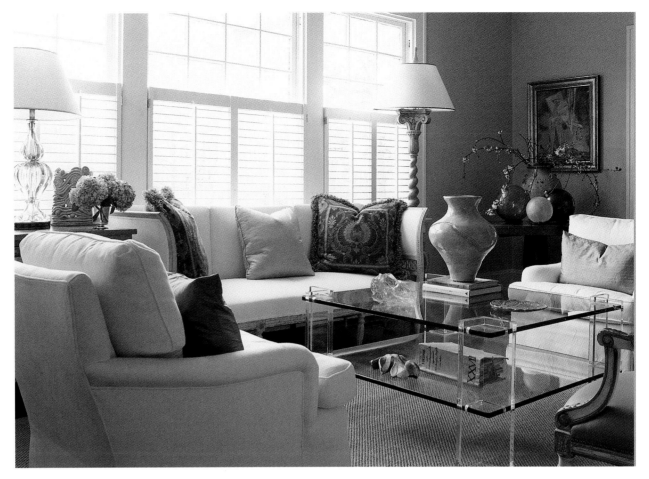

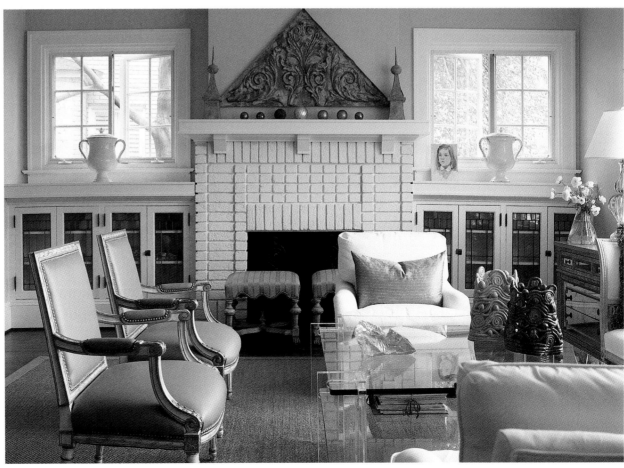

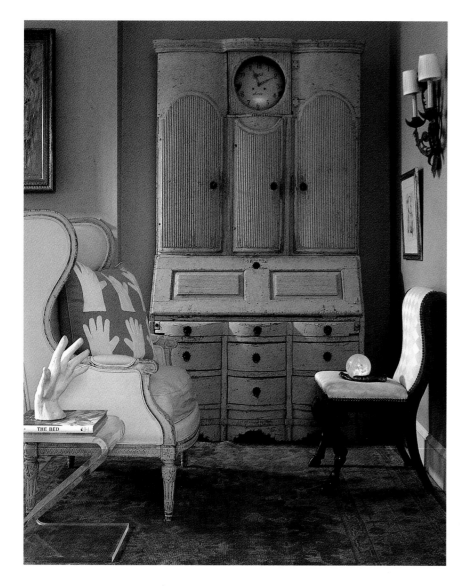

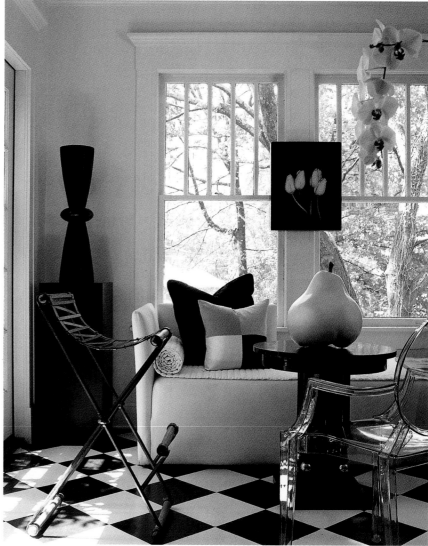

Though it clearly came into being earlier, Mimi's fascination with and appreciation of the wonderful and unique object was refined during the years she spent working in both the retail and wholesale areas of the decorative arts. Since leaving sales in 1996, she's been out on her own as a designer and has done commercial and residential projects not only in Georgia but also in South Carolina, Florida, California, Colorado, New York and Chicago. Her work has been featured nationally in *Veranda*, *Better Homes and Gardens*, *Southern Accents*, *Southern Living* and *House Beautiful*, as well as in many Atlanta-area publications.

Besides art, Mimi's passion is for food. She's a loyal patron of chefs whose work she considers truly original—and an inventive cook herself. Her friends cherish invitations to dine at her table, an experience that is enhanced by the fact that her husband Bennett is a serious wine collector.

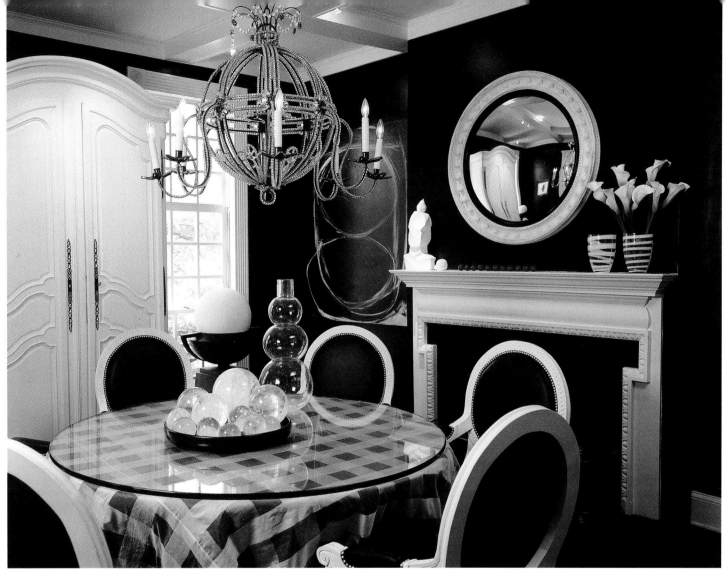

FAR LEFT An extraordinary 18th century painted Swedish secretaire and a Louis XVI bergere, from Jacqueline Adams Antiques, and an Oushak create a welcoming setting for playful accessories. The small 19th century chair is from Parc Monceau.

NEAR LEFT Mimi expresses her wit in vignettes, like this one where she mixes a Hungarian art deco table from J. Tribble Antiques with a vintage French barstool and Philippe Starck's Louis ghost chair. The art is by Joseph Guay.

ABOVE The dining room in Mimi's home is a statement of contrasts and strong forms. The 19th century French armoire from Anne Flaire Antiques wears multiple coats of gesso. The painting is by Craig Schumacher. The Bruce Eicher chandelier is complemented by a collection of rock crystal spheres.

RIGHT Varying her signature muted palette, Mimi threw caution to the winds in designing her office, in a deco-era telephone factory building. Everything in the high loft space is red, white or black.

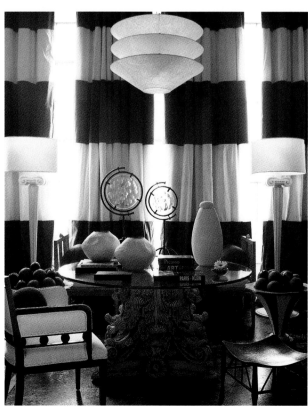

MIMI WILLIAMS INTERIORS
Mimi Williams
828 Ralph McGill Boulevard
Suite 208
Atlanta, GA 30306
404-577-5620
FAX 404-526-9903

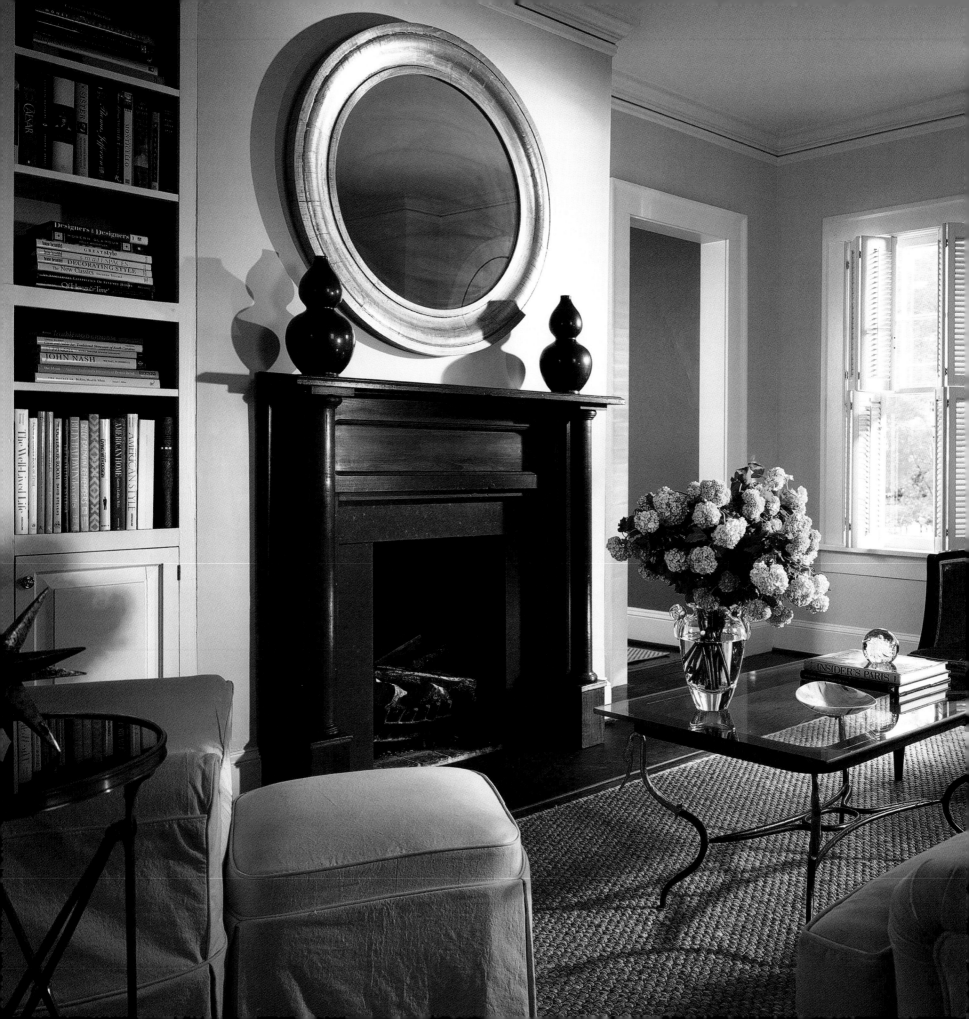

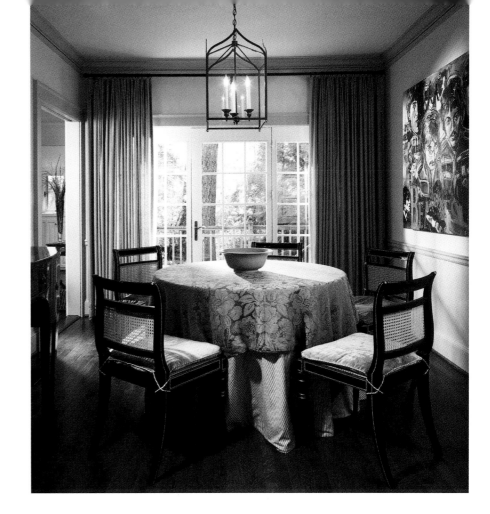

LEFT In this living room, Caroline makes a dramatic gesture with an antique mantel from a Connecticut farmhouse and a fireplace surround in honed black granite. The silver leaf mirror is from Levison-Cullen Gallery.

RIGHT An energetic contemporary painting by Steve Penley is the focal point of this otherwise soothing dining room. A simple gothic lantern from Nierman Weeks is the chandelier.

CAROLINE WILLIS

Caroline Willis Interiors, LLC

Though still young, Caroline Willis has already built a mighty impressive résumé.

She earned a history degree from the University of Virginia thinking she would go on to law school. Instead, she accepted an internship at Christie's auction house in New York. "I thought it would be more fun than doing paralegal work," she says. After that, Atlanta furniture expert and author Deanne Levison, a family friend, helped Caroline get a job in the office of one of the country's top designers, Mariette Himes Gomez.

Caroline then moved to Atlanta and trained for three years with Dan Carithers, another of the country's top designers. By 2002, she had stepped out on her own—to be recognized the following year by *House Beautiful* as one of the country's top 25 young designers.

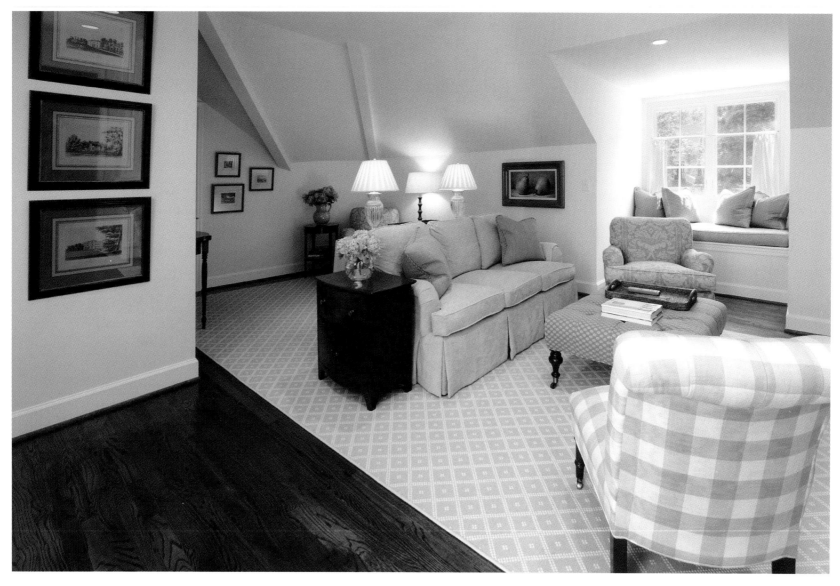

ABOVE In this upstairs retreat off a master bedroom, light colors and a purposeful lack of clutter open up a former attic space.

She might have known she'd end up in the field. Even as a kid, Caroline was always redecorating her room. "I didn't like a lot of clutter, and still don't," she says. "I'm not sentimental. I would just put things out in the hallway and say, 'I'm done with these.'"

Caroline creates clean, classic spaces rooted in tradition. She'll use antiques, but pair them with modern art and pared-down upholstered pieces and accessories. Her instinct is to use soothing palettes combined with textural variety, rather than multiple patterns and colors.

So it's no wonder that the designers whose work moves her most are those who appreciate traditional forms but are forward-looking at the same time. Besides Himes Gomez and Carithers, that includes legends like Billy Baldwin and David Hicks, and top Atlanta designer, Nancy Braithwaite.

"Both my mom and dad have a lot of style," Caroline says. They're now American furniture collectors, though they previously had a more eclectic mix that included European antiques, and they've also always collected contemporary works by Virginia artists, where Caroline grew up. "Now I have a lot of their wonderful castoffs," she laughs.

Caroline's Atlanta home was built in the 1920s. It has a cottage feel and period details like custom moldings, hardwood floors and skinny shutters. She has done its interior mostly in neutral colors, with touches of robin's-egg blue, and a mix of clean-lined antiques and modern upholstered furniture. "My favorite room," she says, "is a deep putty color with creamy linen furniture."

To Caroline, there are two great things about a career in interior design. One is being able to do something different every day. The other is seeing her ideas come to life, and making the people she's doing it for happier and more comfortable in their homes.

RIGHT Caroline specified a custom banquette for this kitchen. The rustic table and chairs with slipcovered seats are both inviting and easy to maintain.

More about Caroline ...

I LIKE WORKING WITH PEOPLE WHO...

Are decisive and open to new ideas.

I'M INSPIRED BY...

Charlottesville, where I went to school, and its classic buildings like Monticello.

IF MONEY WERE NO OBJECT I WOULD...

Buy homes in New York, Paris and Virginia—and a jet to get me from place to place in style.

I LIKE DOING BUSINESS IN GEORGIA BECAUSE...

There are great resources, little attitude, and friendly people who are eager to help.

CAROLINE WILLIS INTERIORS, LLC
Caroline Willis
2300 Peachtree Road
Suite B-205
Atlanta, GA 30309
404-355-9828
FAX 404-355-9629

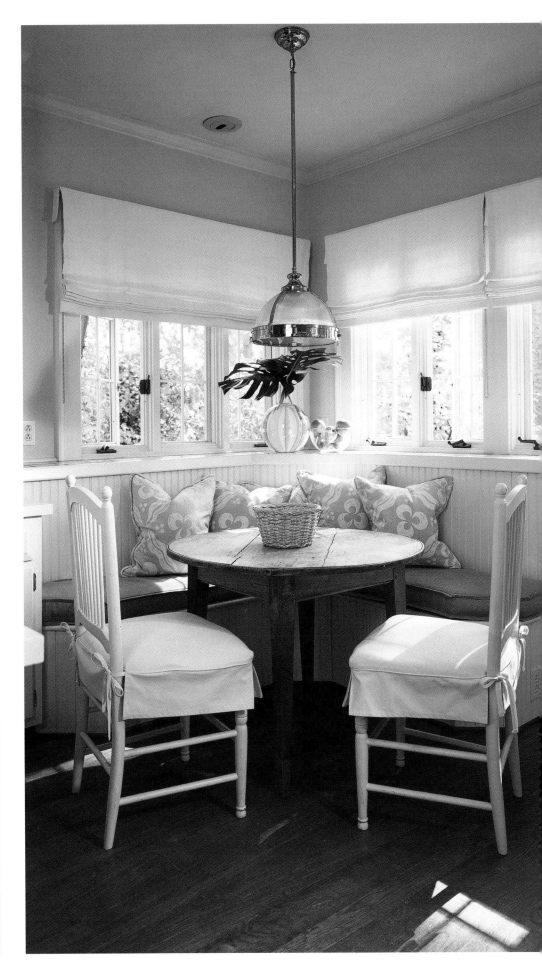

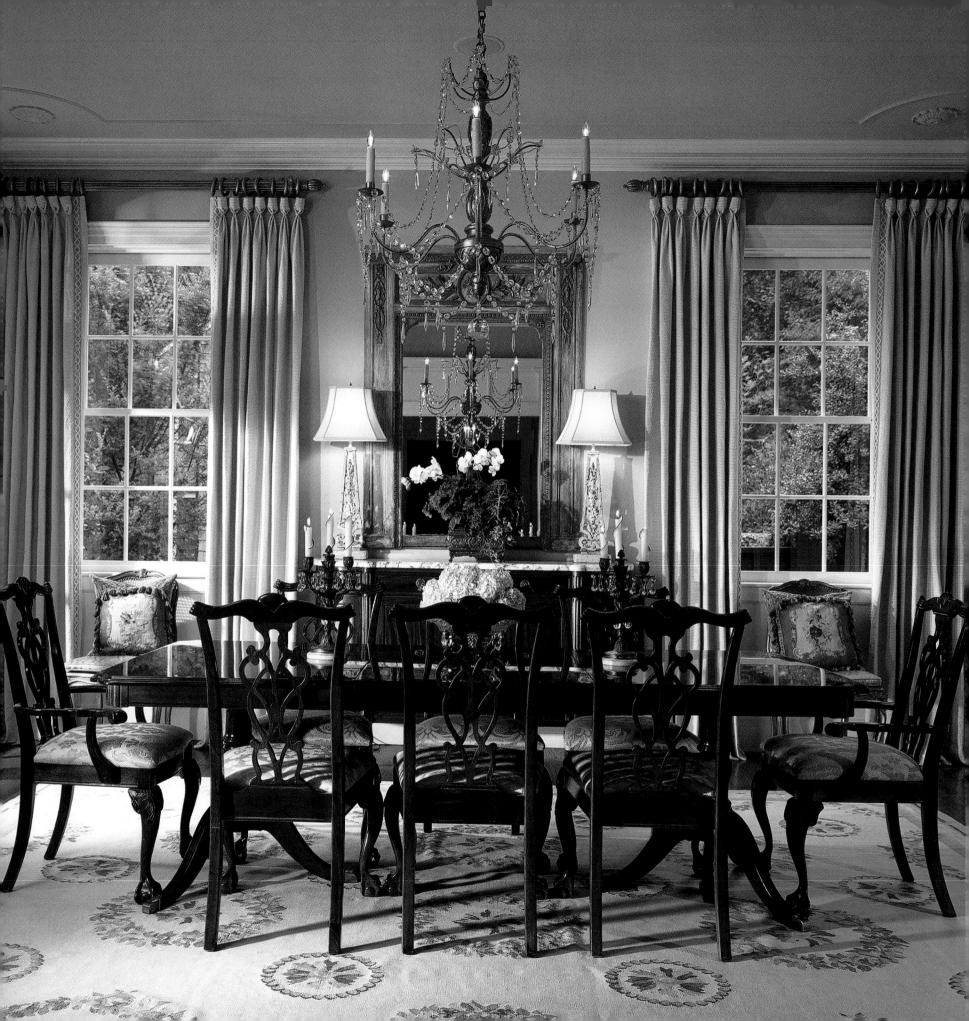

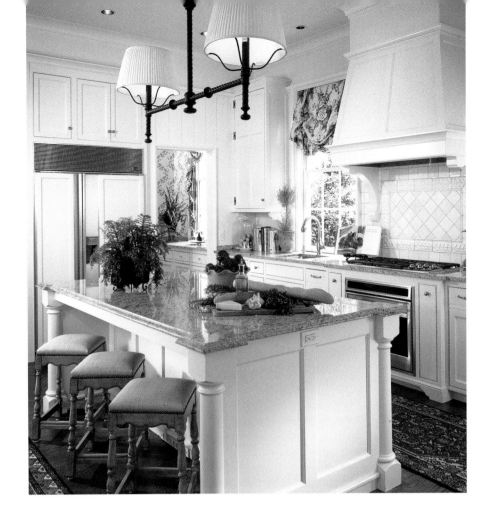

LEFT The muted palette emphasizes the classical architectural elements and furnishings, which include an antique Louis XVI buffet, trumeau mirror and French gilt chairs in this dining room. The draperies are in fabric from Osborne & Little, with Nina Campbell braid.

RIGHT A vibrant mix of natural materials and rich textures gives this kitchen character. The drapery fabric is from Lee Jofa.

CHERYL & ALISON WOMACK

Cheryl Womack Interiors

It's a family affair with Cheryl Womack, who has been an interior designer since 1985, and Alison Womack, who joined her mother's firm in 2000. The family's roots in residential design go back even further. "My husband's entire family was in the building business," Cheryl explains, "he built his first house when he was 16." After practicing law for 10 years, he too became a developer, with Cheryl working by his side. Their daughter, Alison, studied business and worked in radio and advertising, but was eventually drawn to a career in interior design. "I'd spent so much time around it," Alison says, "it was a natural progression."

Cheryl and Alison specialize in giving clients spaces that are both classically elegant, warm and livable. Their work has been recognized with invitations to participate in seven Atlanta Symphony Decorators' Show Houses, the Alliance Theater Guild Christmas House and the

Street of Dreams, for which Cheryl has served as both designer and judge. They have been widely published both in books and in magazines including *Better Homes and Gardens*, *Atlanta Homes & Lifestyles* and *Traditional Homes*.

They also appeared in a Fox Television feature on mothers and daughters who work together. "Our thinking is pretty much in line," says Alison, "and when it's not, we complement each other."

CHERYL WOMACK INTERIORS
Cheryl Womack, IFDA
Alison Womack
240 High Point Walk
Atlanta, GA 30342
404-256-0704
FAX 404-256-8226

THE PUBLISHING TEAM

Panache Partners LLC is in the business of creating spectacular publications for discerning readers. The company's hard cover division specializes in the development and production of upscale coffee table books showcasing world class travel, interior design, custom home building and architecture as well as a variety of other topics of interest. Supported by a strong senior management team, professional associate publishers, and a top notch creative team of photographers, writers, and graphic designers, the company produces only the very best quality of these keepsake publications. Look for our complete portfolio of books at www.panache.com.

We are proud to introduce to you the Panache Partners team below that made this publication possible.

Brian Carabet

Brian is co-founder and owner of Panache Partners. With more than 20 years of experience in the publishing industry, he has designed and produced more than 100 magazines and books. He is passionate about high quality design and applies his skill in leading the creative assets of the company. "A spectacular home is one built for entertaining friends and family because without either it's just a house...a boat in the backyard helps too!"

John Shand

John is co-founder and owner of Panache Partners and applies his 25 years of sales and marketing experience in guiding the business development activities for the company. His passion towrd the publishing business stems from the satisfaction derived from bringing ideas to reality.. "My idea of a spectacular home includes an abundance of light, vibrant colors, state-of-the-art technology and beautiful views."

Candace Werginz

Candace is the Associate Publisher in Georgia for Panache Partners. She and her husband split their time between their home in Atlanta and their lake house in Birmingham "My idea of a spectacular home is one filled with treasured and sentimental possessions—such as my 100-year old four poster cherry wood bed, a most beautiful gift from my grandfather. "

Phil Reavis

Phil is the Group Publisher of the Southeast Region for Panache Partners. He has over a decade of experience in television and publishing. A native to the South, he has lived in Georgia for 14 years. "What makes a home spectacular is my wife and two children. They inspire me every day."

John Umberger

John is the staff photographer for Spectacular Homes of Georgia. He has always studied and enjoyed the art of photography as well as architecture. His 17-year career as one of the area's top architectural photographers has allowed him to combine his two passions on a daily basis.

Donnie Jones

Donnie, the book's production director, is the owner of The Press Group, a publishing production house. The son of small-town printers, Donnie has been in print and publishing his entire life. He and Brian Carabet have worked together creating great books for over a decade. He currently resides in the Dallas, Texas area with his wife and two children.

Additional Acknowledgements
Project Management - Carol Kendall
Traffic Coordination - Elizabeth Gionta and Chris Nims
Design - Alisa Miller, Kathryn Karpf, Anne Rohr

PHOTOGRAPHY CREDITS

Index of Designers